LIN SESLAR

PAINTING SEASCAPES IN SHARP FOCUS

North Light Books
Cincinnati, Ohio

PAINTING SEASCAPES IN SHARP FOCUS

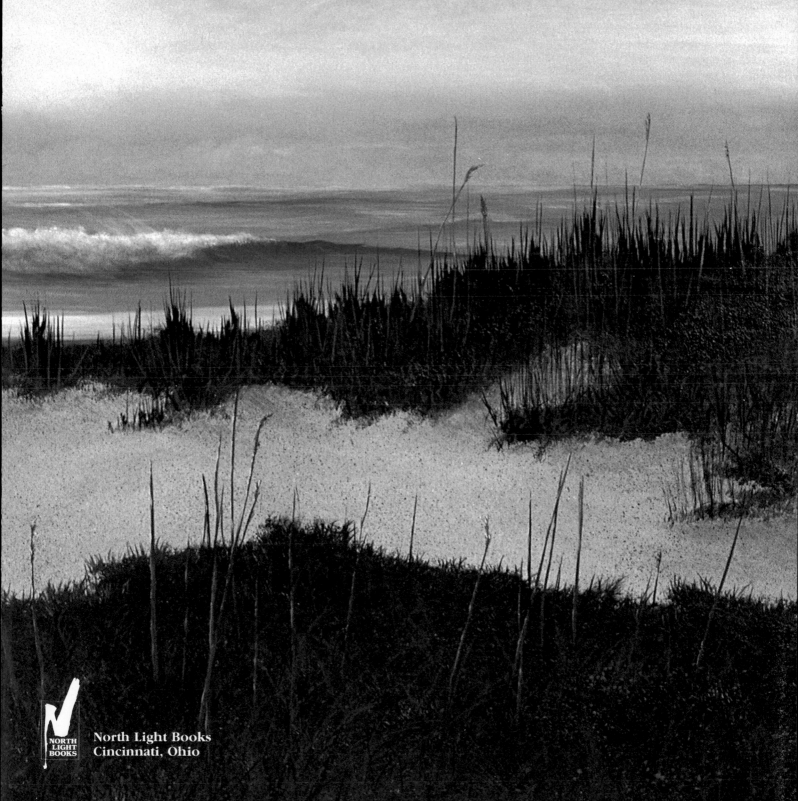

LIN SESLAR

PAINTING SEASCAPES IN SHARP FOCUS

North Light Books
Cincinnati, Ohio

Published by North Light Books, an imprint of F&W Publications, Inc,
1507 Dana Avenue, Cincinnati, Ohio 45207. First edition.

Library of Congress Cataloging-in-Publication Data
Seslar, Lin, 1947-
 Painting Seascapes in Sharp Focus. Includes index.
 1. Marine painting—Technique. I. Title.
ND1370.S4 1987 751.45'437 87-7687
ISBN 0-89134-186-2

Edited by Greg Albert. Design by Carol Buchanan.

This book is dedicated:

...to my parents, without whom I and this book would not have been possible;

...to the galleries that represent my work and the collectors who collect my paintings, without whom my closets would have long since overflowed;

...to Ann and Don, and to my loving and patient husband, Patrick, without all of whose support and encouragement I might have given up art for something easier, like nuclear physics.

CONTENTS

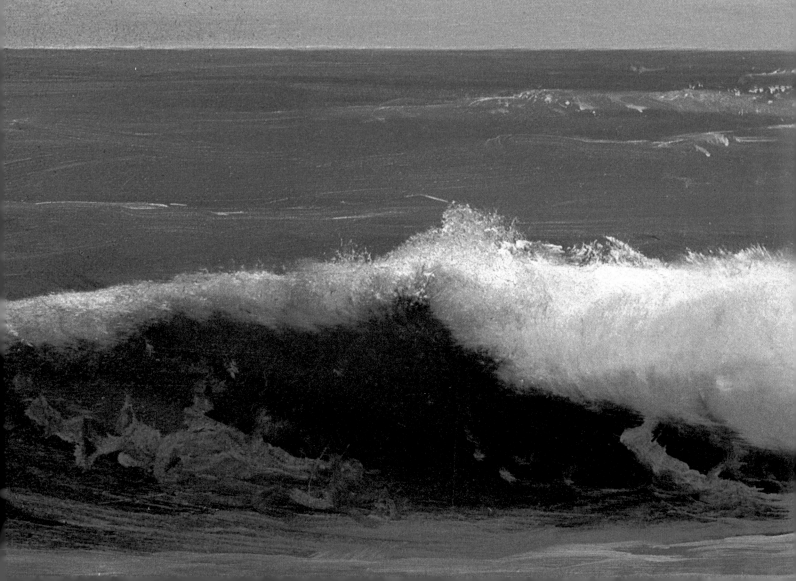

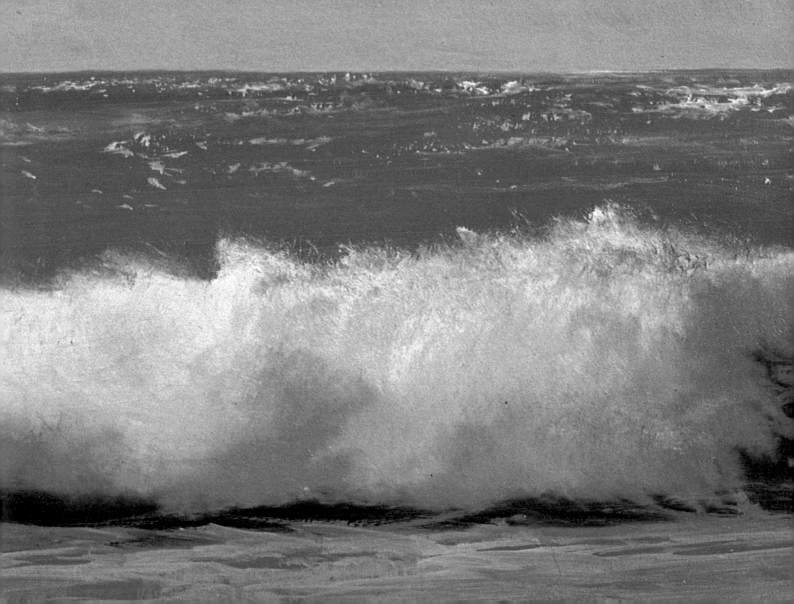

PREPARING TO PAINT IN
SHARP FOCUS

This book is designed to help you learn the techniques of sharp focus painting and to suggest ways to apply those techniques to the grandest and most challenging of all subjects—the sea.

When I was first learning to paint in sharp focus, I asked another artist for his secret. Instead, he related the often-told story about a man who was hospitalized following a terrible automobile accident.

When the man regained consciousness in his hospital bed, he saw that both hands were completely wrapped in bandages. He called for the doctor, who assured him that his hands would be good as new.

"But Doctor," he said, "will I be able to play the piano?"

"Of course," said the doctor, "you'll be playing Bach with the best of them in no time." Overwhelmed with joy, the man leaped from his bed and hugged the doctor.

"You're a genius!" he cried. "I don't know how to thank you. Before the accident, I couldn't play a note!"

In a similar manner, many artists new to sharp focus painting expect too much, too soon. As you work through the demonstrations in this book, try to keep in mind that all painting is an additive process, with each new application of paint further defining the last. In sharp focus painting, the process of definition is simply taken several steps further than in typical scenic painting.

Since you may not be familiar with my techniques, this book begins with a discussion of how sharp focus painting differs from traditional meth-

ods. I'll briefly discuss the key points that are illustrated in later chapters, such as strong value contrasts, lifelike color, attention to shadows, and contrasts between pure and grayed colors.

Later in the same section, we'll look at the materials and equipment I use and why I selected each item. We'll look at an "easel" that isn't an easel and at "canvases" that aren't canvas. I'll let you in on my pet peeves and preferences; I'll tell you about the paints I use and why. Then we'll take a brief look at the brushes I use and what effects each can produce.

In the next section, we'll take a sharp focus seascape apart, or rather, put it together, piece by piece. We'll look at skies, headlands, the horizon line, distant water, the major wave, rocks, surf, birds, beach, and shells. We'll see some of the possible treatments for each element and talk about when, why, and how you might want to use each.

In the third section, we'll see how all these elements come together in completed paintings. I'll also talk in detail about additional techniques that will heighten sharp focus effects in your paintings.

In the final section, we'll look at typical reference photographs and at the paintings that were created from them. Here you'll have a chance to apply the information gained in previous chapters and to try out sharp focus techniques for yourself.

Painting in sharp focus is demanding and requires continuous attention to detail. Yet sharp focus techniques are

well within the grasp of any artist with the desire and determination to master them. Be patient and be persistent. You'll soon be delighted with the results of your newly developed skills.

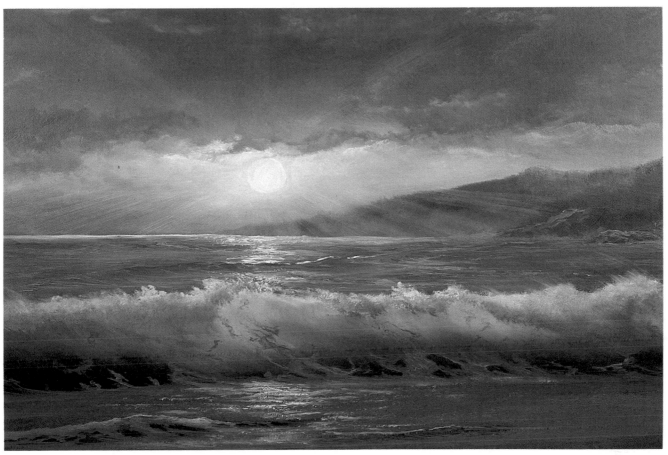

Detail of
Golden Hour

What Makes Sharp Focus "Sharp"

The sea is surely one of the most challenging, frustrating, and ultimately satisfying subjects an artist can seek to capture. The constant motion of the sea, whether swirling, rolling, crashing, or quietly lapping at wet sand, provides a never-ending and continually changing series of images. From such complicated scenery, an artist must learn to isolate one fraction of a moment, freeze it, simplify it, and often, perfect it by combining it with sketches or remembered images. Whew!

When I began painting, I relied heavily on photographs as a means of providing the "frozen moments" that my eyes were not yet trained to see. I was constantly amazed at the many awkward poses seemingly necessary for a seagull to maintain its graceful flight. My photographs of the sea revealed a similar situation—it also had many ungainly moments. I came to realize that in viewing the sea and its creatures, beauty is the accumulation and combination in our minds of the best moments of each element.

So what makes sharp focus "sharp"? In simple terms, a successful painting is created by combining or adding different but related "frozen" images, then further refining each individual image using various sharp focus techniques and textures. The process is one of addition, much like the construction of a building from individual bricks. No one brick, by itself, resembles the completed building, yet each is necessary for the structure to stand. A sharp focus painting is created in much the same way. First, a rough foundation (your sketch) is created, then the exterior walls and other details that define the shape of the building are added (your color block-in of major masses and forms). Only then is the final decorative trim added (sharp focus). If a building or a painting is not properly constructed in the early stages, no amount of decorative trim will hold it together.

The sharp focus effect in seascape is the result of applying a series of general *guidelines* (which I'll discuss in detail in later chapters). I'd like to emphasize that these are only guidelines and not hard and fast rules. As you paint and grow more confident in the techniques of sharp focus, feel free to experiment, to break the "rules"—that's how you'll find your own unique style.

With that thought in mind, here are a few of the guidelines I use:

Value Contrasts. Think of a gray, overcast day. Now think of a brilliant, sunny day. What is the difference? That's right, *value contrasts.* Without regard to the actual colors involved, value contrast is the difference between the lightest light and the darkest dark. You might think of *value* as a scale running from white at one end through various grays in the middle to black at the opposite end. In general, greater value contrasts (or distance between values on this scale) in your paintings will result in a stronger sense of sharp focus.

Edges. In a completely darkened room we see nothing because there is no light and, therefore, no contrast. When a sliver of light appears through a door slightly ajar, we become aware of value contrasts—that is, light against dark—and edges. Edges describe the profile of a chair or a table even before we "see" the object. As the door opens wider, edges continue to define the shape of the chair and other objects in the room, but quickly become subordinate to contrasts between light and shadow and between pure and grayed colors.

Shadows. Shadows are creatures of sunny days. They tell viewers just how bright the sun is and from what angle it shines. Shadows anchor objects to earth; without them, your paintings will have an unsettling, surrealistic look.

Contrasts Between Pure and Grayed Colors. In a confined space such as a room, brilliant colors are an effective device for calling attention to something—a chair, a flower, or whatever. In seascape, pure colors are also used to direct attention to the subject, usually the foreground, but the contrast between pure and grayed colors is also an effective way to convey a sense of distance. Colors closest to us are purer; those farther away are more subdued.

Color. Perhaps the most noticeable characteristic of sharp focus seascape painting is the use of realistic colors—that is, colors that are not greatly different from those found in nature. In later chapters, I'll suggest colors for skies, waves, and dunes, but I urge you to go out and look for yourself; you may find other colors that work as well or better. Truly believable colors cannot be

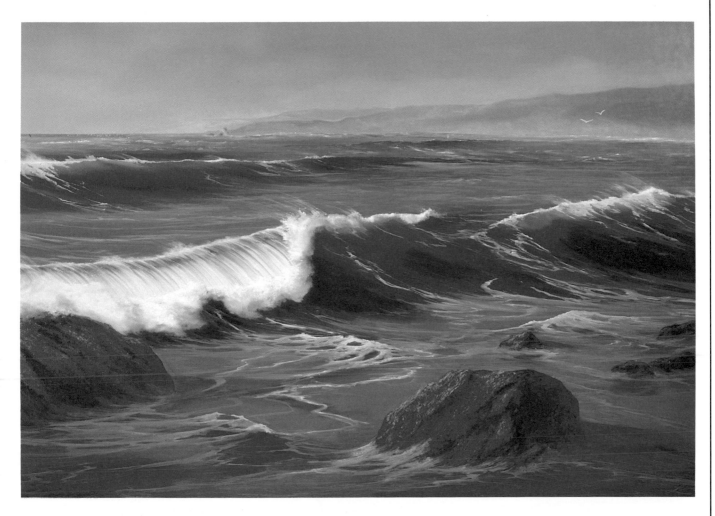

mixed from any predeter-
mined formula in the isolation
of your studio. The colors I'll
suggest will still need to be
mixed and adjusted according
to your own perceptions and
judgment.

Visual Acuity. The most im-
portant guideline: Learn to
use and trust your own eyes.
You can paint only as well as
you see. Look for small de-
tails. Constantly ask yourself
why something looks the way
it does. What defines it? Value?
Edges? Shadows? Color?

So finally, what exactly
makes sharp focus "sharp"?
One thing is certain: There

are no "trick" techniques or
"magic" brushes. Sharp focus
painting is simply a combina-
tion of close observation and
careful application of time-
honored painting practices.

Now, let's move on and
take a look at the materials
and equipment used in sharp
focus painting.

Detail of
Jeweled Breakers

*In this painting, we can see the
characteristics of a painting in
sharp focus: realistic colors,
strong value contrasts, sharp
edges and pure colors in the
foreground, soft edges and
grayed colors in the
background, and well-defined
shadow areas.*

CHAPTER 2
Materials and Equipment

The range of materials and equipment available to artists today is truly staggering. Ironically, as a result of that good fortune, choosing a selection that works well for your techniques and temperament is a task that often spans an entire career.

To further complicate matters, what "feels right" for one artist may be totally wrong for another. Nevertheless, what follows is a description of the materials and equipment I use and why I like each item. Use it as a guide, not a bible—most of the effects I'll describe later could be produced as easily in several different ways.

Painting Surface. Although canvas is the surface most painters use, I prefer to paint on gessoed hardboard. Don't be alarmed if you've never worked on hardboard before—all of the techniques which are described later in the book can be applied to canvas as easily as to hardboard.

If, however, you want to work on hardboard as I do, here's how: At your local lumberyard, ask for 1/8-inch *untempered* hardboard. A 4' × 8' sheet is usually less than ten dollars. (Hardboard is also available tempered. Don't use the tempered type, because it is impregnated with oils that will permeate and darken your paintings over time.) Ask the lumberyard to cut the panel into suitable sizes for your needs, or haul the whole panel home and cut it up with a hand saw, as I do.

During manufacturing, a slick, waxy surface is added to make the panel look better. To prepare the panel for painting, thoroughly sand the smooth side with 220-grit sandpaper to remove all traces of the slick finish. (Tip: a power sander saves lots of time!)

Gessoing can be accomplished in several ways, depending on how smooth or textured a surface you like to paint on. A utility brush will produce a texture much like canvas if you brush the first coat horizontally, the second vertically, and so on, until you've put on three or four coats. A paint roller can be used in much the same manner to produce a more subtle texture. Finally, an airless paint sprayer can be used to apply five or six thinned coats for an ivory-smooth surface (my preference). Regardless of the method you choose, sand between coats and after the final coat.

I use Liquitex brand gesso, but I've also had good results with Grumbacher's Hyplar brand. Several other brands I've tried created a surface that was too absorbent and left insufficient time for blending thin paint layers (a rather surprising problem to have with oils).

Easel. Once again, you have many types of easels to choose from. I use two types: one for painting in my studio, and another for traveling or painting on location.

The one I use in my studio is not an easel at all, but a drafting table, approximately 32" × 42". With this "easel," I can comfortably paint on panels up to 36" × 48" without trouble. What is important is that the table provides a rigid and stable support for the large, gessoed panels that I use instead of canvases. With the tabletop tilted to a nearly

vertical position, I can easily control brushwork for fine detail or maintain the light touch necessary for effective blending of adjacent colors. The tabletop can also be rapidly tilted to horizontal should I need to keep a loose glaze from running. In addition, the table doubles as a handy work space when I brush the final varnish onto my paintings.

The second easel, which I use when traveling or painting on location, is a French-style folding easel. The French easel is reasonably light and remarkably solid. It folds to about the size of a small suitcase and has compartments for paints, brushes, and palette. Because of its small size, however, it does not provide adequate support for painting on panels larger than 18" × 24".

Palette. I prefer disposable paper palettes (usually 12" × 16" with a slick surface), and I'll often have two pads covered with paint mixtures at one time. At the end of each painting session, I scrape together any paint mixtures I'll need later and transfer them to a new sheet on one of the disposable palette pads. Then I place this pad in a plastic tray with a tight-fitting snap-top lid (available in most art supply stores) to keep the paints fresh for a few days until I can work on the painting again. Needless to say, this procedure saves a lot of paint and time spent remixing.

Paper Towels. I wonder what Rembrandt did without them. I use about one roll per session. They're great for wiping paint or thinner out of brushes, for wiping out passages of paint that don't quite work, and of course, for wiping my

hands. And, even if it sounds like a TV commercial, I do like the better-quality brands because they really are stronger and more absorbent.

Thinner. I use ordinary mineral spirits instead of turpentine for thinning my paints and cleaning up afterward. Mineral spirits are cheaper, work as well, and have far less odor. I do use turpentine, but only where there's no substitute for its potent solvent qualities—i.e., for mixing painting mediums and for cleaning the varnish out of brushes used for coating paintings.

Painting Mediums. For initial block-in of major forms, I use a mixture that's six parts linseed oil and four parts turpentine. For any subsequent work over the initial block-in, I use straight linseed oil to "loosen" tube colors to a soft, buttery consistency. For transparent glazes, I use a mixture of one ounce of damar varnish, one ounce of stand oil, five ounces of turpentine, and fifteen drops of cobalt drier. You may find it useful to label or color-code one oil cup for each medium to keep everything straight while you're painting.

Palette Knife. I have only one palette knife, which I use primarily for mixing paints on the palette, scraping out passages that don't satisfy me, and, to a very small extent, creating certain textural effects, which I'll describe later.

Varnish. I don't use varnish in the actual painting process (except when glazing), but I do coat completed works with Liquitex's Soluvar brand of varnish. Soluvar comes in liquid or spray and in either matte or gloss finish. I use the

liquid variety and mix the gloss and matte varnishes in equal parts to create a semi-gloss finish. Aside from its handling characteristics and clarity, I like Soluvar because it's easily removed with turpentine if I decide to rework a section of a previously completed painting.

Value Finder. Not since the invention of three-hole notebook paper has anyone created anything quite as simple and useful as the Liquitex Value Finder. Made of lightweight cardboard, the Value Finder has gray values from 2 (dark) through 9 (light) reproduced along its left margin, with two holes punched through each value sample. By holding the holes in the gray scale over a color and squinting, you can find the approximate value of any color. A gray scale such as this is invaluable in controlling values for sharp focus effects and in accurately mixing the necessary colors. This item should be available in your local art supply store for less than one dollar.

35mm Reflex Camera. Used intelligently and as a tool rather than as a crutch, a camera is one of the most useful pieces of equipment an artist can own. In fact, many great artists, from Degas to Francis Bacon, have used photographs. Even Vermeer is thought to have used a primitive version called a *camera obscura.*

Until the advent of the camera and Muybridge's pioneering work in high-speed photography, artists could only speculate about the stop-action appearance of fast moving objects, such as the legs of a galloping horse—as a result,

they devised many ingenious postures for horses, which in retrospect, are quite preposterous. The sea, like Muybridge's horses, is in constant motion—guesses and assumptions about its movement will lead to preposterous images just as surely now as in Muybridge's day. Photographs are an important tool for stopping the action and allowing us time to study the anatomy of a wave or of a seagull's flight.

For our purposes, any good 35mm camera with through-the-lens ("reflex") viewing will do nicely. In addition to the standard 50mm lens, a 28mm wide-angle lens and a 70-150mm zoom telephoto will greatly expand your camera's usefulness.

So now you know what materials and equipment you'll need. Let's go on to the next chapter and look at specific colors you'll want for your palette and at a unique color mixing system.

CHAPTER 3
Selecting a Palette

When I first began painting, I'd look at the sky and say, "That's blue." Then I'd mix a glob of phthalo blue and a little of almost everything else on the palette trying to get the color I'd seen. It wasn't until much later that I realized my mistake. I had only one blue and I was trying to make it work for every blue I needed. I'm not saying it couldn't be done, but "one size fits all" is an approach better left to cheap sweaters. Besides, I wanted to spend most of my time painting, not just mixing colors.

So, I bought every blue I could find in the art supply store. I was going broke, thinking of getting a pack mule for my paint box, and still having trouble mixing the blue I wanted.

That's when I discovered my second problem. I knew I had to gray my colors a bit on occasion, and I was told I could mix a nice gray from phthalo green and alizarin crimson—complements on the color wheel. Each time I painted, I'd mix up a batch of gray; sometimes I'd just mix a little here and there as I went. Something always seemed a little out of balance in my work, and I couldn't figure out why.

Then one day I had a glob of gray left from a previous session and a fresh batch I'd just mixed. I mixed a little of the same blue with each and got two distinctly different colors. One day's gray was greenish, the other day's was reddish. Voilà! What I needed was a standard gray so I'd always know how it affected my other colors.

My solution was to purchase tubes of standard grays from Liquitex in a range of premixed values from value 3 (dark) to value 8 (light). But you don't have to do it my way. If you have a favorite gray mixture, such as phthalo green and alizarin crimson or burnt sienna and ultramarine blue, that you're comfortable with, simply decide on a formula—such as 50/50—that gives you a gray you like, and then don't deviate from it. The important point is not which gray you use, but how consistently it produces predictable color mixtures.

As so often happens, one discovery led to another. Liquitex also makes a color chart called an Oil Color Map & Mixing Guide. Among the many useful pieces of information it imparts is the exact value of each of the company's premixed tube colors. Furthermore, an actual paint chip shows how each color looks straight out of the tube, then with a little gray, and finally with a lot of gray. In addition, paint chips are provided for color mixtures that aren't available as tube colors, with instructions on how to arrive at that exact color.

The Color Map changed my way of seeing color. Now instead of looking at the sky and saying, "That's probably phthalo blue," I look at the sky, then try to find a near match on the color chart. All that remains then is to mix the colors indicated and make a few minor adjustments to get just the color I want.

Once again, this is not an advertisement for Liquitex; I'm simply describing what works for me. If you have a set of colors you're accustomed to, there's no point in changing on my account. With the Value Finder described in the previous chapter, you should be able to quickly classify your colors by value and construct a similar color map that is uniquely your own. The point is not what brand you use, but the ease with which you arrive at desired color mixtures. Our objective, after all, is to spend more time painting and less time mixing while creating the most lifelike colors possible.

A good basic palette will contain the following colors:
grays—values 3, 4, 5, 6, 7, 8
titanium white
ivory black
Light Magenta
Deep Magenta
Acra Crimson
burnt sienna
cadmium orange
cadmium yellow medium
yellow ochre
raw umber
Brilliant Yellow Green
Permanent Sap Green
Phthalocyanine Green
Permanent Light Blue
cerulean blue
cobalt blue
ultramarine violet

In addition, the following colors are often useful:
cadmium red light
raw sienna
burnt umber
Bright Aqua Green
Phthalocyanine Blue
Permanent Light Violet

You can see the palette colors I prefer (except titanium white and ivory black) in the chart on page 9. At this point, most of the colors I use are made by Liquitex. (The names of paints are capitalized when they're Liquitex names; all others are generic.)

However, I prefer Winsor & Newton's titanium white because it appears to be ground

more finely than other brands. This is very important when painting skies on hardboard panels because even small granules of coarsely ground color stand out like boulders.

Useful Color Mixtures

The top chart on page 10 shows three possible sky palettes in vertical columns. The first is based on cobalt blue, the second is based on ultramarine blue, and the third is based on cerulean blue. In addition, the chart is arranged into rows according to where the colors would be used in painting a sky. Specifically, Row 1 is the color to be used for the sky directly overhead, which appears in a painting in the upper left and right corners; Row 2 is the color of the middle distance, seen in the middle of the sky area; Row 3 is the color just above the horizon line; and Row 4 is the color of the background water below the horizon line (which is derived from the basic sky mixture used in each case). One of these three palettes should be appropriate to match any daytime sky you might encounter.

The bottom chart on page 10 shows two color mixtures for rocks. The top row is based on burnt umber and raw sienna mixed with gray and white to produce a range of warm colors. The bottom row is based on burnt umber and ultramarine blue to create cool colors. The chart on page 11 shows more useful color mixtures. The top two rows show basic mixtures for blue and green waves. The bottom two rows show mixtures for foam, sand, grasses, and kelp.

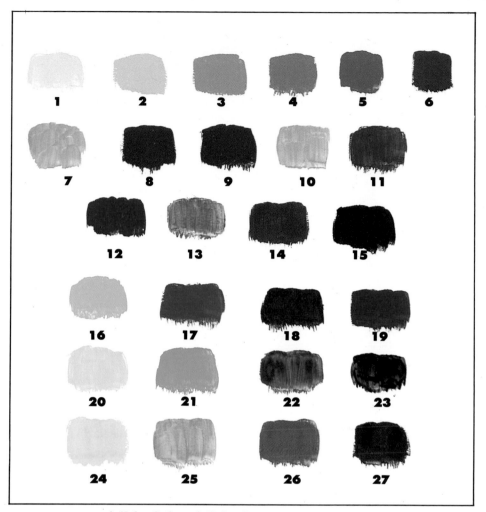

1. Value 8 Gray. 2. Value 7 Gray. 3. Value 6 Gray. 4. Value 5 Gray. 5. Value 4 Gray. 6. Value 3 Gray. 7. Light Magenta. 8. Deep Magenta. 9. Acra Crimson. 10. Permanent Light Violet. 11. Ultramarine Violet. 12. Cadmium Red Light. 13. Cadmium Orange. 14. Burnt Sienna. 15. Burnt Umber. 16. Permanent Light Blue. 17. Cerulean Blue. 18. Phthalocyanine Blue. 19. Cobalt Blue. 20. Brilliant Yellow Green. 21. Bright Aqua Green. 22. Permanent Sap Green. 23. Phthalocyanine Green. 24. Cadmium Yellow Medium. 25. Yellow Ochre. 26. Raw Sienna. 27. Raw Umber.

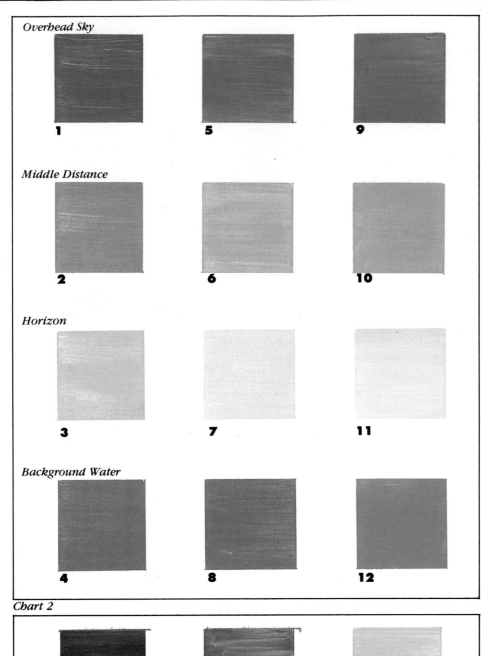

Overhead Sky
1 5 9

Middle Distance
2 6 10

Horizon
3 7 11

Background Water
4 8 12

Chart 2

Useful Color Mixtures

Sky Palettes

1. *Cobalt Blue plus gray of same value.* 2. *Same mixture as no. 1, plus white.* 3. *Add still more white plus a hint of Permanent Light Violet.* 4. *Add more gray of same value to mixture no. 1.*

5. *Ultramarine Blue plus gray of same value.* 6. *Mixture no. 5, plus white.* 7. *Add still more white plus a hint of Ultramarine Violet.* 8. *Add more gray of same value to mixture no. 5.*

9. *Cerulean Blue, Phthalocyanine Blue, and gray of same value.* 10. *Mixture no. 9 with more Cerulean Blue and white.* 11. *Add more white plus a hint of Ultramarine Violet.* 12. *Add more gray of same value to mixture no. 9.*

1 2 3

4 5 6

Chart 3

Rocks: warm colors

1. *Burnt Umber plus gray.* 2. *Mixture no. 1 plus Raw Sienna.* 3. *Mixture no. 2 plus white as necessary.*

Rocks: cool colors

4. *Burnt Umber, Ultramarine Blue, and gray.* 5. *Mixture no. 4 plus white.* 6. *Mixture no. 2 plus more white.*

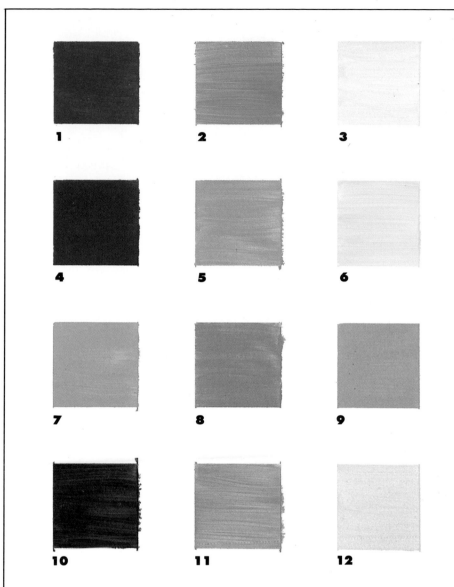

Mixtures for blue waves

1. Base of wave: Cerulean Blue plus gray. 2. Middle of wave: Brilliant Blue plus gray. 3. Top of wave: Permanent Light Blue plus gray.

Mixtures for green waves

4. Base of wave: Phthalocyanine Green plus gray. 5. Middle of wave: Turquoise Green plus gray. 6. Top of wave: Bright Aqua Green plus gray.

Mixtures for foam and sand

7. Foam: Permanent Light Violet plus gray and a hint of Cerulean Blue. Lighten with white as necessary. 8. Sand, red base: Cadmium Orange plus gray. 9. Sand, yellow base: Yellow Ochre, Burnt Umber, and gray.

Mixtures for grasses and kelp

10. Permanent Sap Green plus gray. 11. Vivid Lime Green plus gray. 12. Brilliant Yellow Green plus gray.

Chart 4

CHAPTER 4
Brushes and Brushstrokes

Like individual bricks that overlap and interlock to create the form and structure of a building, each brushstroke in a painting adds to the strength and vitality of the final image. Yet bricks and brushstrokes are only building blocks. In the end, it is the architecture and the image we want viewers to see. Therefore, in completed paintings, sharp focus techniques should strive to minimize distractions such as visible brushstrokes and impasto passages.

To keep such distractions to a minimum in my paintings, I keep paint layers relatively thin and I smooth the surface of each newly applied paint layer with a synthetic sable fan brush. The process begins during my initial block-in. While I establish the major masses and values using a ¾-inch synthetic sable watercolor brush, I'm careful to keep my colors thinned to about the consistency of heavy cream with my 60/40 linseed oil-turpentine painting medium. (A tip: too little medium and the paint will not smooth out; too much medium and the paint will not cover.)

At subsequent sessions, I continue to keep the paint surface as flat as possible, using other tools to further develop the initial image: the edge of a palette knife; spatters from a toothbrush; swift strokes from a dagger striper. With care and practice, few ripples remain to tell of the brush's passage; the final image conveys a startling sense of reality.

Let's take a look now at each of the brushes in turn and see what they can do. As you study the paintings and work through the demonstra-

tions that follow, you'll have a chance to see how each brush and brushstroke is used. As you begin to put your new knowledge into practice, refer back to this section often. Soon the proper combination of brush and brushstroke will become second nature, and you'll be able to concentrate your energies and talent on the main purpose of this book: learning to paint the sea in sharp focus.

Below is a list of the brushes I use regularly.

Useful Brushes

White sable Skyscraper (Robert Simmons); Sizes ½", ¾", and 1"
Sabeline flat (Uniprise); Sizes #10 and #14
Bristlette flat (Grumbacher); Size #3
Liners (Winsor & Newton); Sizes #0 and #2
Fan brush, bristle (Delta); Sizes #1 and #4
Fan brush, synthetic sable (Robert Simmons); Size #6
Dagger striper (Grumbacher); Sizes #0 and #1
Toothbrush, ordinary household variety

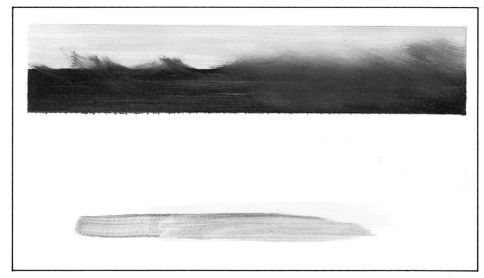

White sable Skyscraper, all sizes

Rough blending stroke

Flat watercolor brushes are also excellent for rough blending of adjacent colors. Use a succession of overlapping curves, lifting the brush just slightly toward the end of the stroke.

Glazing

Flat watercolor brushes are useful for laying down a transparent tint over a dry underpainting to "warm" or "cool" previously applied colors, or simply for adding a unifying tint to pull colors into harmony.

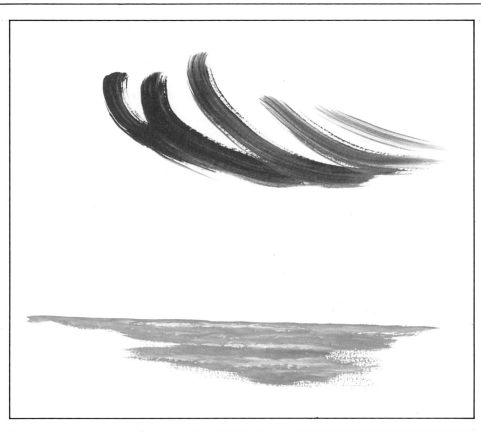

Sabeline flat, all sizes

Block-in stroke for waves

Very similar to flat watercolor brushes, Sabeline flat brushes are well suited for blocking in tight areas such as waves, where a stroke that curves downward and then moves almost horizontally is best.

Block-in of distant water

Turning a Sabeline flat so that the edge is horizontal is the best way to block in the distant water below the horizon line. Once a middle value is blocked in, a light value can be used to suggest foam or whitecaps, while a darker value can suggest waves silhouetted against the troughs. Strokes should be thinner and closer together at the horizon, gradually growing thicker and farther apart as you approach the foreground and main wave.

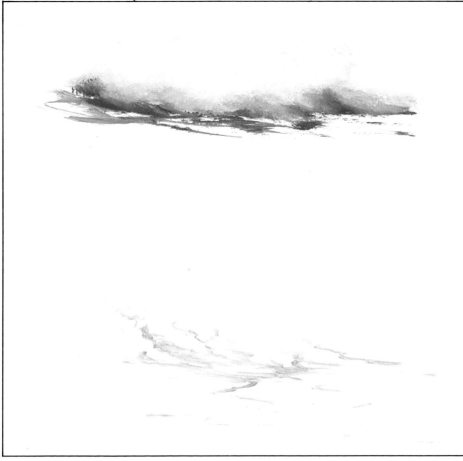

Bristlette flat #3, and liners, all sizes

Bristlette flat #3, block-in of foam

The size and stiffness of this brush is great for suggesting the turbulence of foam, using short jabbing strokes.

Liners, all sizes, foam patterns

Liners have many uses for brightening highlights and refining detail, but their longer tip and point offer a fluidity that's unmatched for rendering the "wiggles" of foam that slide down the face of a wave.

13

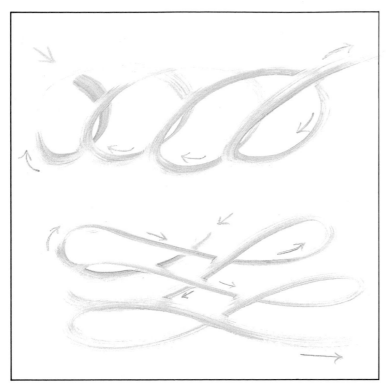

Synthetic sable fan brush for blending

Preliminary blending stroke

A light touch and overlapping circular motions with a synthetic sable fan brush soften transitions between adjacent colors.

Final blending stroke

A synthetic sable fan brush moving in overlapping figure eights with a feather-light touch will remove most brushmarks.

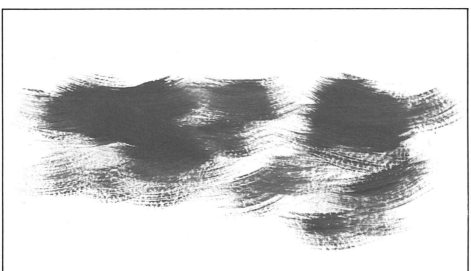

White sable Skyscraper, all sizes

Block-in stroke with Skyscraper

Flat watercolor brushes are excellent for initial block-in. As each curved stroke overlaps the last, the paint is brushed out thin and smooth, leaving few brush marks to be blended out later.

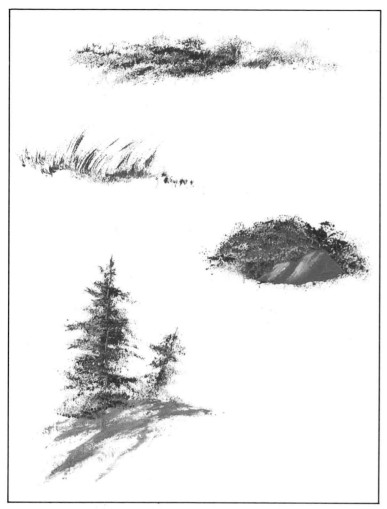

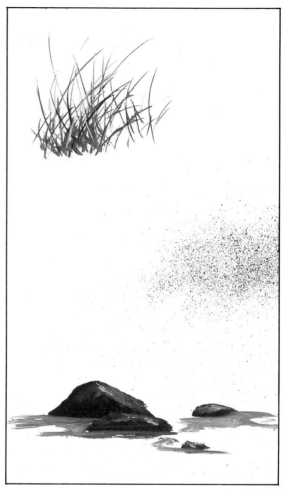

Fan brush, bristle

Low grasses

Use a bristle fan brush in short jabbing strokes to create the look of low grasses.

More grasses

A slight upsweep of the bristle fan brush suggests taller grasses.

Low bushes

A denser build-up of jabbing strokes creates the look of thick bushes such as those often found on hillsides overlooking the ocean.

Pine trees

Pine trees are easy to suggest with short jabbing strokes that angle like the sides of a rooftop on either side of the trunk.

Other useful tools

Dagger striper

For tall, waving grasses, nothing beats a dagger striper moving in graceful upward strokes.

Household toothbrush

Spatters from a toothbrush add life to sand, rocks, and foam.

Palette knife

A palette knife is great for rocks. Large areas can be "troweled" on with the broad side of the blade, while narrower areas (like these highlights) can be scumbled on by laying the blade flat against the panel and sliding it back and forth in strokes parallel to the handle.

STEP BY STEP

Now that you have a better idea of what it means to paint in sharp focus and you know what colors, brushes, and other equipment are necessary to speed you on your way, let's begin by looking at the anatomy of a painting.

As you'll discover in this section, I divide a painting into distinct areas (skies, headlands, horizon line, background water, etc.). These areas represent the nine steps I normally go through to complete a painting. By following these nine steps, you, too, will soon discover how much simpler it is to concentrate on one area of related colors at a time rather than being overwhelmed by the complexity of the whole image.

As we move through each chapter, we'll be looking at the important planning and painting considerations for each of the nine areas: in some cases, I'll be recommending specific colors or brushes; in other instances, I'll be helping you learn to see what makes a painting look "real." In every chapter, I've tried to anticipate the problems you'll face and the questions you'll want answered.

One final note before going on: In general, at the block-in stage I carry each section as far toward its final appearance as possible without losing detail or creating mud. At each subsequent session, I work over the dry paint of the previous session and again carry the image as far toward completion as possible. How far I can go at each session depends, of course, on how familiar I am with the colors and the subject—and this varies from subject to subject.

Initially, you may not be

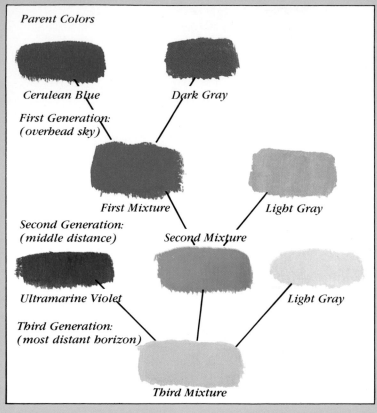

Parent Colors

Cerulean Blue Dark Gray

First Generation:
(overhead sky)

First Mixture Light Gray

Second Generation:
(middle distance) Second Mixture

Ultramarine Violet Light Gray

Third Generation:
(most distant horizon)

Third Mixture

able to go as far as I do at the block-in stage. Never fear. Think of creating a painting as a process much like building a pyramid (another formidable task): the block-in forms a broad base that defines the area and basic structure of the painting. At each subsequent session of painting (or pyramid building), the area that needs to be covered is smaller, until, at the end, only a few small highlights are needed to put the point on the pyramid, so to speak.

As in the fable of the hare and the tortoise, it isn't terribly important how quickly you get to the finish line—only that you get there. With this in mind, the following chapters describe not only the block-in process for each of the nine areas of related color, but also the subsequent steps necessary to bring each area to completion. How far you go at each session will be determined by your own judgment and emerging skills.

Now, let's begin with skies.

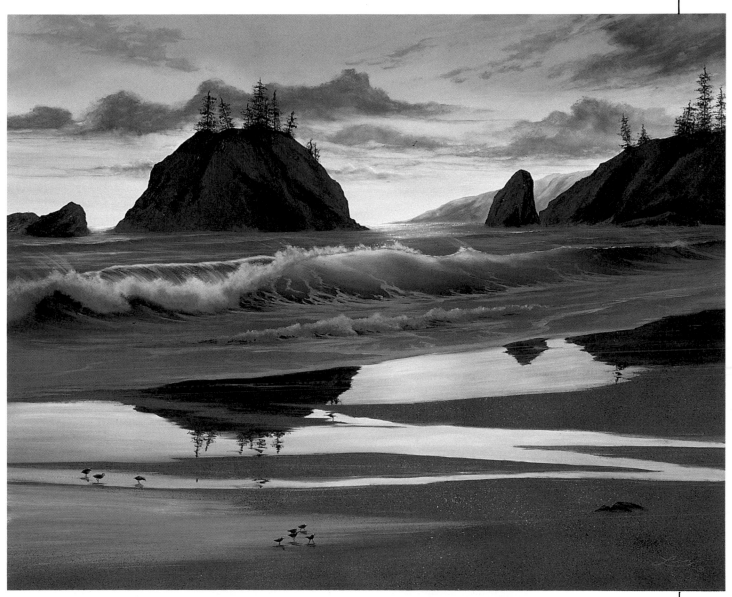

Reflections at
Sunset
24″ × 30″

A painting such as Reflections at Sunset, *no matter how complicated, is made up of distinct areas of related colors, such as the sky, headlands, horizon, and so on. By concentrating on each one in turn, you will discover that each step is not that difficult, and that they add up to a beautiful sharp focus seascape.*

CHAPTER 5

Skies: What Color Is Air?

Skies can be as simple or as complex as your mood. Too often, however, we tend to oversimplify and say, "The sky? Yeah, it's blue with white clouds." Then, when we sit down to paint, the results are disastrous. It may sound elementary, but the place to begin is outside under the sky with your brushes, your easel, and a fresh panel. You won't find a better "formula" for mixing lifelike colors. Take time to mix the various colors you see—and make thorough notes so you'll be able to repeat the process in your studio even if it's raining or snowing outside.

In the meantime, here are a few tips for making your mixing go more smoothly:

First, look past the obvious color to judge the underlying value—that is, the relative lightness or darkness of the color on a scale from white to black. I've found that rough value sketches of a scene drawn with an ordinary office pencil are an excellent way to develop this value sense.

Next, determine the overall color family on which you will base your mixture. For sunny days this will typically be either cerulean or cobalt blue.

Finally, judge the purity of the color—the amount of gray which must be combined with the basic tube color to reduce its brillance to a usable level.

In other words, when using this system, a sky color might be defined as a value 6 cerulean blue, slightly grayed. Needless to say, a sky will require several different mixtures, but this basic mixture of cerulean blue and gray will be a good starting point or *first-generation color.*

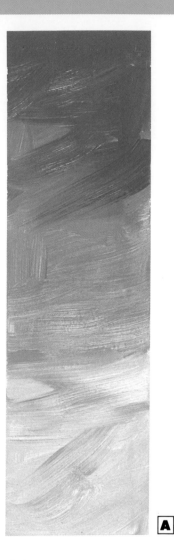

A

B

Column A:

This is how a sky looks after rough block-in, graded from a dark at the top to a lighter value above the horizon line.

Column B:

This is how the background sky should look after blending with a white sable fan brush—evenly graded from dark to light, ready to receive more sharply focused clouds.

Like a human family, the blues in skies are all related. From a parent mixture of cerulean blue and a gray of about the same value (see illustration on page 16), mix a *first generation,* the color of sky nearly overhead—usually seen at the upper left and right corners of a painting.

Next, mix a lighter gray with your first-generation color to create a *second generation,* the color of sky in the middle distance—usually the central portion of a painting.

Finally, mix your second-generation color with a lighter gray and add a hint of ultramarine violet to create a *third generation,* the color of the most distant sky near the horizon line.

On another day, perhaps less sunny or more toward twilight, the colors of air would be different; however, once the color family and basic values are determined, the mixing process is essentially the same. Now that we have the colors, let's try our hand at painting a simple sky.

Simple Skies that Dramatize Rocks and Surf

A simple, graded sky such as the one in *Ocean's Lace* (page 20), offers many more possibilities than seem apparent at first glance. Aside from the fact that a simple sky keeps us from getting tangled up in clouds before we're ready, a simple sky is also an effective foil or contrast which we can use to emphasize the feeling of bright lighting and sharp focus in foreground elements. In addition, a simple, graded sky forms the basic structure of sky in virtually every paint-

ing—the framework on which we'll hang all the ornaments (clouds) in later skies.

For a simple sky to be effective without further development, you'll need a strong center of interest in the foreground—usually a particularly interesting wave, a plume of sunlit foam, or perhaps rocks wet with runoff. In fact, all of these elements may be present; if so, concentrate on one as the center of interest and keep the others subordinate through your use of value, color, and detail.

By that same logic, the sky also should be subordinate to the center of interest. In *Ocean's Lace,* for example, I've accomplished this in several ways. First, I've kept the sky area relatively small in relation to the whole painting. Second, I've kept the colors less pure (grayer) than in the foreground. Finally, I've suggested soft cloud forms in the middle distance. The clouds help keep viewers from lingering overlong on the sky, which, in this case, serves the same role as a stage curtain behind the actors in a play.

As I've explained, the structure of skies follows a definite pattern. (See *Ocean's Lace,* page 20.) The top of a painting represents the sky closest to us, the sky directly overhead. Its color is the purest and deepest in value in the sky portion of the painting.

The sky farthest from us lies just above the horizon line. The color here is considerably less intense or pure, and noticeably lighter in value than the color at the top of the painting.

The area between the top of the painting and the horizon line I call the "middle

distance." It represents the area of transition between the sky overhead and the horizon line. For simplicity's sake, you can block your skies in as three bands of color: overhead, transitional, and distant sky. This will help you visualize and plan the necessary values and colors. Once you've completed your block-in, however, be sure to blend the color bands into each other with a soft, synthetic sable fan brush to achieve a smoothly graded tone. Little wisps of unblended color can, of course, be left behind to add interest and to suggest high, feathery clouds. (See detail at top of page 21.)

For *Ocean's Lace,* I decided I wanted the sky overhead to be approximately value 5. (Got your Value Finder handy?) At the horizon line, I wanted value 7. That took care of planning the sky values. For color, I mixed cobalt blue with Light Blue Violet and value 5 gray to get the color of the sky directly overhead. For the sky just above the horizon line, I mixed Light Blue Violet, Permanent Light Violet, value 7 gray, and a dab of white. For the middle distance, I mixed intermediate tones from the color mixtures just described.

On overcast or stormy days, skies have a different set of rules, but since sharp focus techniques are most effective on bright sunny days, we'll leave the gloom for others to discuss!

In the next chapter, we'll look at how we can use the contrast between sharp and soft edges to really make those sunny-day skies come alive.

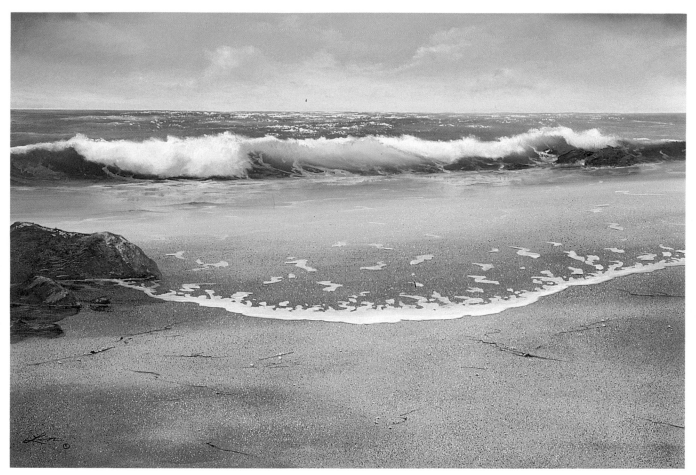

A simple sky provides an effective backdrop for a dramatic foreground by completing the image without competing for attention. The background sky was blocked in using three mixtures: a dark at the top, representing the sky overhead; a grayer and lighter value for the middle area; and finally, a still grayer mixture with a hint of lavender for the most distant sky just above the horizon line.

Ocean's Lace
16″ × 24″

After the background sky was blocked in and blended, wispy cloud forms were added by painting white directly into the wet paint in the middle of the sky area. Because I used a flat watercolor brush to apply the white, the white mixed with the blues already on the panel. This wet-in-wet mixing lowered the value of the white and softened the cloud edges to give a better feeling of depth.

The colors of the sky and background water were intentionally mixed so they would not be as pure or as deep in value as the colors in the foreground. The effect, as you can see, is a strong sense of depth and a feeling of vitality in the image.

Contrasting Soft- and Sharp-Edged Forms

In the previous chapter, we looked at how to paint the basic structure of a sky as three bands of color that represent degrees of distance from the viewer. Now let's look at another way to heighten the feeling of depth even more.

You've undoubtedly heard the old artist's rule: soft edges recede, while sharp edges come forward. But how does this rule apply to painting skies? In a simple, graded sky, whatever depth we perceive is largely the result of our experience in the real world; in other words, we "read" depth into the painted image because it conforms to the colors and placement of values that we experience in the real world.

To heighten our perception of depth, we need to add other depth cues that our minds will "read" in the same manner. The loosely indicated clouds in *Ocean's Lace* (shown in Chapter 5), for instance, not only add interest, but also perform another more subtle function: They convey depth. Their more definite edges tell us they are closer to us than the soft sky against which they contrast.

What else might we find in the distance between those high, feathery clouds and the foreground? Distant seagulls are one possibility. Another is cumulus clouds, those billowy, soft forms suspended in midair like giant piles of cotton balls. The edges of cumulus clouds are more defined than those of high, feathery, cirrus clouds, and as a result, we "read" them as being closer to us—which in fact they would be.

In *Cape Hatteras Dune,* for example (below), I've used both cirrus and cumulus clouds to create depth in my

Cues such as cloud edges and foreground objects add depth by telling the viewer where he or she is in relation to the other objects in the painting.

Cape Hatteras
Dune
11" × 14"

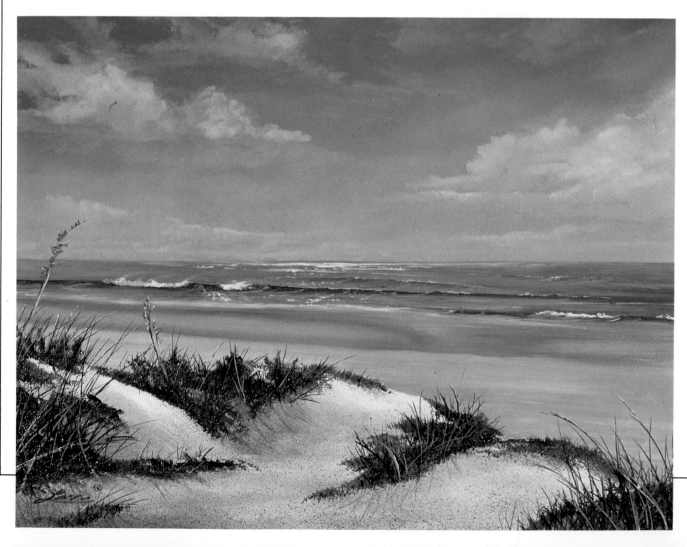

sky. The cirrus or feathery clouds are painted during block-in, while the sky is wet. Cumulus clouds, on the other hand, are scumbled on later over the dry underpainting.

In addition, by contrasting the crisp edges of a stalk of sea oats against the soft backdrop of my sky, I've pushed the sky back even farther. Tall beach grasses would be equally effective. Other elements such as waves that break the horizon line, rock formations, and distant headlands are also useful and will be discussed in later chapters.

An important tip for painting skies: try to forget names like cirrus and cumulus. It's only human nature, but when we name things, we stop looking and trying to understand for ourselves. Painting is a right brain or nonverbal activity, so let's not do anything that sidetracks our natural abilities. The same reasoning, by the way, applies to colors as well. Learn to translate what you see directly into color mixtures without naming the colors beforehand. If you purchased a Color Map & Mixing Guide or made your own as I suggested in Chapter 3, you'll see that this method of color mixing is not only possible, but eminently simpler than the way you've probably been taught.

And speaking of color mixtures, you may recall that in this chapter and in the previous one, I've suggested that you make the colors near the horizon line less pure than those in the foreground. The reason for this is something called atmospheric perspective—which is the subject of the next chapter.

Sea oats and grasses are amazingly effective and simple devices for conveying a sense of distance. Notice that the colors of the grasses (permanent sap green and gray) and sea oats (yellow ochre, raw sienna, and gray) are purer and "warmer" than the beach and sky against which they contrast.

While soft, filmy cirrus clouds are best worked into a wet underpainting, cumulus clouds should be scumbled in with a flat watercolor brush over a dry underpainting. For the cumulus clouds in this painting, the shadows were defined with mixtures of ultramarine violet and gray, and then a "lit" side was added using light magenta and gray. Finally, the "lit" side was highlighted with mixtures of white and yellow ochre.

CHAPTER 7
Contrasting Pure and Grayed Colors

The challenge of depicting three-dimensional space on a two-dimensional canvas or panel does not lend itself to any easy solution. Once again, we must study our own processes of perception. No one visual cue by itself tells us where an object is in the expanse between where we stand and the distant horizon. Instead, our eyes collect and assemble a number of different cues until our minds have enough information to determine an object's true location.

As we learned in Chapter 5, a simple sky with little texture is one technique that helps our eyes "read" a sense of depth into a painting. Then, in Chapter 6, we "pushed" the veil of sky back farther into the painting by placing sharp-edged sea oats in the foreground and by placing well-defined but soft-edged cumulus clouds in the middle distance. Each of these depth cues will help our viewer's eyes "read" a third dimension into a painting. In this chapter, we'll look at a more subtle cue: atmospheric perspective.

Have you ever been to the beach on a foggy day? As you looked down the beach as far as you could see, did you notice that everything in the distance looked fuzzy? You could recognize shapes but probably couldn't make out many details. And whatever you saw didn't have much color—everything had a gray cast to it. What you saw was quite literally the atmosphere—water particles suspended in the air.

The term *atmospheric perspective* is composed of two words: *atmosphere* (the cause) and *perspective* (the result or

effect). Particles of moisture, dust, and pollutants are always present in the sky. In the distance, these airborne particles partially obscure clouds, headlands—even the blue of the sky, causing them to appear less defined and less intense in color. Objects closer to us, however, have less atmosphere in between to obscure their shape and color, and thus appear sharper-edged and brighter or more intense in color.

As a result of a lifetime of visual experience in our world, we know (subconsciously) how to "read" variations in the sharpness of edges and intensity of color as measures of relative distance or perspective. As ordinary viewers of our world, we don't have to think about this process. As artists, however, not only do we need to understand the process, but we must make conscious use of it if we are to create the most effective paintings possible.

In *Sunset's Splendor* (opposite), notice that the distant headlands are, indeed, softer edged and less pure (grayer) in color than the cliffs closest to us. The result is a very strong feeling of depth. The water particles that form the fog bank reflect the lavender of the sunset and act like a colored filter, imparting sunset hues to the distant headlands.

As a general rule, whether painting daylight or sunset scenes, use the color from just above the horizon line to moderate the colors of distant objects. The result will be the appearance of atmospheric perspective.

Finally, as you plan your

paintings, keep in mind the effects of atmospheric perspective as you premix your sky colors. Then, when you begin to paint, you can recreate these subtle but important visual cues spontaneously without making the process needlessly mechanical.

This completes our preliminary discussion of skies, although you'll find additional tips and suggestions as we progress through later chapters. In the next chapter, we'll take a look at headlands and what you should know to block them in and use them effectively to join the sky to the rest of the image.

Creating depth with skies is always fun—it's exciting to see how each depth cue builds on the last until a tremendous sense of depth is the result. This painting employs everything we've covered in the two previous chapters and adds a new twist—atmospheric perspective.

Sunset's Splendor:
Mendocino
24" × 30"

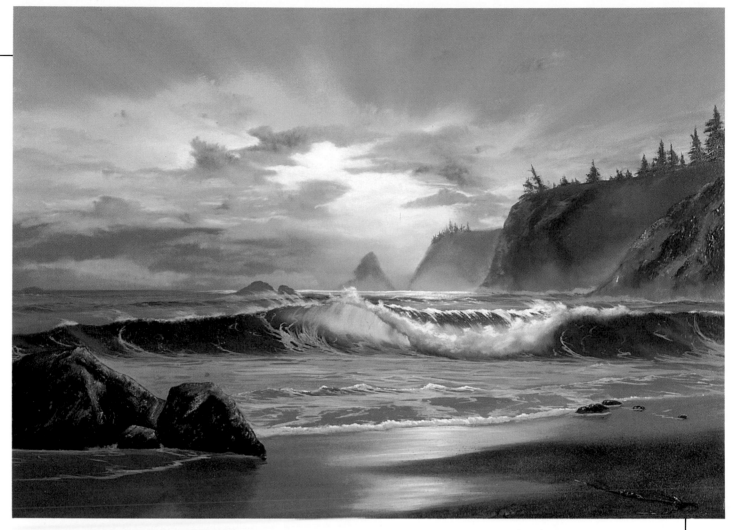

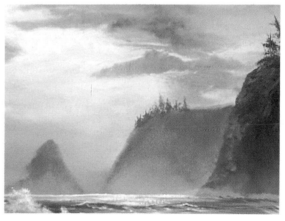

As the hills grow more distant, their edges are diffused (that is, made softer-edged) by water particles in the air. Their colors blend with the sky's sunset colors.

Colors at the horizon line are most affected by atmospheric perspective. Specifically, the colors at the horizon line are less pure (i.e, contain more gray) than the colors in areas which are closer to us.

CHAPTER 8
Developing the Middle Distance

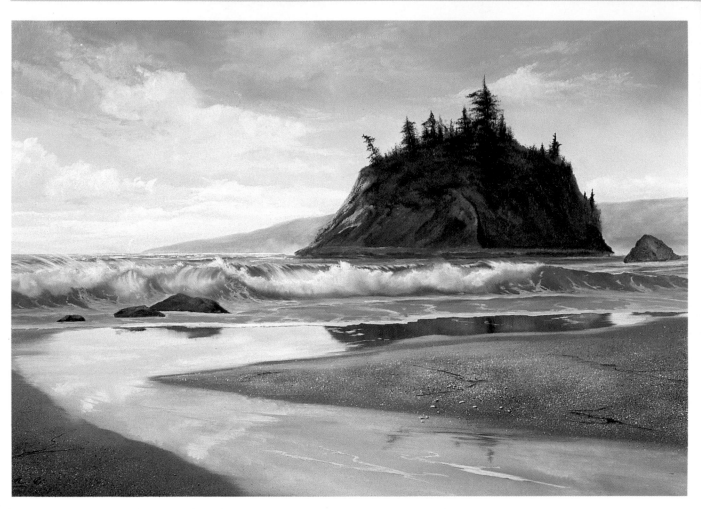

Trinidad Beach
20″ × 30″

One thing that has always puzzled me is the subtle difference between how a scene looks in real life and how it comes out as a painted image. For instance, when I stand on a beach and look out to sea watching the waves roll in, I'm certain that the scene will make a beautiful painting. Yet if I paint exactly what I see, the sky often seems quite separate from the water and beach—something is lacking. That something is connectedness, for want of a better word.

So, what is this connectedness and why is it missing? When I stand on the beach, I unconsciously sweep the horizon with my eyes, collecting various details that link the whole image together. But when I paint on a panel, I essentially put blinders on myself and my viewers: they can see only the portion of a scene I'm able to capture on my panel. (This, incidentally , might be a good rationale for painting very long paintings—and, in fact, I find I prefer longer proportions such as 16″ × 24″ to the standard 16″ × 20″ size.)

Obviously, even if you could always paint very long panels, you still could end up with mediocre paintings, be-

Headlands are a subtle but effective "bridge" between sky and water, because, when properly painted, they contain colors from each area.

cause the essence of good painting lies in improving on nature. As painters, we improve on nature by collecting the "good stuff" from a large area (our field of vision) and condensing it into a smaller area (our panel). Aside from making a painting more interesting, the "good stuff" also provides the missing element of connectedness.

There are many ways to provide this sense of connec-

tion between sky and water: birds, people, buildings, flumes of foam, rocks, and headlands are just a few of the possible linking devices. Most of these will be discussed in later chapters. For now, let's take a look at headlands (a point of land extending into the water) and how to paint them.

In *Trinidad Beach* (left), we have examples of two common headland situations. At the risk of oversimplification, let's call them distant and close-up headlands. In many scenes, of course, the headland will be a combination of both types as the shoreline moves away from us and recedes into the distance.

Before we get into a discussion of specific colors, take a moment to look at the two headlands in *Trinidad Beach*. Think back to our discussion of atmospheric perspective in the previous chapter. Aside from size, what is the most obvious difference between the two headlands? The color of the distant headland is more like the color of the sky, whereas the color of the one nearer is more like the color of the sand.

Two other differences are worth mentioning. First, size: The headland nearest us appears larger. If this particular rock had been lower to the water, the sense of distance between it and the background headland would have been considerably less effective. Second, edges: The more distant headland has softer edges, while the closer headland is better defined. These, along with atmospheric perspective, are important visual cues that make the painting look right.

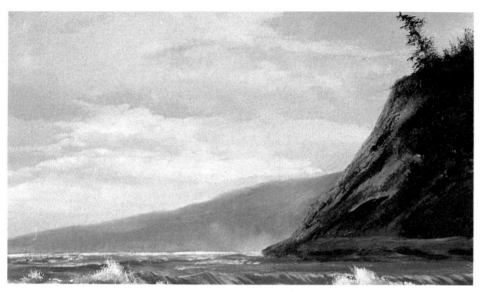

The headland closer to us has richer colors, is larger, and has relatively crisp edges. The color of the more distant headland is partially a result of its actual colors (probably much like those of the closer headland), and the "colored filter" effect of atmospheric perspective.

Now, what about colors? Keep in mind that when it comes to color, one size doesn't fit all. In other words, the colors I'll describe are correct for this particular painting, but should serve only as a general guide for your own paintings.

So, with that in mind, the distant headland is painted from mixtures of the sky color plus Light Blue Violet, burnt umber, and gray. The closer headland is painted with mixtures of burnt umber, raw sienna, and gray, with cadmium yellow deep and a little white also in lighter areas.

The tree forms were roughed in with mixtures of permanent sap green and gray, then highlighted with Vivid Lime Green and lots of gray. Finally, after both headlands were completed and allowed to dry to touch, I brushed on an atmospheric haze—a transparent mixture of the sky color at the horizon line and the glazing medium described in Chapter 2.

The key point to keep in mind when painting headlands is that they are an effective bridge primarily because they contain colors from both sides of the horizon line, in varying proportions according to how close or far away the headland actually is from the viewer. By varying the proportions of the mixture, it's possible to "move" the headland closer or farther away at will. More of the burnt umber would bring it forward, while more of the sky and light blue violet would move it away.

But what happens when there simply isn't any headland? You could put one in every painting but that would be boring. Let's move on to Chapter 9 and see what else can be done to ease the transition from sky to water.

CHAPTER 9
Integrating Sky and Water

Many scenes have no headlands or other objects (ships, buildings, or the like) to bridge the meeting of sky and water at the horizon line. Without such bridging devices, an unbroken horizon line can easily divide a painting into two visually separate rectangles. Furthermore, if the horizon line is placed at or very near the center of a painting, the effect will be unusually disturbing to viewers.

Obviously, placement of the horizon line to avoid cutting the panel in two visually is easily avoided by measuring its exact location as part of the sketching process. For my own tastes, I like to place the horizon line about one-third of the way down from the top. In certain situations, however, such as when painting sea birds up close, I may not have a horizon line at all!

Assuming that the basic placement of the horizon line is not a problem, how then do you deal with the hard, straight edge formed by the horizon line? How can you minimize the tendency to divide the painting when you can't use headlands or other bridging devices?

Here's one way: If the composition and point of view permit, use swells or waves in the background water to break a straight horizon line. This technique is especially effective for deep water scenes, particularly those with lots of rocks and turbulence.

Here's another way: Use atmospheric perspective. Remember that atmospheric perspective diminishes value contrasts and makes edges softer. As a general rule, you should almost always blend the horizon line lightly to soften the meeting of sky and water. In addition, you can glaze over the horizon line and some of the background water with a transparent mixture of the sky color at the horizon line to reduce value contrasts. (The technique is the same as that described in the last chapter for integrating headlands into a scene).

Take a look at *Rocks and Surf* to see how I've used the glazing technique to introduce atmospheric perspective into the scene. The horizon line is there, but it's almost invisible. it's almost invisible.

In your own paintings then, remember: place the horizon line well above or below center, blend the horizon line to soften the transition, use swells to make the line interesting, and use atmospheric perspective to downplay the edge and value contrasts.

In this chapter and the previous one, we learned three ways to integrate sky and water: headlands, waves that break the horizon, and soft horizon lines. Now let's move on to background water—the area between the horizon line and the major wave, and talk about what happens when we try to do too much too soon.

Waves that break the horizon line are nearly as effective as headlands for bridging sky and water, particularly when coupled with a "soft" horizon line, as in this painting. By choosing a point of view that's low, the amount of background water can be kept to a minimum, making it relatively easy for a large breaker to cross into the sky area of the image; to tie sky and water together.

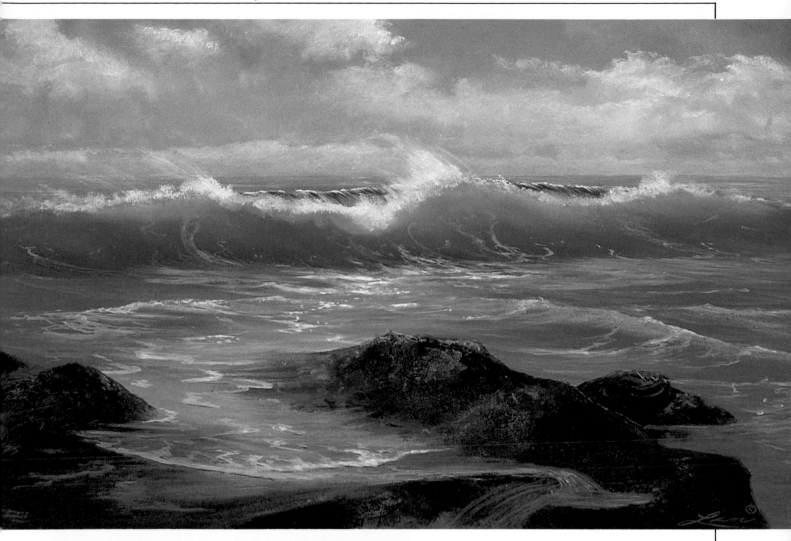

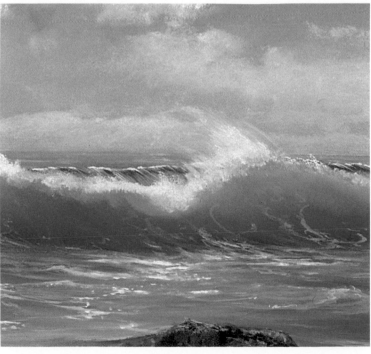

Rocks and Surf
10" × 16"

Another way to "connect" the
sky with the water is by making
it easy for the eye to travel from
one to the other. The way to do
this is by reducing contrasts
between the sky and
background water at the
horizon line. Try mixing a
semiopaque glaze with the
glazing medium described in
Chapter 2 and a little of the sky
color from just above the
horizon line. Use this mixture
to glaze over the background
water only, until it ceases to be
a visual obstacle.

CHAPTER 10
Avoiding Overworked Color

In the rush of enthusiasm to complete a painting, colors can easily become overworked and muddy. The dangers of overworking color are especially applicable to the background water, where the colors are rather gray to begin with. But the condition is usually temporary and often more trying than terminal.

The problem: muddy, overworked colors make for a dull painting. In daylight scenes, for instance, you're usually working with analogous colors—colors that are side by side on the color wheel, like greens and blues. If you overmix, your background water won't have much vitality—but at least you'll probably have something that is basically green or blue.

When painting sunsets, however, the danger is more serious because sunset colors are often complements on the color wheel; when mixed, they produce lifeless grays. In *Jeweled Hour* (opposite), for example, the main colors are yellow and lavender—an open invitation to gray not only because the colors are complements, but also because the colors are subtle in this case. Typical sunset colors are, of course, blues, oranges, and yellows, which are reflected in the background water. Blue and orange, being complements, produce gray, while blue and yellow produce green; neither outcome is particularly desirable. Yet it is possible to work with analogous or even complementary colors in the same painting without producing mud.

The most basic cause of muddy, overworked color is trying to do too much too soon. An impressionist painting can probably be completed at one sitting, but a sharp focus painting requires at least two sittings—one for rough block-in and one (or more) for refining the image. When you're using complementary colors, it may be necessary to break the block-in itself into two sessions, one for the first color and a second session for working with the complement after the first color has dried.

Therefore, *Rule One* is: Realize that the block-in and any intermediate stages of development always look terrible compared to your mental image of the completed painting. Learn to stop when you've taken a painting as far as you

reasonably can at one sitting.

Knowing when to stop applies not only to the painting, but also to your own endurance. To paint well and to mix clean, bright colors, you must be fresh and rested. Therefore, *Rule Two:* Learn your physical limit. Mine is about four hours per session. After that, I get tired and my colors go gray and muddy. To keep myself fresh, I take a fifteen-minute break after painting for a couple of hours. Then I break for lunch and perhaps go for a leisurely stroll before picking up my brushes again.

It may seem surprising that avoiding overworked color appears to have so little to do with actually mixing colors, but painting requires as much

The background water is a microcosm of all the other colors in a painting: it contains, or at least reflects, a little of nearly every color present elsewhere in the painting. To keep the vitality of both the yellow and lavender in this painting, I underpainted the sky in yellows, then allowed them *to dry before returning to scumble in the lavender clouds with my flat watercolor brush. For the background water, the procedure was just the opposite: the underpainting was mostly lavenders, which I allowed to dry before returning to apply the yellow highlights with a liner brush.*

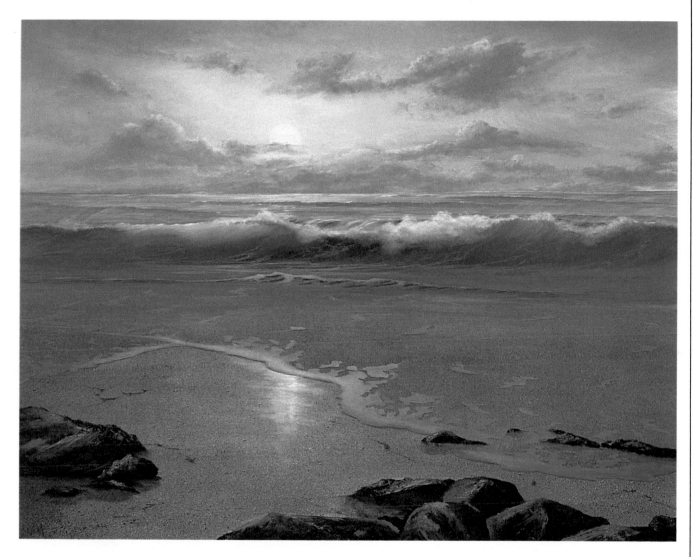

Jeweled Hour
16" × 20"

mental discipline as it does technical expertise. Patience is a must for painting in sharp focus.

OK, now for *Rule Three:* During each painting session, concentrate on putting down your colors with as few strokes as possible. Resist the urge to keep going back over the same area again and again; the more you fuss, the muddier and less defined your work will become.

And finally, *Rule Four:* Learn how colors mix with each other. Make a color map as I suggested in Chapter 3 (see the appendix for detailed instructions). From then on, a quick glance will tell you what colors to combine to arrive at any desired mixture using the *least possible number of base colors*—and that's the real secret of keeping vitality in your paintings.

There's another way to put life in your background water—as well as in the rest of the painting. We'll examine it in the next chapter.

Painting in sharp focus not only entails learning how and where to start, but also, where and when to stop. In this painting, the challenge was to work with two vibrant colors, lavender and yellow, without producing monotonous grays.

Capturing the Sparkle of Bright Sunlight

Few things thrill me quite like a bright, sunny day at the beach. I love the challenge of bringing that same feeling into my paintings. At first glance, bright sunlight seems to suggest liberal use of light values (like the sunlight itself). This, however, is seldom an effective or satisfying approach. In fact, bright sunlight can be recreated most effectively by *limiting* the amount of light value color in a painting. I think of the "sparkle" like pepper: a little bit goes a long way.

In the close-up from *Surf Patterns* (below), you can

see what I mean. Before I ever began painting, I made a conscious decision to reserve my lightest values for the sparkles. To make sure that the sparkles were effective, I kept all the other values lower (darker) than I might have for a less brilliant day.

I began by painting the basic color of the sky using Light Cerulean Hue mixed with value 5 gray. Then I suggested soft clouds with a mixture of Brilliant Blue and value 8 gray. For the background water, I used phthalo green and lots of value 3 gray to establish the overall color.

Next I painted the troughs using the two sky colors, working them directly into the wet phthalo/gray underpainting. The result was a new col-

Nothing brings dull background water to life more quickly than the sparkle of bright sunlight. In fact, the somewhat dark and drab colors of the background water are an excellent backdrop for creating "sparkles" so effective you'll reach for your sunglasses and suntan oil. The values for the sky and background water should be kept low enough to assure strong contrasts when the sparkles are applied.

Detail of
Surf Patterns

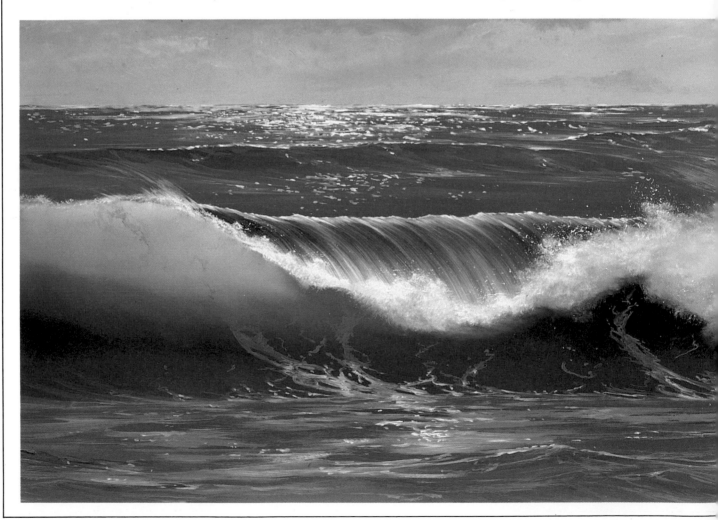

or with a value between that of the sky and the background water. You could, of course, mix this color on your palette and achieve a similar effect, but I prefer the natural variation I get from mixing intermediate values directly on the panel.

For the wave, I mixed Bright Aqua Green with value 8 gray to get the illuminated portion of the wave, and phthalo green with value 3 gray for the dark at the base of the wave. Again, I created the intermediate value by mixing the two color mixtures just described directly on the panel.

The foam on the wave was also painted from two basic values. The shadow portion of the foam was mixed from value 6 gray and the sky colors. The sunlit portion was created by lightening the shadow mixture with white. The frothy look of foam was simulated using quick dabbing strokes with the tip of the brush.

Then, as I moved into the water ahead of the wave, I continued to use the phthalo/gray mixture, but moderated it with lots of the two sky values, which I placed to suggest troughs and ripples.

When I had completed this underpainting, I added the foam patterns on the face of the wave, various highlights, and, finally, the sparkles.

The foam patterns on the face of the wave were painted using the two sky values (once again) and very loose brushwork. To sharpen the focus and to raise values, I added highlights to some of the ripples in the foreground and to the sunlit foam, using a value slightly lighter than the one already down.

The sparkles went on last. Using a mixture of white and yellow ochre, I painted the sparkles using a drybrush stroke to add a little rough texture and broken color over the dry underpainting of the background water. As I had planned, the sparkles are the highest value in the painting.

In the course of this chapter, I've made several suggestions about bringing the sky colors down into the background water, major wave, and foreground ripples. In the next chapter, we'll explore this procedure a little further and learn how to use subtle color to add vitality in these and other areas of a painting.

The major wave was painted using two basic values: a dark and a light. The foam was then added, and that color, in turn, was lightened with white for the highlights.

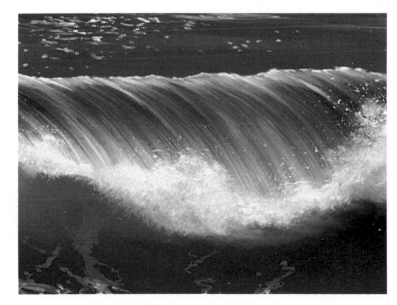

Using Subtle Color to Add Vitality

Whenever I go to the art supply store, I feel like a kid in a candy store. I look at all those racks of luscious colors and I want to buy every tube. In the beginning, that's pretty much what I did. I thought if I bought enough different colors, I'd never have to mix anything again. Of course, that rarely worked in practice—what I usually ended up with was a horrible, clanging absence of color harmony in my paintings.

From those early experiences, I learned the wisdom of working with a limited palette. Then, as I painted more and gained experience in handling colors, I gradually added new colors to my repertoire. My early hopes were partially fulfilled—the new colors did make mixing easier and more direct—but they certainly didn't eliminate the need altogether. More important, what I learned was that those additional colors could add vitality and weave a rich texture in my paintings if I used them properly. But how?

One painter advised me early in my career to include all the colors from my palette in each painting. He told me that if only I'd look hard enough, I'd see subtle touches of every color imaginable throughout a scene. The key word here is *subtle,* and that's probably the difference between experienced and inexperienced artists. My early attempts still clanged with discordant color as badly as before.

My first successes came when I began to use analogous colors—colors close to each other in the spectrum (or on a color wheel). A plain cadmium orange by itself, for example, isn't nearly as dynamic as it is with cadmium yellow interspersed. Somehow, the two colors seem to radiate light when placed side by side. Yet the effect is quite subtle. These two colors and their neighbors on the color wheel are, of course, quite useful when painting sunsets.

Now, let's see how analogous colors work in daylight scenes. Take a look at *The Beach Crowd* (opposite page). When painting the sea, I find that the color of the wave (usually Permanent Sap Green or phthalo green with value 3 gray) becomes much more interesting visually when I add subtle accents of Light Cerulean Hue and Permanent Light Blue.

Subtle colors also add life to shadows. Try adding cerulean blue to the shadow side of a seagull, for instance, or perhaps a little green from the wave. The basis for my artist friend's advice about including all the colors on my palette in a painting is simple once you understand it: reflected light. Every rock, wave, tree, or cloud picks up a little color from the objects—yes, even the air—around them.

So, when you paint realistically, remember to consider other colors in the vicinity of any object you paint. Then, experiment by adding hints of those adjacent colors. You should notice a new vitality to your whole painting. Of course, if you notice a clanging, you may be being too bold—or perhaps you've just invented a totally new style!

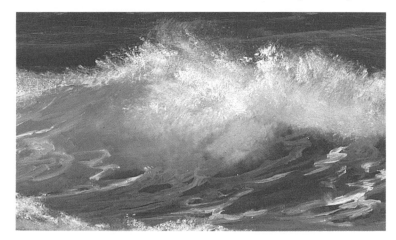

While no sky is shown in this painting, the unseen sky still influences the color of the water, as this detail shows. So, although the basic color of the background water and waves is a deep, grayed green, the surface reflects blue from the sky except on the faces of the waves (which are less reflective of the sky from the point of view of this painting).

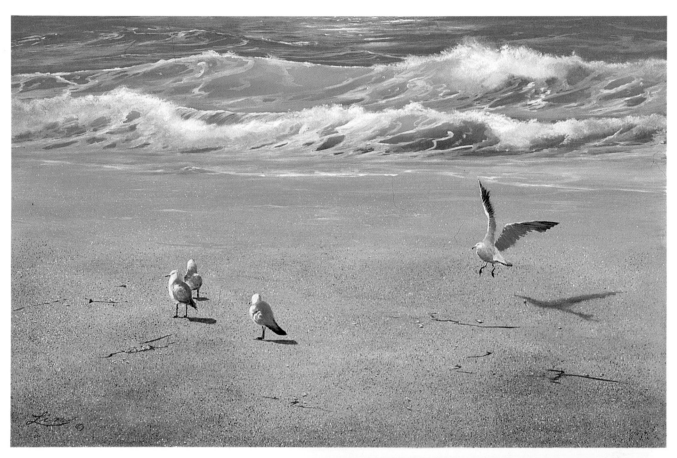

The Beach Crowd
12" × 18"

Moving water provides many reflective surfaces which mirror other colors in the vicinity. By adding subtle accents of color from the sky to the sand and water, we give our paintings a whole new vitality.

These seagulls looked rather "flat" when I first painted them—until I remembered to add reflected light to the sides of their bodies that were in shadow. In addition, when I painted the seagull's cast shadows on the beach, I chose a mixture containing ultramarine violet instead of several deadly dull mixtures I'd been tempted to use. The violet seemed to suffuse the shadows with life and warm, reflected light.

CHAPTER 13
The Translucent Wave

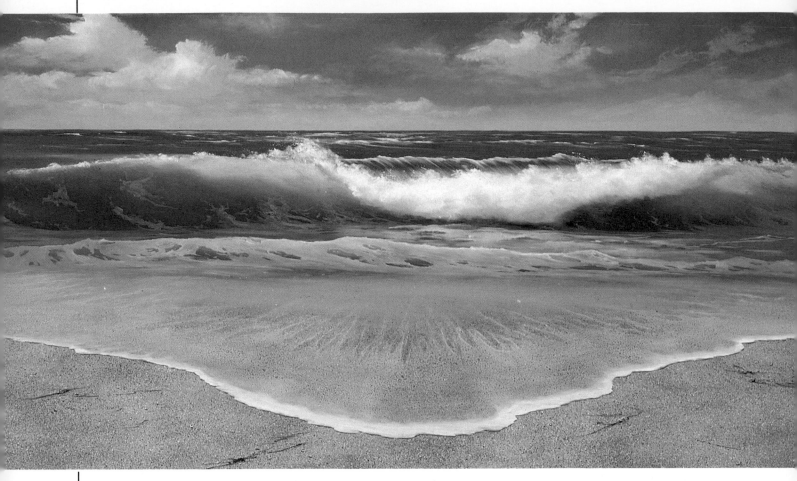

No other moment captures the jewel-like beauty of water in motion quite so well as a sunlit, translucent wave. There's something terribly inviting about the soft luminous color of water infused with radiant sunlight—perhaps because not every wave has that special quality. It reminds me of watching for falling stars— every time I see one, I say, "Look, there!"—as if it were the first and the last one I'd ever see.

I feel a large responsibility when I paint translucent waves; the effect has been so overdone in cheap sofa paintings that it has almost become a cliché. To be sure, good

painting calls for a certain degree of embellishment on nature. And an artist of necessity must often move things around, add things that weren't there, and nearly always heighten colors and contrasts. Yet the line between theater and theatrics is a fine one indeed—a thought I try to keep in mind when I'm tempted to push my colors a little too far. So, if you must err, err to the side of being conservative in your colors and your paintings will be the better for it.

I hesitate to recommend specific colors for waves because waves are only one part of a painting. The color of the

Capturing the look of sun-illuminated water without being gaudy is an interesting challenge. This painting is typical of the colors and motion you're likely to find on any southern California beach during the summer. Once you've mixed a light, middle, and dark value, block them in as three bands, then blend the entire wave carefully. In this painting, the green of the wave is an example of yet another palette possibility, different than those shown elsewhere in this chapter.

Rolling In
24″ × 36″

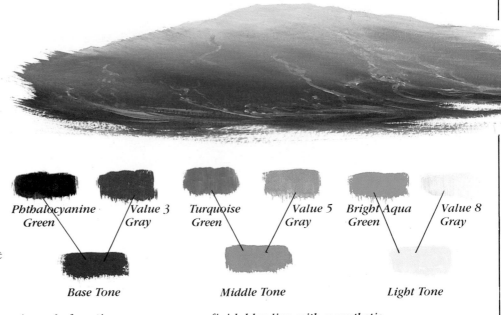

sky affects the color of the sea. The colors of the sky and the sea, in turn, subtly reflect on every other object in a scene. In short, all the colors in a painting must be inter-related.

With that caution in mind, let's proceed. For skies that are derived predominantly from cerulean blues, I mix the background water color from phthalo green and gray (see Chapter 11 for a more detailed discussion). At the base of the wave I use phthalo green again, but with less gray. For the middle value of the wave, I use Turquoise Green and gray, and finally, for the translucent value I use Bright Aqua Green and gray.

For skies that contain cobalt or ultramarine blue, I usually use cerulean blue plus gray for the background water, then cerulean blue with less gray for the value at the base of the wave. The middle value is mixed from Brilliant Blue and gray, and the translucent portion is mixed from Permanent Light Blue and gray.

The actual block-in is fairly straightforward—simply paint the wave as three bands of color (base, middle, and translucent values), then blend the three to achieve a smoothly graded transition.

To see how this all works in practice, look at *Rolling In.* The sky contains ultramarine blue, but the wave colors are really an intermediate color between the green and blue palettes I've just described. Once again, color is not absolute; it has to reflect the other colors in a painting and that all-important intangible, your own judgment.

Phthalocyanine Green *Value 3 Gray* *Turquoise Green* *Value 5 Gray* *Bright Aqua Green* *Value 8 Gray*

Base Tone *Middle Tone* *Light Tone*

A word of caution: Phthalocyanine is a strong tinting green—too little gray and the result will be eye-popping. When you have all three colors mixed, simply block them in as bands, rough blend them with a 1" Skyscraper, then *finish blending with a synthetic sable fan brush until your wave looks something like this. (See Chapter 4, Brushes and Brushstrokes, for details on both rough and finish blending strokes.)*

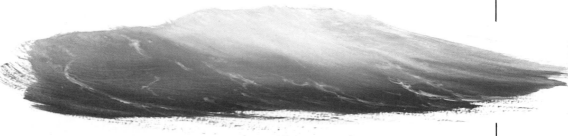

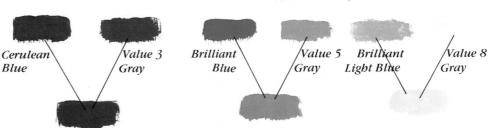

Cerulean Blue *Value 3 Gray* *Brilliant Blue* *Value 5 Gray* *Brilliant Light Blue* *Value 8 Gray*

Base Tone *Middle Tone* *Light Tone*

To mix the dark tone at the base of a wave, mix cerulean blue with a dab of phthalo blue and a gray of about the same value. Like Phthalocyanine Green, Phthalocyanine Blue is a strong tinting color—too little gray and the result will be *phosphorescent. And again, too much gray, and the result will be dull. When you have all three colors mixed, simply block them in as you did above until your wave looks generally like this example.*

Lively Brushwork/Foam Forms

The term "sharp focus" seems to cry out for precise edges and crisp, well-defined shapes. Yet, in reality, painting the sea calls for creating two kinds of illusion: the illusion of sharp focus and the illusion of motion. And foam, surely, is one of the most "unsharp" things in a seascape. Foam, in its various forms, constantly tests our ability to create the illusion of motion while at the same time maintaining a feeling of sharp focus.

As you look at the ocean, a succession of waves rise, roll over, and break; foam billows like piled cotton balls. Then, as you look more closely, you notice that the foam indicates the shape and direction of each wave though spray seems to radiate in many directions at once. To paint the rolling foam of a breaking wave accurately, first study the overall shape of the foam; you might want to lightly sketch that shape onto your panel. But don't start painting just yet.

First, take a moment to study the anatomy of the breaking foam (see close-up of *Rolling In* and sketch, page 40.) It is densest at the base and therefore transmits less light. As the foam splashes upward and disperses into the air, it becomes a fine mist. The mist, in turn, transmits more light and is therefore lighter in color. The denser portions of the foam (at the base) have more defined edges. As the foam rises and thins, the edges become softer and less defined. Finally, notice that there are few, if any, true shadows on breaking foam. The foam is basically translucent, illuminated by the color of the sky and reflections of the wave color. The darks you see are simply variations in the translucency of the foam.

Applying this knowledge to an actual painting, begin blocking in the breaker foam by painting the darker portion with a grayed version of the predominant blue from your sky. If your painting includes a fog bank, that color will also work nicely for the foam at the base. Next, gradually lighten the color with white as you indicate the rising foam billow. Be sure to soften the upper edges with light dabbing strokes of a brush.

The second form of foam that you notice when looking at the ocean is the type I call "noodles"—the little bits and streaks of foam that seem to ride or slide on top of the water. Noodles appear in a variety of shapes depending on how (or if) the water underneath is moving. Noodles on still water take on globular shapes. In slow-moving water, the globs become lazy *s* shapes, and finally, when the foam slides down the face of a wave the *s* becomes a *c* that indicates the concave shape of the wave face.

Needless to say, foam isn't quite so simple in real life, but this should at least give you an idea of where to begin and how. As an artist friend once told me, "Pretend you're water, then try to go with the flow."

Rolling foam is densest and therefore darkest at the base. There, the foam contrasts sharply with the deeper green of the wave. As it boils upward, gathering more air and moving out of the shadow of the wave, rolling foam becomes lighter in color and gradually loses definite edges. Simply add more white to your basic foam mixture (sky color plus gray) and soften edges with light jabbing strokes of a bristle brush.

Near the top of the rolling foam, edges are quite soft and the color is very light—usually one of the lightest values in a painting. Once again, add more white to the foam mixture, and soften edges with a bristle brush. Finally, use a household toothbrush to spatter a few free flying droplets of foam as an added touch.

The foam that rides up the face of a wave is usually painted in a shadow tone mixed from the sky color plus gray, though the mixture leans more toward the sky color than in the rolling foam to the right. Anything goes here, so long as the foam shapes follow the contour of the wave face— which is usually concave or sunken in. This means that the foam here should generally take the form of the letter C or S.

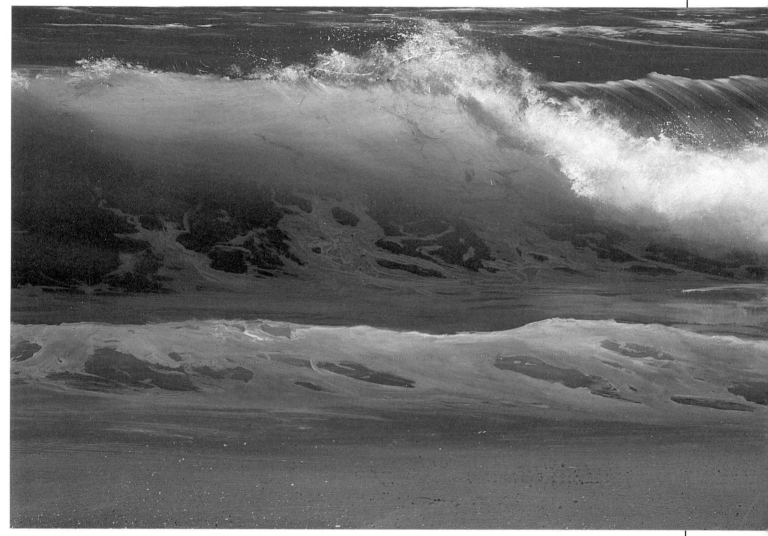

Detail of Rolling In

A: *It helps to think of the anatomy of a rolling wave as a barrel rolling on its side toward you. Thus, the front half of the barrel curves or bulges toward you. As you paint, imagine dragging your brush along the surface of that imaginary barrel in a smooth, curving motion from the top, bulging out forward and then down to where the boiling foam rises to meet and obscure the surface of the barrel.*

B: *When painting the main body of a wave, imagine that your brush follows the back half of the barrel, moving from the top downward in a smooth curve, again following the imaginary surface of the barrel. Notice that here, the curve sinks downward in the middle like a valley, whereas in the breaking wave on the right, the curve rises in the middle like the arc of a rainbow.*

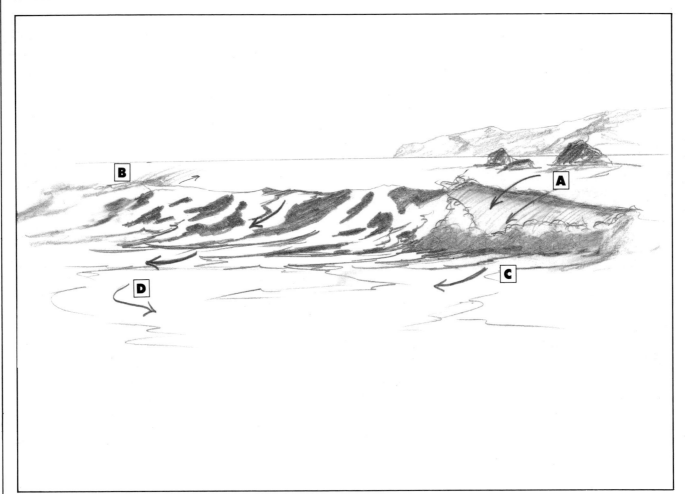

C: *Ahead of a wave, the water is nearly flat, but it rises slightly in anticipation of the coming wave. Here, your strokes should gradually lose their curvature and move at a slight downward angle. If the wave moves from right to left as this one does, the water ahead of the wave should. also appear to drop from right to left. If your wave moves in the opposite direction, the angle of the water ahead of the wave will reverse also.*

D: *With all this motion heading toward the left, your eye could easily be led out of the painting. To avoid this, introduce foam trails that curve back to the right to bring your eye into the image once again and to build a zig-zag movement through your painting.*

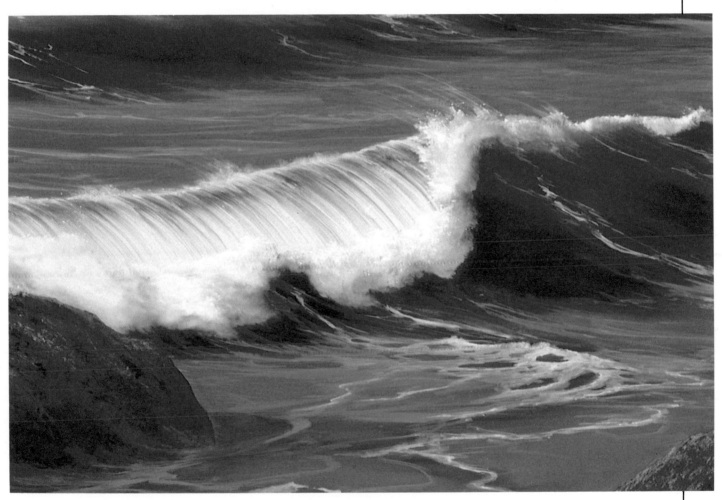

Detail of
Jeweled Breakers

In this detail of Jeweled
Breakers *you can see how foam
patterns and soft edges enhance
the illusion of motion.*

Creating the Illusion of Motion

As artists, we are at somewhat of a disadvantage when it comes to things that move. Picasso and Duchamp tried with some success to convey the idea of motion with multiple images superimposed on the same canvas. That approach is fine if you are a cubist, but is of little use when painting realistically. Caught in the quandary of depicting motion on a panel that doesn't move, many seascape artists create what one critic aptly called "the concrete wave."

The concrete wave can be avoided, of course, but first you must solve a mystery—how to create the illusion of motion. If our task was to solve a murder mystery, we might say, as the French do, "*cherchez la femme,*" which means "look for the woman." And, just as a woman is often at the root of a French murder mystery, so too, there is one element above all others that determines whether a wave moves or appears cast in concrete.

To solve our mystery and find that elusive element, we might coin our own version of *cherchez la femme*; ours would be: look for the edges. When you think of concrete (as in "the concrete wave"), what do you think of? Hard edges, right?

Actually, hard edges usually increase the illusion of sharp focus. They're fine for things like rocks, but not always for waves. Without some sense of an edge, we wouldn't know where one wave began and another ended. Yet hard edges sometimes tell us more than we need or want to know. So vary your edges, particularly on waves; keep them soft and keep some of the mystery.

Several devices help convey a sense of motion. Foam is one of the easiest and best. Take a look at the close-up from *Rocky Shore* to see what I mean. (The complete painting is pictured in Chapter 28). The lower edge of the rolling foam is fairly definite, though not hard. The uppermost portion, where the foam dissipates into the air, is quite soft by comparison. Notice, too, that along the left side of the main wave, the foam sweeps back, blown away from the wave by wind coming from onshore or simply being left behind by the powerful forward motion of the wave.

The roll also conveys a strong sense of movement, projecting the rolling foam ahead of the main body of the wave. A more subtle cue is the water running off the foreground rocks and forming pools with floating bits of foam. Other cues worth noticing are the foam trails on the face of the wave which reinforce the concave shape of the wave, again suggesting a shape which is moving forward. Foam splashing against a foreground rock suggests the last evidence of a wave that preceded the one we now see. With devices such as these, we can not only suggest movement in the present, but also motion that has already taken place and other motion that is yet to take place.

If the term *concrete wave* implies a painting with too little motion, the opposite extreme—too much motion—is what we often encounter in deep water, the subject of the next chapter.

A: *The contour along the bottom edge of the rolling foam is deliberately left uneven. Then, as the foam rises higher, the edges grow softer still, with some individual droplets becoming visible. To soften these edges without losing the light foam color in the adjacent darks, you may wish to allow your block-in to dry, then come back to refine the foam with jabbing strokes of a bristle brush.*

B: *Spray is an effective way to suggest motion. A bristle fan brush dragged lightly back in a sweeping motion over a dry underpainting should do the trick.*

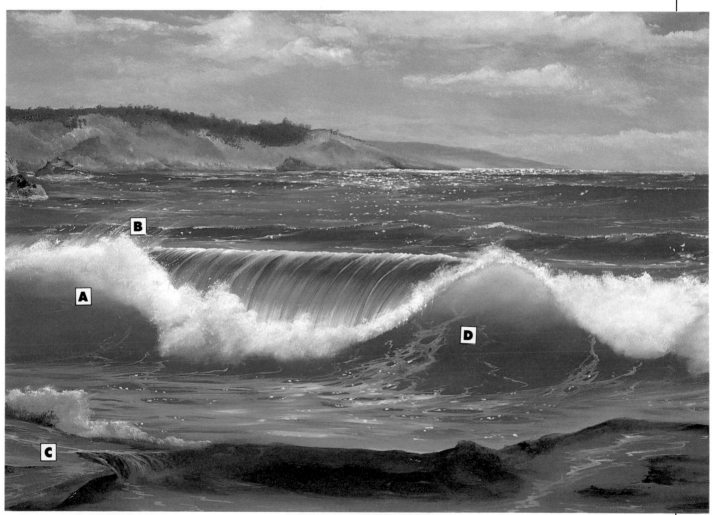

Detail of
Rocky Shore

C: *Don't forget the little things, like water splashing against a rock or running off afterward in miniature waterfalls. These devices suggest the aftermath of motion that has already taken place. Use colors from the sky liberally herè, and watch values closely so as not to compete with the main attraction—the major wave.*

D: *Foam trails on the face of the wave tell us about its shape—a concave form that literally propels itself toward the viewer. Keep values low to avoid competing with the sunlit foam.*

Deep Water

I love the raw power of deep water, but when I look at it as something to paint, my first reaction is that I see only an indistinct, churning mass. My eyes strive to create order out of the seeming chaos of constant motion. I watch for a wave or a rock to "hang" a painting on—and finally, one or the other appears. The trick, if it's proper to call it that, lies in learning to limit and simplify.

I've found two mechanical aids that help considerably. The first and least expensive is a simple piece of mat board with a rectangular opening cut in the middle. By looking through the opening while holding the mat board at various distances, you can eliminate a lot of distractions and isolate any portion of a complex scene for closer scrutiny.

The second aid is a 35mm reflex camera (the kind with through-the-lens viewing) and a zoom telephoto lens. I find that a 70-150mm zoom is about right. The essential process of limiting and framing possible subjects is the same as with the mat board; however, a telephoto makes it possible to rapidly test many different compositions and quickly record any interesting details.

Both of these aids will assist you in limiting a scene to manageable proportions, but the task of simplifying is still up to you. If you're at all familiar with the Big Sur coast of California, you'll have some idea what I was up against in terms of complexity when I painted *Rocky Point* (opposite page). If you haven't seen Big Sur—well, you should.

In the actual scene that I worked from, there were more waves than you could shake a brush at, and they seemed to move in all directions at once. Nevertheless, I narrowed my focus down to one specific set of rocks and waves. Then, instead of six waves moving in different directions, I selected two major waves as the focus for the painting.

There are no easy rules for simplifying a deep ocean scene, but the best advice I can give is this: (1) start with one major wave; (2) add only as many other waves as are absolutely necessary to keep the main wave from looking like a bump on a tabletop; (3) make one wave the centerpiece and keep all others subordinate. Remember: every wave you add vies for attention and reduces the impact of every other wave.

For more on this, check Chapter 42, where you can see another deep water painting and the actual reference photograph I worked from. By comparing the two, you can get a better idea of how to simplify your own favorite deep ocean scenes.

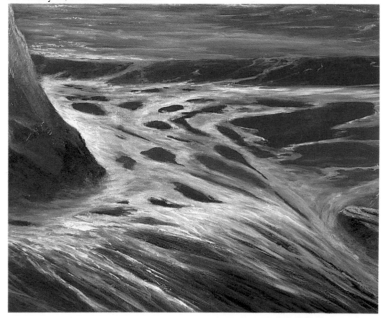

Although waves in nature seem to move about willy-nilly, in a painting they must be tied together in a definite visual path if the end result is to be aesthetically pleasing. In the center, s-shaped foam patterns carry the eye from the secondary wave down through the water running off over submerged rocks and, finally, to the major wave itself. On the "return trip," the eye follows the line of the main wave up toward the left until it rebounds off the rocks, passing again up through the runoff and s shapes to the secondary wave. In this painting, many waves and foam patterns that were present in the actual scene were omitted altogether, and the rocks on the left side were kept in low contrast to avoid drawing the focus away from the central area of the painting.

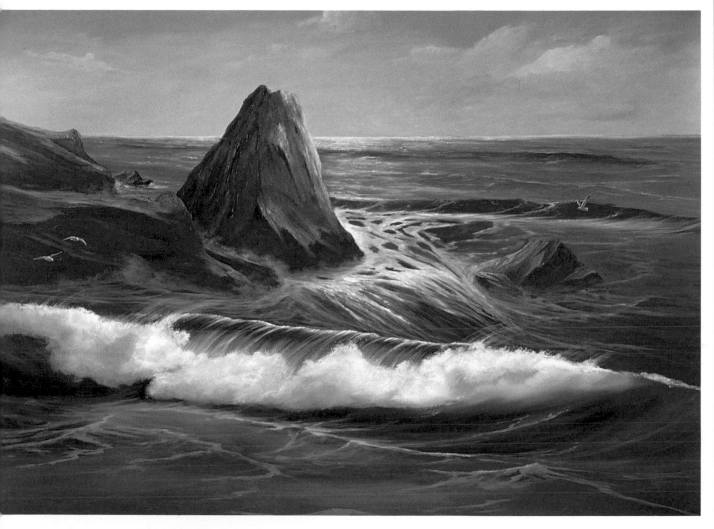

Rocky Point
30" × 40"

Make one wave the star—even if you have to create one, as I did here. To do this, observe the predominant natural movement of the waves, then watch for one wave that is particularly appealing and sketch it in in whatever size works for your treatment of the subject. In Rocky Point, *the mood is peaceful power, so the wave is relatively large but still well-formed. Add only as many secondary waves as are absolutely essential to keep the major wave from looking out of place. Keep them smaller in scale and subdued in color in comparison to the major wave.*

CHAPTER 17
Rocks: Integrating Sea Forms

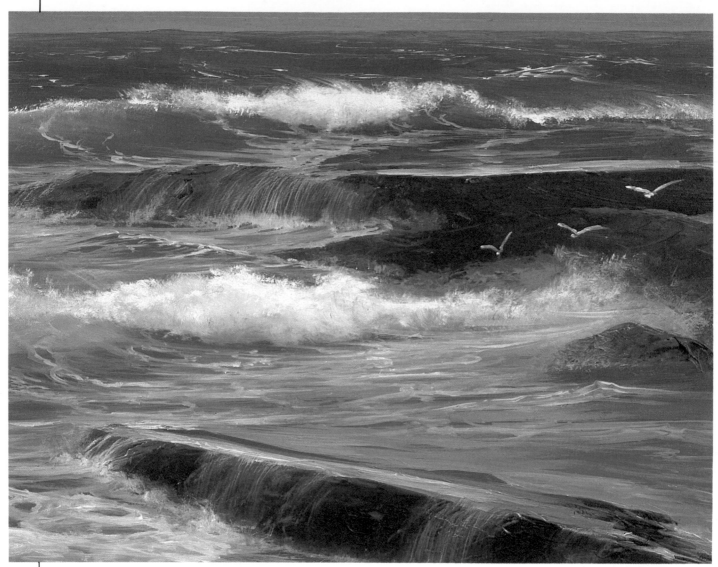

I used smaller, more parallel strokes on the more distant rocks to strengthen the feeling of distance. Then, when the underpainting was dry, I glazed over these rocks with a transparent mixture of the sky color from just above the horizon line to add depth through atmospheric perspective.

Detail of
Rising Tide

Compared to the elusive motion of waves and foam, rocks ought to be easy to capture—they'll gladly stand motionless for hours, posing with their "faces" to the sun. Yet many artists consider rocks their ultimate nemesis. As with most things we find difficult to paint, the problem lies not so much in the object itself as in our own inability to truly see what the object looks like and why.

So let's take a closer look at rocks. Are they rounded or angular? What is their surface like? Dry? Wet? Does the surface have a speckled texture or is the color fairly uniform? Are there cracks or crevices? Does seaweed grow on the surface? Are the rocks large or small? How close are they to us and how does that affect their color (remember atmospheric perspective)?

And what about natural groupings of rocks? Do they look hopelessly jumbled? Try

squinting your eyes to get a sense of the overall form. Then simplify, simplify. Don't try to paint every crevice and strand of seaweed. Instead, establish an overall pattern of values and colors. Then develop the details only as much as necessary to give the impression of sharp focus.

Does that seem like quitting too soon? Try putting in every detail right down to a snail's tail and see what happens: your painting will probably look somewhat surrealistic. Why? Because, in a similar expanse of nature, your eyes are incapable of seeing everything in sharp focus at once. Subconsciously, you know there is something subtly wrong with a painting that shows more detail than your eyes would ordinarily see.

In the same vein, be ever alert for accidental forms that suggest themselves as you paint, and don't be afraid to use them. Stand back often—you'd be surprised at how different a painting looks close up than at a distance. Remember, people form their first impressions of your paintings from a distance.

Likewise, beware of spooks and goblins that appear in your rocks when you least expect them. In one recent painting, I'd completed a beautiful group of rocks with which I was very pleased—until my husband came along and asked why I had included a large fish jumping open-mouthed out of the water. As I looked at the rocks from his perspective, I not only saw the open mouth, but a large dark eye as well!

Let's take a look at *Rising Tide* (page 49) for some other

tips: (1) *Rocks*. I used smaller, more parallel strokes for rocks closer to the horizon line and bolder strokes at an angle for the rocks in the foreground (compare the close-ups). (2) *Rock edges*. I've kept some hard and some soft. Unbroken edges are boring and might lead a viewer's eye right out of a painting. (3) *Shadows*. I've subtly anchored my rocks to earth with shadows. I didn't use black for the shadows; instead, I allowed both rocks and shadows to reflect colors from the sky and sea (see complete painting). (4) *Value contrasts*. I carefully avoided stark value contrasts between light foam and dark rocks, except near my center of interest—the area between the translucent wave and projecting rock mass. Along the panel's edges, I darkened the foam with shadows near dark rock edges, or lightened the rocks with mist or runoff to ease the transition of values. (5) *Atmo-*

I used bolder, more angular strokes on the rock shelf in the foreground, and relatively purer colors. I blocked in basic values and shapes with a brush, then scraped and patted the area with a palette knife for a more rocklike texture. Next, I added cracks using a dark value and a liner brush. Finally, I spattered the rock faces with dark and light values from my original block-in colors using a toothbrush.

spheric perspective. I've built a strong sense of depth into the painting by including progressively more of the sky color from just above the horizon line in rocks as they receded into the distance.

You'll probably find, as I do, that it's easier to block in rocks with a brush, then use a painting knife to create a more rocklike texture. I stop when my rocks look right. Learn to trust *your* senses, too, and don't forget to *stand back* to get the big picture.

Moving Mountains—Creating a Visual Path

Obviously if you intend to include rocks in your paintings, you need to know the techniques necessary to paint them. But there is another problem. Nature, in her boundless enthusiasm, often provides an excess of rocks—at least from an artist's standpoint. So, before you can paint rocks, you need to know which rocks to take and which to leave. And sometimes, you must literally "move mountains"—or at the least large boulders.

In nature, rocks are strewn every which way, yet they remain a beautiful and harmonious part of the natural environment. That's because our eyes sweep the horizon to supply continuity in a scene. In a painting, however, we are restricted to the view from a small window—our panel.

When we isolate a small portion of the panorama of nature, we may find that rocks dominate our window or block the path our eyes should take through a scene. Or perhaps, natural rock formations merely lead us toward the edge of our window, suggesting that better things are just out of sight.

Rocks shouldn't be stumbling blocks in a painting, nor should they lead us astray. Instead, rocks should subtly guide viewers into and through a painting. These are lofty goals, to be sure, but practically speaking, how can we make rocks work for us rather than against us? Let's take another look at *Rising Tide* (right) for a few examples:

First, *decide on a focal point* for your painting—the feature you want to capture or dramatize, be that a wave about to break on a rocky shore or the explosion of foam and spray that comes just after. In *Rising Tide,* I wanted to focus on the translucent wave and, to a lesser extent, on the large rocks that seemed to lie in wait. In your own paintings, feel free to pick and choose from among nature's offerings. But do pick a focal point—and please, don't place your focal point in the exact center of a panel, or your viewers will never see the rest of your painting.

After selecting a focal point, next *decide how you want your viewer's eye to move.* In *Rising Tide,* I developed an *s* or zig-zag composition. Here, the rocks act like bumpers in a pinball machine, keeping the eye moving through the image from one point to another.

Creating a visual path is much simpler when you realize that your eye (and your viewer's) is almost involuntarily drawn to areas where value contrasts are strongest. Once there, your eye is also inclined to follow any continuous line formed by strong value contrasts. If no single line is continuous, your eye will simply look for a series of strong contrasts, with which it will form its own line in a sort of mental connect-the-dots fashion.

The eye can rebound off rocks abruptly or gently, depending on the contrast between rocks and foam or sky. A hard edge (that is, a stark contrast between a dark rock and white foam) invites the eye to change direction and follow. Be careful, however, that hard edges don't lead your viewer right out of a painting. A strategically placed "stop rock," such as I've used in *Rising Tide* (see lower left corner) is one way to turn an errant eye. A more subtle change of direction, however, can be initiated by simply reducing value contrasts near the edges of a painting. In other words, near the edges, darken foam or lighten rocks with mist or spray so the change in value between them is minimal.

As an example, look at the rocks and foam in the close-up of *Rising Tide.* The low-value contrast between the rocks and foam allows the eye to move easily to the lighter foam of the breaker just above the rocks. The light-value foam of the breaker "grabs" the eye and carries it back toward the center of the painting. The compositional circle is complete.

Finally, two pieces of advice that are worth repeating: (1) Vary rock edges and shapes to avoid monotony. (2) Stand back frequently to look at your paintings—about eight or ten feet is a good distance. Glaring errors that are invisible at brush length stand out vividly at ten feet.

A: *In this painting, the focal point is the tension between the translucent wave and the massive rock that awaits. Smaller rocks that were present in the actual scene have been omitted because they would have diminished the feeling of tension between the large rock shelf and the wave.*

B: *Light values, such as rolling foam, can easily lead a viewer off the edge of your painting, never to return. This can be avoided by reducing contrasts between adjacent values near the edges of the image. In this case, the foam near the center right edge of the panel was simply glazed over with a transparent, but deeper-value, tint of the sky color to reduce the unwanted contrast.*

Rising Tide
18″ × 24″

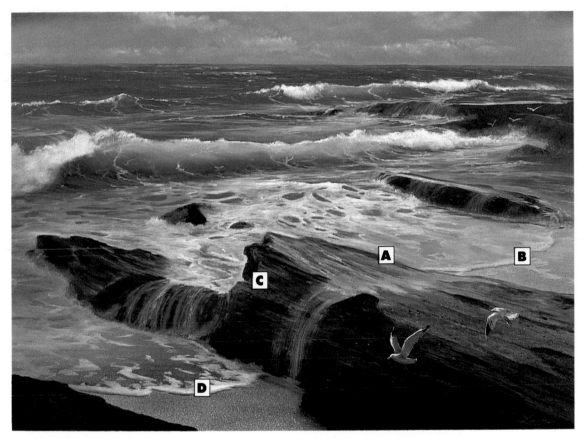

C: *A rock with definite edges is an effective device for deflecting the eye in another direction or for stopping a viewer's eye from escaping out of the painting altogether.*

D: *In this area of* Rising Tide, *the strongest continuous contrast is the curved edge of foam rolling toward shore. This line, in turn, leads into the reflective puddles on the rock just above, which lead to the light foam directly above them, and so on around from strong contrast to strong contrast until the compositional circle is complete. Thus, by the simple act of raising or lowering value contrasts, you have amazing control over the visual path your viewer's eye will take through your painting.*

CHAPTER 19
Ripples and Wavelets

When I first began painting the sea, I was so preoccupied with getting the "big wave" right that I forgot all about wavelets (little waves) and ripples (littler waves that usually appear in the troughs between waves). The result: my seascapes looked stilted; my "big wave" stood out like a tuxedo at a nudists' convention. But in retrospect, I forgive myself; the sea is complex, and it's only natural to concentrate on the major features first. Fortunately, as I painted more, I gradually became aware of many smaller water movements that added texture and contributed to the overall sense of realism.

Of course, it's easy to overcompensate for an initial shortage of wavelets and ripples by creating what I call "laundromat seascapes"— great thrashing waves and churning wavelets. That, too, is a natural part of the learning process. And there's nothing wrong with this approach; many artists paint it quite well, and many art patrons like an angry, turbulent sea. But since I get seasick easily, I prefer a more tranquil view of the ocean. In fact, I'm an enthusiastic supporter of the theory that less is more. As a result, my approach is somewhat more restrained when it comes to painting wavelets and ripples.

Take a look at *Pebble Beach Surf* (opposite). Count the waves and wavelets. How many do you see? One main wave, one wavelet, and a few discernible ripples, right? In practical terms, every additional wave or wavelet in a painting must vie for attention with the main wave, thus di-

viding the impact into progressively smaller bits. Therefore, use only as many subsidiary waves and wavelets as will support but not detract from your focal point or center of interest. Clearly, in *Pebble Beach Surf,* the main wave is the star, followed closely by the veil of water washing up on the beach.

Notice also that although swells and foam are suggested in the background water, they're kept subordinate. And except for the highlights on the wavelet, its overall values are lower than those of the main wave. I've placed the wavelet off center to the left to balance the foam on the right side of the main wave. In addition, the translucent (lighter) value of the wavelet also subtly balances the light-value foam on the main wave.

I blocked in the painting with mixtures of phthalo blue, phthalo green, and gray for the predominant color. For the translucent portion of the wave, I modified my basic mixture with Turquoise Green and gray. In the foreground, ahead of the main wave, I indicated the position of the single wavelet using the Turquoise and gray mixture. Otherwise, I simply worked back and forth between the color mixtures I already had to subtly suggest ripples, but I really didn't worry about trying to define any specific shapes at the block-in stage.

Finally, I came back with the highlight color and some of the sky blue to accent areas in the underpainting which seemed to suggest ripples. Again, I defined only as many ripples as were absolutely necessary to keep the image

from looking overly simple. In areas of relatively even value and color, I introduced additional texture using another value, perhaps to suggest foam trails. My real purpose, however, was to keep the surface visually interesting.

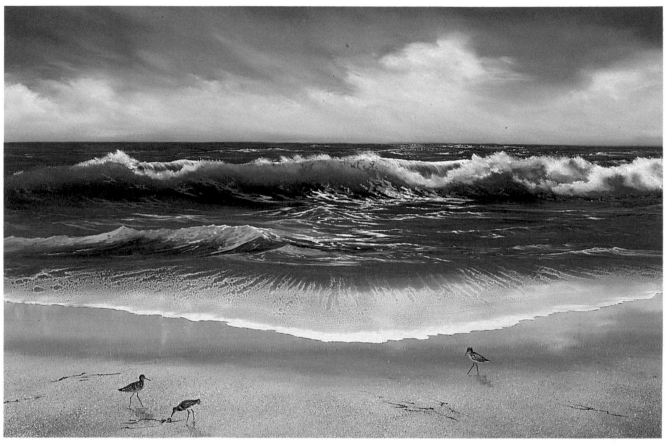

Pebble Beach Surf
16" × 24"

Balance is the key to a successful image—neither too much action nor too little. In this painting, notice that one large wave acts as the focal point while a smaller wavelet (in front and to the left of the main wave) acts as the supporting cast. Swells and foam, such as in the background water area, add interest, but should be kept subordinate in value and contrast to the main wave. To paint distant swells or waves, mix a grayed blue that is slightly darker than the background water and apply with long, thin strokes of a #10 sabeline flat brush. A return trip with the same brush using a foam color slightly tinted with sky tones will help to define the waves and swells and put a little life in your background water. The ripples ahead of the main wave add authenticity, but their primary purpose here is to add texture to an area of relatively consistent color.

A wavelet in front of the main wave on the left is used to add interest, but it also adds balance: the light, translucent portion helps to counterbalance the light values of the foam on the right side of the main wave, and the mass of the wavelet is purposely set off center to the left to balance the visual "weight" of the foam on the right side of the main wave.

CHAPTER 20
The Water's Edge

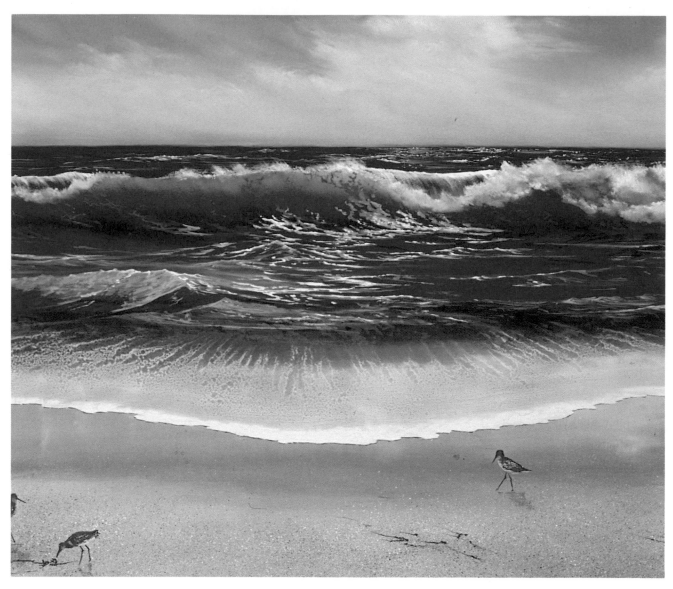

Detail of Pebble Beach Surf

The thin veil of surf on the beach is almost always in motion, either coming in or going out. I call these two types "incoming" and "receding" surf. In this painting, you have a good example of receding surf, when the water has stopped moving onto the beach and begins to drain rapidly back toward the next wave in a frothy mixture of sand and foam. Watch values closely along the water's edge. This type of foam usually forms a layer that rises about an inch or two above the sand, enough to warrant a small shadow at its base and a highlight at the top of the short vertical face. Furthermore, between the highlight and the shadow, the short vertical face should be painted with a shadow color derived from the sky color. For the surf line, choose a color for the front edge that is tinted with color from the sky and paint the curving front edge of foam. Next, use that same value and color and a liner brush to indicate the wiggly lines of frothy surf that converge toward a point at the center of the horizon. You may find the effect more realistic if you work the foam color directly into the wet underpainting, but you might prefer to experiment in relative safety over a dry underpainting until you feel you have developed the right "twist of the wrist" for frothy foam.

For nonseafarers—myself included—the water's edge is the part of the ocean most readily observed. Yet, too often, we're so entranced by big, crashing waves that we overlook the subtle beauties of quieter water gliding over a sandy beach. Within this thin veil of water is a wonderful world of whorls and eddies, tiny currents, bubbles, and transparent water—each a joy and a challenge to paint.

Let's take another look at *Pebble Beach Surf,* to see what makes the water's edge look the way it does. The first thing you notice is the gently curved line of foam that defines the water's farthest advance onto the shore. In nature, waves roll in at every conceivable angle and in every imaginable shape. As artists, we have the unique privilege of selecting from among nature's offerings only those that we feel are most pleasing or most characteristic. I happen to like this particular moment, when the foam assumes its graceful arc. Consequently, I use this image quite often in my paintings. You, however, might prefer a different moment or a different shape. Why not do a little "shopping" the next time you're at the water's edge?

In addition to the contour of the water's edge, you have several other options to consider. For instance, sometimes the water is mostly transparent, with little bits of floating foam. At other times, the water is covered with a thick, bubbly blanket of white. In *Pebble Beach Surf,* I've depicted yet another moment: the moment just after the water has stopped its forward motion and begins to drain back in little rivulets.

Your choices don't end there, either. Will your water roll onto dry sand, moist sand, or sand still wet and reflecting the sky? In this painting, I selected wet sand reflecting the sky, but you can well imagine the possibilities. Don't fall prey to the idea that there is only one way to paint water on a beach. The variations are practically endless, and fun to experiment with, as well.

Once you've decided on a particular combination of shapes and features you like, you're ready to begin painting. In *Pebble Beach Surf,* I began by blocking in a band of color from the sky (slightly grayed) just below the dark blue at the base of the wave. I carried this color down the panel beyond the point where I planned to place the curve of the water's foamy edge. After that, I added a narrow band of slightly darker blue (also slightly grayed) before switching to the sand colors (see Chapter 23).

I carefully blended the transitions between the base of the wave and the sky reflection, between the lighter and darker sky reflections, and between the dark blue reflection and the sand. Next, I suggested cloud forms by working a slightly lighter value into the sky reflection.

Finally, I painted the water's edge using fairly opaque color, then worked the foam (sky tone plus lighter gray or white) back along lines converging toward a point at the center of the horizon line. I chose this perspective simply because I prefer a more symmetrical composition. You might want to bring the water's edge in from a different angle or around rocks, or perhaps have one thin sheet of water overrunning another as so often happens in nature. Don't be afraid to experiment.

CHAPTER 21
Controlling Values for Dramatic Effects

Greatly oversimplified, the skills necessary to become proficient as an artist are: (1) the ability to see or sense something about a scene that makes it paintable, (2) the ability to translate that something onto canvas or panel with pen or brush, (3) the ability to mix colors, and (4) the ability to see and control values.

The first three of these skills are obvious, the last is not. Perhaps the only time we're really aware of values is when we draw with a graphite pencil and our "palette" is limited to the shadings (values) we can get by varying the weight of our strokes. Alas, the hectic pace of modern life doesn't seem to allow much time for such niceties as working out the values in a scene before beginning to paint. But it hasn't always been that way.

In the past, many artists blocked in their subjects in monochrome—that is, by using different values of the same color. Their purpose was to establish dynamic lighting in a painting before adding the complicating element of color. Today, some artists still follow essentially the same procedure: they draw a preliminary sketch on canvas with diluted burnt sienna, for instance, or ultramarine blue. The amount of thinner or turpentine added to the color determines its covering power. The result is a "value plan" which serves as a guide for their full color block-in.

Ultramarine blue, for example, is quite dark straight out of the tube—in fact, nearly black. Diluted in varying degrees, it becomes lighter in value, approaching the underlying white of the canvas or panel. You might want to try blocking in one of your paintings using this technique sometime. Without the distraction of a full palette, you'll probably be surprised to learn how often you've tried to use color for contrast when what you really needed was a change in value. Theoretically, you can use almost any color you like when painting, just as long as your basic value relationships are correct. If you don't believe me, take a look at paintings by LeRoy Neiman.

To see how controlling value relationships works in practice, take a look at *Through the Mist* (opposite). In this painting, I kept values and contrasts low in the distant headland and sky to set the stage for the strong contrasts in the foam and wave which I planned for the foreground. As I continued my block-in, moving down the panel from top to bottom, I began to increase contrasts between adjacent values. For example, notice that although the foggy headland barely contrasts with the sky, the sea stacks in the foreground are in distinct contrast to the headland immediately behind them.

When I came to the smaller wave that appears just above the main wave, I added light foam, but still kept the value somewhat muted in anticipation of the lightest value I had planned for the painting—the foam on the main wave. Before proceeding, however, I decided that the sea stacks contrasted more than I wanted, so I glazed the rock on the left and the sea stacks on the right with a semiopaque mixture of the sky color to bring them down to the value you see here.

Then I painted the main wave, using my purest colors and strongest value contrasts. The effect is a sense of bright sunlight peeking through the mist and lighting this particular breaker. To complete the painting, I added the sand, but I kept its value low also to help frame the lighter values above.

Once you're accustomed to seeing the underlying values of your colors, learning to control them for dramatic effects will be considerably less difficult. Nevertheless, you'll probably still find it necessary to go back and make adjustments in values (as I did on the sea stacks). In the meantime, while you sharpen your value-sensing skills, here are two techniques which should help:

First, try taking black and white photographs of your subject and of your paintings as they progress. If you can't bear to wait for ordinary black and white film to be developed, look at Polaroid brand cameras—yes, they still make black and white instant film. Check any well-stocked camera store for the correct Polaroid camera and film.

Second, make or purchase a "gray scale" showing values ranging from black to white and any number of shades in between. Then, when you plan your paintings, compare your color mixtures to the gray scale and reserve the two or three lightest values for accents.

Remember: the basis for creating dramatic sharp focus

Through the Mist
12″ × 16″

effects is strong value contrasts—like those you would see on a bright sunny day. As a matter of fact, when creating sharp focus effects, strong contrasts are actually more important than precisely rendered details. Of course, if you use too many strong contrasts, each must share the spotlight, in a manner of speaking, with the others and the overall impact of your painting will be weakened proportionately.

In the end, what controlling values for dramatic effects really means is planning your paintings so that the strongest contrasts occur at your center of interest.

Keep values low in the background sky and the contrast between distant headland and sky to a minimum to provide an interesting but noncompetitive backdrop for the center of interest—the wave in the foreground. As we move toward the beach (bottom of panel), value contrasts become more pronounced and colors purer. The secondary wave adds interest to the background water, but its value is still kept somewhat lower so that it doesn't detract from the impact of the major wave. Likewise, the rock on the left and the sea stacks on the right have a definite, but still subdued, contrast with the background.

The foam on the major wave

is the lightest value in the painting and, consequently, the center of interest. The colors of the wave are purer here, also. The "squiggles" of foam that ride on the face of the wave are painted with a lightened value of the color of the background sky to keep color harmony and to heighten the sense of light versus shadow.

The sand, which is approximately the same value as the background sky, completes the "frame" for the center of interest. Lighter sand would have competed with the light foam, while darker sand would have made the contrast too stark. Details of kelp and reflections were kept to a minimum so that the eye travels directly to the major wave.

CHAPTER 22
Creating Depth with Exaggerated Perspective

I hate to admit it, but I do watch television—occasionally even the commercials. I remember one commercial in particular that made a deep impression. It couldn't have been too successful, however, because I don't remember what was being advertised. What I do remember is that people poked their faces so close to the camera that their noses looked as big as Texas. The commercial got my attention through the use of exaggerated perspective.

Now, I'm not suggesting you include noses in your seascapes, but exaggerated perspective can be useful for creating depth and grabbing a viewer's attention. This is not a technique for everyone or every painting, yet for certain carefully chosen subjects, exaggerated perspective can be strikingly effective.

Exaggerated perspective really isn't anything new in seascape, but it's a technique that requires conscious thought when planning a painting. Normally, perspective is a way of drawing or painting objects to show their relative distance or depth. But when you make a wave seem larger (closer) than it actually is, for example, you are exaggerating perspective. By the same token, when you make a headland appear more distant than it really is using atmospheric perspective, you are again changing or exaggerating reality. In that respect, all painting, but most especially sharp focus painting, has a lot in common with theater.

Let me explain. In Chapter 1 and again in Chapter 2, I discussed using the camera as a tool for providing "frozen moments" from which to learn and paint; I also discussed the use of realistic colors—all of which would seem to suggest a fairly literal transcription of nature. But in fact, in painting as in the theater, our gestures must be somewhat overstated if we are to get our message across. So we make waves bigger, rocks rockier, and sand sandier than in the real world.

If you haven't worked with photographs as reference before, you'll feel a strong temptation to replicate exactly what you captured with your camera. Ironically, if you succeed, you'll almost certainly be disappointed. Only with experience can you learn when and how much to exaggerate perspective, but that's part of the fun and challenge of painting the sea. As a start, however, you can almost always make the wave a little grander, the surf more powerful, the lighting more brilliant.

As an example, one of my favorite subjects is the brief moment when a thin veil of water and scudding foam races across a sandy beach toward shore—seemingly about to overrun the viewer at any instant. Take a look at *Surf Patterns* (30″ × 40″) to see what I mean. In addition to the obvious distortion of the front line of foam and the wave, I also lowered the horizon line a bit; it just seemed to look better that way.

I can't give you any formulas for when to exaggerate and when not to, but I can give you some sound advice: always be on the lookout for a chance to make the most of a scene with a little embellishment on reality. By the way, did I ever tell you about the fish I caught?

Surf Patterns
30″ × 40″

At the center of this painting, the surf line projects strongly forward. The foamy edge then narrows rapidly as it moves from the center back "into" the painting. Thus, by exaggerating the forward movement of the surf line, this image becomes more dramatic; the water seems almost ready to overrun your sneakers at any moment. The effect works because the laws of perspective are bent, but not broken. The perspective has also been exaggerated subtly by placing the horizon line lower than it would normally appear, making both the wave and the surf line seem larger and more imminent. Finally, wiggles of floating foam converge toward a point at the center of the horizon line. Notice that they get smaller and less distinct as they move "into" the painting, again reinforcing the strong sense of perspective.

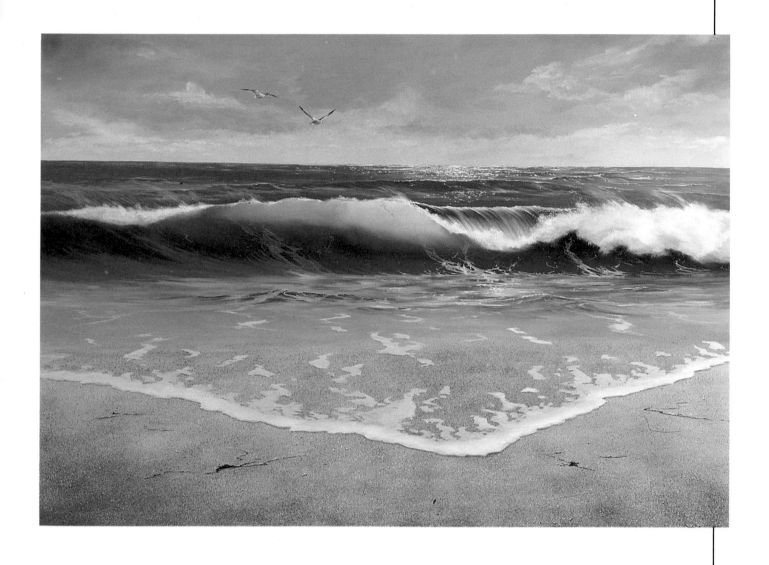

Textured Patterns

I'm absolutely in awe of the seeming ease with which nature weaves various textures into a unified whole. And, like the stitching that holds a garment together, subtle textures are more likely to be noticed for their absence than for their presence.

Gritty sand, a lazy stand of grass on a dune, a pile of shell fragments, a strand of tattered kelp washed ashore, foam swirling, tumbling, bubbling, endlessly moving—these are only a few of the textures and patterns that nature creates and effortlessly overlaps. For me, however, these textures and patterns pose a constant challenge. I'd rather concentrate on powerful waves and massive rocks, yet subtle textures are no less important when creating the look of sharp focus realism.

Various textures and pat-terns are discussed in other chapters, so for now, let's take a look at the sand in *Gulf Dune* (opposite). At first glance, you may be tempted to think of sand only in terms of its superficial appearance and texture—the grit that gets into your shoes, that clings to the condensation on a cold can of cola. But look further. The sand on the sunlit side of a dune is warm, both to the touch and in color. On the opposite side, in shadow, the sand is cool to the touch and cool in color. These are good memory images to keep in mind when painting sand and dunes.

At the base of a dune, bits of debris often collect, turning the sand slightly darker (as in *Gulf Dune*). These are all tex-tures and patterns to be estab-lished in your underpainting: warm colors on sun-washed slopes, cool colors in shadow areas, darker sand at the base of the dune.

I generally use yellow ochre, burnt sienna, burnt umber, and gray to mix my basic sand color. To cool the shadow side, I work in a sec-ond mixture of ultramarine vi-olet and gray. Of course, the color of sand varies greatly from one part of the country to another and even within the same scene. Wet sand, for instance, is darker than dry sand, and Florida's west coast beaches are nearly white by comparison to California's

Underpaint the sand (dune or beach) with various mixtures of the above colors, then add oil or thinner to the mixtures remaining on the palette and use them to speckle the underpainting by flicking the bristles of a toothbrush with your finger.

Burnt Umber

Yellow Ochre

Burnt Sienna

Neutral Gray

deeper-toned sand. (Beaches on many tropical islands are *black* sand with golden flecks.)

Once you have blocked in your basic sand color and indicated the shadings necessary for dunes, it's time to add the gritty texture of sand. I do this with an old toothbrush. Using a dark, middle, and light color from my sand mixtures, I speckle each color in turn over the underpainting. As in golf, speckling is all in the wrist, and there's no substitute for practice to get a feel for the proper amount of speckling and the balance among the three values.

It's said that nature abhors a vacuum—that is, a space with nothing in it. And so it seems: nature abounds with textures and patterns. As we attempt to paint nature, we too must abhor a vacuum—flat tones with nothing in them. Sand is only one example of the rich variety of textures and subtle color shifts nature has to offer. Watch for them and avoid flat tones wherever possible; flat tones are boring, nature isn't.

A: *Underpaint the sand with mixtures of yellow ochre, burnt sienna, burnt umber, and gray, lightening with white as necessary. Next, loosen the paint remaining on your palette by adding oil or thinner. Then grab a toothbrush and spatter a texture over the wet underpainting (using dark, middle, and light values) by drawing your finger along the bristles from the tip toward the handle. It's messy but effective.*

B: *To heighten the sunny effect on the dune, glaze over the dry underpainting with a semiopaque glaze of yellow ochre and white. Where there's sunshine, there are shadows. Again, glaze over the dry underpainting with a semiopaque mixture of ultramarine violet and gray.*

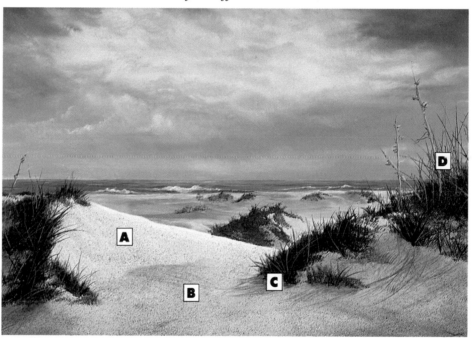

Gulf Dune
14" × 20"

C: *Don't forget the little things, such as decayed plant matter, that often darken the sand at the base of a dune. Add this during your underpainting if possible; it'll be much harder to integrate over dry paint.*

D: *Underpaint these grasses with a bristle fan brush and a dark, low-value green to create the bushy density at the base. Use a dagger striper to sweep dark grasses up with the same dark green mixture. Next, add yellow ochre and white to your basic mixture to create a middle green, then sweep a few more grasses up. Finally, mix raw sienna plus gray and white to indicate dried grasses. If you work over a dry underpainting, mistakes will be easier to correct, but grasses may look unattached to the dune.*

CHAPTER 24
Contrasting Warm and Cool Colors

We've already discussed the two primary ways of conveying depth in previous chapters: atmospheric and mechanical perspective. As you may recall, objects under the influence of atmospheric perspective become softer-edged and less intense in color as they recede into the distance. If you don't recall a specific discussion of mechanical perspective, your memory is correct. Nevertheless, I've made numerous references to its basic premise in several chapters: distant objects simply appear smaller than their counterparts nearer to us. And, as an extension of this concept, occasionally I'll deliberately exaggerate mechanical perspective to heighten the sense of depth beyond what occurs in nature (as I did in Chapter 22).

Another useful way to convey depth is by contrasting warm colors against cooler colors. Strictly speaking, this falls under the heading of atmospheric perspective, but it's worth a closer look by itself. No one has ever come up with a satisfactory scientific definition of warm and cool colors—they seem to be something we just feel. The consensus, however, is that colors that remind us of sun and fire are warm colors: reds, yellows, and oranges; colors that remind us of night or daytime shadows are cool colors: blues and purples. Other colors, notably greens and browns, have an identity crisis, being cool one time and warm the next.

And finally, underlying all these warm/cool assumptions is yet another: warm colors appear closer and brighter, while cool colors appear more distant. In the end, of course, we're not particularly concerned with scientific explanations (or the lack thereof); all we really want is to learn how to put this information to work for us.

Let's take a look at *Near Morro Rock* to see how warm/cool perceptions can be put to use in an actual painting. Notice how much warmer the colors of the dune are in comparison to the cool granite expanse of Morro Rock. When I first blocked in the rock, it felt too close, so I "cooled" it with a glaze of the sky color. The background water also received some of the same glaze, though I made the mixture more transparent because the green of the ocean already leaned toward the cool side.

When I'd done all this, I suddenly discovered that I'd created two virtually separate visual planes—one containing the rock and distant water, the other containing the foreground dune. Such is the power of contrasting warm and cool colors.

To lessen the separation between the two visual planes, I did two things: first, I went back to Morro Rock and re-established the highlights on the rock faces using a *warm* mixture of yellow ochre and white (below). Then I built more dimension into the dune by adding *cool* glazes of ultramarine violet and gray to the shadow areas (bottom right).

The secret of using warm and cool colors to convey depth lies in finding the proper balance. For that, I look to my own experience of the real world. You too have a lifetime of visual experience to draw upon if you choose. Incidentally, the best way to see if your warm and cool colors are in balance is to stand back about ten feet and take a fresh look at what you've created.

The cool colors of granite recede into the image. I cooled them by simply glazing over the dry paint with transparent mixtures of the sky colors. But then it seemed to recede a bit too much, so a second semiopaque glaze of yellow ochre and white was applied to the rock highlights to warm them and bring them forward.

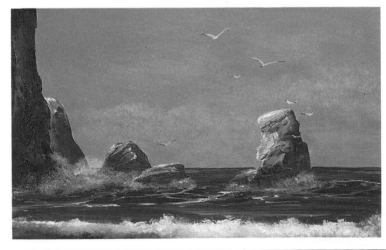

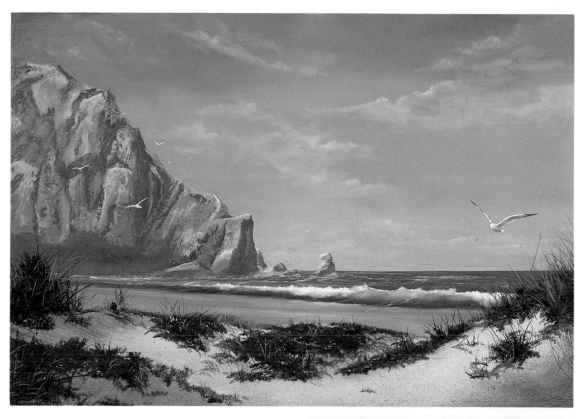

Near Morro Rock
20" × 30"

In Near Morro Rock, contrasting warm and cool colors were used to convey depth. Because cool colors appear to recede and warm colors appear to advance, the background rocks and water were painted in cool colors, and the foreground dune in warm colors.

An essential part of bringing an image together lies in balancing warm and cool colors. Here, a glaze of ultramarine violet is used to cool the dune shadows slightly and strike a subtle balance with the cool rock mass in the background. At the same time, the shadow adds a sense of depth to the image and helps the viewer's eye move directly into the image via the sunny faces of the dunes.

CHAPTER 25
The Natural Look: Sea Birds

Sea birds: as they gracefully maneuver overhead, their shrill cries echo and mix with the *boom-shoosh, boom-shoosh* rhythm of the surf. In most areas of the world, sea birds are as much a part of the ocean as the waves over which they fly. So I'm always surprised at how many people who paint the sea don't choose (or remember?) to include sea birds in their paintings.

Seagulls are certainly the most common sea birds, but there are places, I suppose, that have none. For example, when I visited the island of Mooréa, Tahiti, the only birds I saw were snow-white terns with long, forked tails. On the other hand, our own Atlantic and Pacific coasts are teeming with seagulls and several species of birds loosely referred to as sandpipers.

Painting the sea is an exercise in memory, both for artist and for viewer. By including sea birds in our paintings, we add a new dimension—sounds, though not heard, nevertheless keenly remembered. And, after all, isn't that what we're trying to accomplish when we paint a big, crashing breaker? We want our viewers to not only see what we saw, but also *to hear* what we heard.

Of course, including sea birds in our paintings is more challenging than it looks. As lovely as they are, they seldom sit still, and when birds do sit still, they often look, as my grandfather used to say, "like so many bumps on a log." In short, not very interesting. It is the motion of a wave that intrigues us and so, too, it is the motion of a

seagull that catches our attention.

But capturing our attention and capturing the image of a seagull in motion are two different things. I find that a loaf of bread and a 35mm camera simplify the task. Seagulls are basically shy—except when it comes to food. Then, beware. They can go through a loaf of bread faster than a pack of hungry ten-year-olds. If you can get a friend or spouse who is willing to be the center of a mob scene, let that person feed the gulls while you stand back and snap photographs.

When you get your film developed, you'll be surprised at how truly awkward these seemingly graceful birds really are. Enjoy a good laugh, then pick the poses that are as beautiful as your memories of seagulls in flight.

What I try for when using seagulls in a painting is a sort of slice of life. Take a look at *Shore Birds* (opposite page) to

see what I mean. The painting has a rather quiet, peaceful feeling overall. The waves in the background are small and gentle; two gulls are doing what gulls do often: standing like bumps on a beach. A third gull glides by, perhaps scanning the sand for a tasty morsel.

If you've been to the beach, you've undoubtedly noticed that not all gulls are white and black; some are brown with subtle spots. These are juvenile or young gulls. As they mature, they'll change color until they too are white and black. I don't often include juvenile gulls in my paintings for one simple reason: their colors don't contrast well with

As you study sea birds and capture their movements with a camera, you'll discover more awkward poses than you ever thought possible. Choose the best and most graceful and make sketches like these as reference for later paintings.

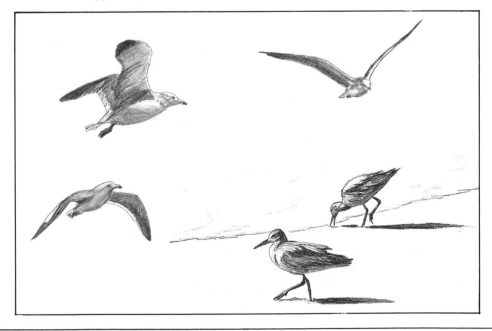

Shore Birds
10" × 16"

anything. Their colors are all middle values, and sharp focus works best with strong value changes.

We'll talk more about painting sea birds in Chapter 48. In the meantime, here are two tips to get you started: (1) The white of a seagull is usually the lightest value in a painting, so plan your values accordingly. Mix a mound of white slightly tinted with yellow ochre, then test every other light value in your painting against it to be sure that no other element diminishes the seagulls' impact. (2) When painting seagulls, be sure to include reflections of surrounding colors, such as the color of the waves, the sky, or the sand. This will give your painting better color harmony and will make the gulls more a part of the painting.

When painting a "portrait" of shore birds, use the water and waves like a stage curtain in a theater—as a backdrop for the center of interest. In this painting, the background waves are kept small and simple to convey a peaceful mood and, of course, to assure that the waves don't compete with the real stars, the seagulls.

Although the pose is completely natural and quite common, a bird standing on the beach just isn't very interesting. Still, the pose adds to the sense of realism and creates a very tranquil mood. The image can be made more dynamic by using strong highlights and deep luminous shadows on the bird and dark, rich cast shadows on the beach. To further enliven the rather static pose of gulls standing on the beach, try adding a puddle or a sheen of water in which you can reflect the broken image of the seagull.

A lone, flying gull adds just enough action to make this image interesting. In addition, the wings of the flying gull serve as a subtle compositional aid by forming a visual bridge between waves, sand, and reflections.

CHAPTER 26
Close-up Views: Shells

I'm not what you'd call a "classical" seascape artist—I have a somewhat different point of view. Classical seascape looks at the ocean from a safe vantage atop a bluff as storm-tossed waves batter a rocky shoreline. My view is more intimate, a view gained by walking along sandy beaches, savoring the *squish* of wet sand between my toes, listening to the soothing rhythm of the surf and the sharp cries of gulls wheeling effortlessly over their domain. Mine is a peaceful ocean, and one filled with countless small and wonderful details.

The "big" wave is definitely interesting and important to many of my seascapes, but often it's the little things in a painting that add just the right touch to make the image believable. And in my world, shells just happen to be one of those little things.

I painted *Water's Edge* (right) on the basis of a walk I took along the beaches of Cumberland Island National Seashore near Saint Marys, Georgia. To find not one, but many large, intact whelk shells strewn along this stretch of beach was truly exciting—as a West Coaster, the only shells I'd seen were small and broken. Even so, the whelk by itself did not make a painting.

A painting should tell a story. *Water's Edge* was about the excitement of my discovery and about the little details that caught my attention: transparent water, airy foam, fragile bubbles glistening in the sun, gritty sand, and a whelk shell, bits of scattered kelp, and fragments of other, smaller shells.

To paint the story of *Water's*

Edge, I drew the outline of the whelk shell directly onto my panel, then brushed on the colors of the wet and dry sand and added speckles (see Chapter 23), taking care to leave the area for the shell free of paint. After completing the patterns of floating foam, I established the basic shading of the whelk shell with mixtures of Prism Violet and gray (for shadows and dark values), and yellow ochre and white (for highlights). Finally, I used a stiff fan brush to apply the faint striations that encircle the conical upper portion of the whelk shell.

Every beach has many such stories to tell. On this same beach, there were horseshoe crabs the size of football helmets, stranded awaiting high tide; ivory clam shells subtly tinted with lavender and brown; my own footprints vanishing beneath the incoming tide as quickly as I left them. On another beach, this

time on an island in the Dry Tortugas, another story: a starfish resting beneath the shallow water near shore, its shape constantly changing, stretching and contracting like a reflection in a fun house mirror.

To a small child, the world is an ever-unfolding story filled with natural wonder and endless fascination. As adult artists, our challenge is to see with the eyes of a child, yet paint with the world-wise hands of an artist. If ever you need a refresher course in seeing, just go to the beach and watch a child explore: watch as a child scrutinizes every seagull and sandpiper, every bit of foam, every torn and tangled heap of kelp, every ephemeral bubble, and, seemingly, every grain of sand. It'll give you a new perspective and, perhaps, help you capture something in your paintings to excite the child hidden in all of us.

Faint conical striations were dry-brushed onto the upper portion of the shell with a bristle fan brush, and highlights were strengthened with the yellow ochre and white mixture.

After the contour of the water's edge and the outline of the whelk shell were drawn onto the panel, the wet and dry areas of sand were painted and then spattered using mixtures of burnt umber, burnt sienna, yellow ochre, white, and gray. The shape of the shell was simply left unpainted while the sand was blocked in around it. However, it could have been masked off with masking tape just as easily, if desired. As soon as the sand was blocked in and speckled, I blocked in the whelk shell using mixtures of Prism Violet and gray for the shadows and mixtures of yellow ochre and white for the highlights, without waiting for the sand to dry (this was possible because the shell area had been left unpainted). When this underpainting had dried, the shell was detailed. Then foam patterns were painted over the dry sand underpainting using mixtures of white, gray, and a faint tint of purple. The surface of the foam was textured while still wet, using light, jabbing strokes of a round bristle brush. Finally, light-value speckles were added with a toothbrush.

Water's Edge
20″ × 24″

*Keep a sketchbook of small
details like this clam shell to
include in paintings—
remember, it's the little things
that make sharp focus "sharp."*

There's something captivating about a large bubble in the surf line—so delicate, shiny, and perfect. Sketches such as these are a good way to learn the anatomy of a bubble before including one or more in a close-up such as Water's Edge.

A: The upper, domed shape can easily be drawn with the help of a drafting template that has various-sized oval holes in it for just such occasions. The lower half is drawn in a similar manner, using a narrower oval from the template.

A

B: Darken the line along the base more heavily to one side, depending which way you wish to suggest the cast shadow.

B

C: Next, add a graded dark tone to the upper, domed shape.

C

D: Finally, add a curved highlight in the middle of the area you just shaded, make a few suggestive "squiggles" of foam, and voilà—a bubble.

D

CHAPTER 27
Indefinite Forms: Kelp

We tend to think of realism in terms of definite objects—rocks, waves, seagulls, shells, and so on. Yet realism is, in fact, the sum of many smaller textures intertwined and overlaid until the whole approximates reality. Strands of kelp are one of those smaller textures, though perhaps not one you'd ordinarily notice. Nevertheless, they are important. Indeed, their absence often gives a painting an unsettling, surrealistic appearance.

In my early paintings, I was so caught up with the problems presented by other parts of the subject that I left my beaches as flat and as free of debris as a recently vacuumed carpet. You can accuse the sea of being many things, but neat is not normally one of them. Take a look around: the ocean slings kelp, shell fragments, driftwood, and all manner of flotsam and jetsam wherever it pleases. Hardly neat, but certainly part of its charm.

From the viewpoint of someone wanting to paint the sea in sharp focus, all this disarray can be a little disconcerting, but it needn't be. As I've suggested several times before, the place to begin is by studying your subject—in this case, kelp. Once again, you'll find a 35mm camera helpful, but certainly no substitute for your own eyes.

Begin by noticing the color of kelp: When first washed ashore, it has a dull green appearance. As it dries on the beach, kelp turns slightly more toward yellow, then fi-

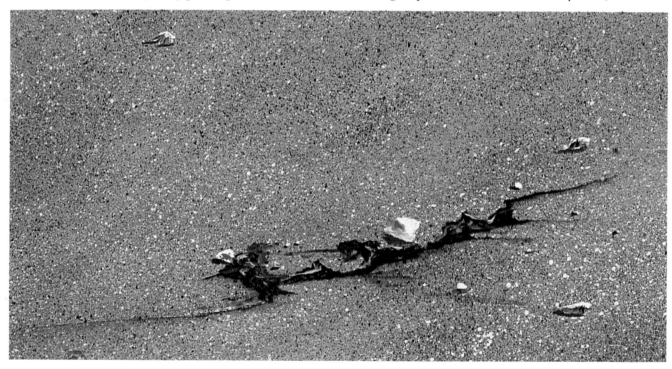

Detail from Water's Edge

Kelp can be a compositional aid—a kind of signpost for directing the viewer's eye toward the center of interest. In this detail from the lower left corner of Water's Edge, *notice how the kelp strand is angled diagonally. Now look back at the whole painting in Chapter 26, and you'll see that this kelp strand points almost directly at the painting's center of interest—the whelk shell.*

Kelp is relatively straightforward to paint. Simply mix a warm, dark green or brown and lay down a wiggly line with a liner brush over a dry sand underpainting. If you want to add a kelp clump, wiggle the liner around in the center of the line you just painted. Finally, paint a few delicate trails wherever they feel right; you'll know almost immediately if they fight the movement of your eye through the painting or seem to make the image unbalanced. Once the kelp strands and clumps are established, clean the paint out of your brush and lightly dab the lower edges to soften them—this suggests shadows and, most important, visually anchors the kelp to the sand.

nally almost black. Next, look at the shape of kelp: The leaves are long and slender with small bumps. The leaves, in turn, are connected to narrow, cylindrical stems. The stems cling to the ocean bottom and grow vertically thirty or more feet to the surface. This entire, amazing mass of leaves and stems is kept afloat by natural, air-filled "floats" in the stems. On the beach, a float is usually found in the middle of a three- or four-foot length of stem, looking for all the world like a snake that has just swallowed a softball.

Despite all these unusual anatomical characteristics, by the time kelp reaches the beach, only three features remain distinctive: (1) clumps—the result of taking thirty feet of kelp stems and leaves and rolling them willy-nilly onto the beach in a heap; clumps are usually accompanied by clouds of sand gnats too small to paint, but just large and numerous enough to be thoroughly obnoxious; (2) a few scattered leaves trailing out from the clump, pointing back toward the water; and (3) the softball-swallowing snake: stem floats.

The detailed close-ups pictured are from various paintings throughout the book and should give you a better idea of how I render the indefinite form of kelp. Although real kelp is a fine model, I suspect that each artist will render it a little differently, rather like the differences in handwriting from one person to another.

In a painting, I use the dark clumps to balance other dark masses, and I use the trailing kelp leaves to point the way

toward the center of interest. I don't often include kelp floats in my paintings because they are more definite in shape and, as a result, draw attention to themselves—which is very unkelplike behavior. Nonetheless, if you should ever want to draw attention to an area, the curious shape of a kelp float will certainly have the desired effect.

For fresh kelp, I use a mixture of Permanent Sap Green and gray. For slightly dried kelp, I use raw sienna and gray with a bit of burnt umber. For dry kelp, I increase the amount of burnt umber in the previous mixture.

The painting procedure is equally straightforward: I put

down a rough clump shape in a dark value over the dry, textured sand, then trim or extend it as necessary into "tails." Floats must, of course, be drawn in like any other object with a definite shape, then painted with appropriate values and shadings to suggest their spherical appearance.

The air-filled, ball-shaped chamber is what keeps a kelp stalk afloat in the water. Kelp floats vary in size from the diameter of a marble to the diameter of a softball. The cylindrical stem is a portion of the kelp stalk. The kelp leaves are flat with pea-sized bumps, though you'll seldom have occasion to paint either characteristic in detail.

FINISHED
PAINTINGS

In the previous section, we looked at the primary techniques for developing each of the nine components of a seascape and at various methods for using color and detail to build sharp focus. In this section, we change our point of view from specific areas of a painting to an examination of the whole image. Unlike the previous section, the chapters in Section III are arranged in no particular painting sequence. Instead, each chapter stands alone, touching upon more advanced techniques and considerations for painting the sea in sharp focus.

In several of the following chapters, you'll see a reference photograph of an actual scene and a completed painting, along with suggestions about how to translate what you see in nature into a finished painting. Other chapters will examine completed paintings and point out how various techniques were used to make the overall image more effective.

In nature, we are confronted with a myriad of possibilities for each painting, and with many elements that seem to vie for our attention. The key to a successful painting, however, lies in learning to simplify complex subjects, the subject of the first chapter in Section III.

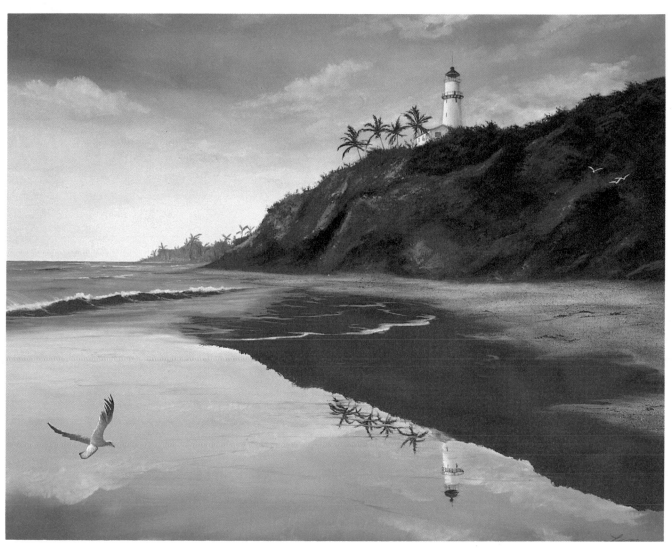

Reflections—Diamond
Head Light
24″ × 30″

CHAPTER 28
Simplifying Complex Subjects

Perhaps one of the greatest misconceptions among artists about painting the sea in sharp focus is that you must paint every last rock, wave, and grain of sand in excruciating detail. Of course, that's completely wrong. It's perfectly okay to leave a couple of grains of sand unpainted; I'm not going to tell on you.

The fact is that painting the sea in sharp focus is more a matter of effect than of actual detail, more a matter of knowing what to leave out than what to put in. Alas, nature, for all its wonder, isn't always as beautiful or as well-organized as we artists would like. Remember the ungainly seagull poses I mentioned in an earlier chapter? Even though those awkward poses are absolutely necessary for the bird to remain in flight, we simplify his movements, choosing only those that are attractive (by our standards) and fit our compositional needs.

The same logic holds true for rocks and waves and, in fact, for everything in a scene. (As an aside, when you paint in sharp focus, those who like what you do will compare your work favorably with photographs; those who dislike your paintings will also make references to photographs, as in "if you wanted a photograph, why didn't you buy an Instamatic like mine?")

All of which brings up an important point: how does painting in sharp focus differ from photography? If you've painted well, your work will certainly have the look of reality; yet, at the same time, it will be different. The difference lies in limiting and sim-

plifying your subject. A photograph is a totally objective record; it includes the awkward poses of seagulls right along with hopeless jumbles of rocks and countless waves, each moving in an opposing direction. As artists, we bring order to a scene, both for our own benefit and to create a more pleasing image.

As you look at a potential subject, a good place to begin is by asking, Do I really need that group of rocks? Could they be combined into one larger, more easily comprehended rock? How about all those waves? Can I get by with only one? In short, include only as much complexity as is essential and appropriate for the subject and for the composition.

Take a look at *Rocky Shore* and at the reference photograph I used as a basis for the painting. As you can see, I've remained basically faithful to the scene. However, the day was slightly overcast, so I altered my palette for a sunnier

The sky in the original scene (above) was slightly overcast and rather monotonous. In this case, "simplifying" meant changing to sunnier colors and adding clouds for interest—changes that, in fact, made the image more complex. Yet in a roundabout way, the more complex image was ultimately simpler to paint, because nothing is harder to paint well than dull colors and boring skies like those in the photograph.

The headland in the photograph was too long and uniform in shape. It seemed to suggest a closed body of water where waves would be less powerful. Shortening the headland opened the way to the sea and made the size of the wave more logical. In addition, increasing the slope of the headland added interest and reinforced the diagonal movements in the composition.

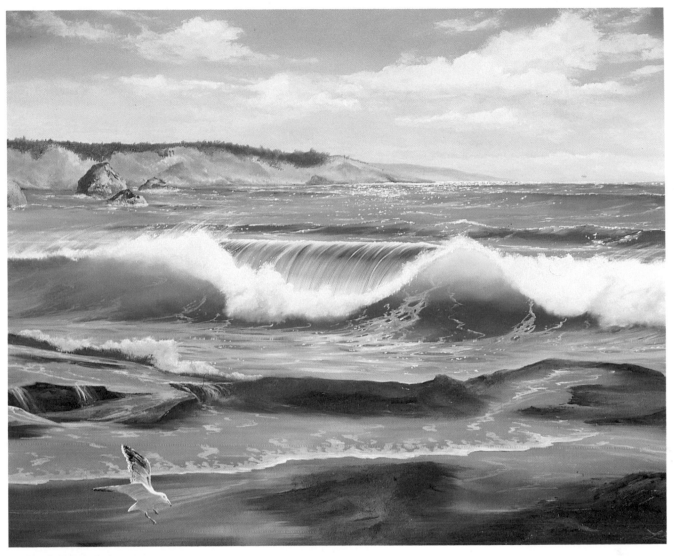

Rocky Shore
24" × 30"

look and included more distinct cloud forms. The shape of the distant headland was monotonous and too long, so I shortened it and made the shape more interesting.

In the background water, I *added* a smaller wave to make the area more interesting. The major wave in the photograph had interesting color and distinctive foam patterns, but the large splash on the left was oddly shaped and rather distracting, so I designed my own wave and foam patterns to fit my composition. The large, flat rock in the foreground was also interesting, but far too extensive. I contemplated extending the foreground water and shortening

the rock mass, but finally decided to develop and simplify the foam already spilling over the rock.

In the painting, the thin veil of water and foam is more easily comprehended than the random patterns in the photograph. At the same time, the front line of the foam in the painting leads the eye diagonally across the rock toward the major wave. Finally, I added a seagull about to land. In addition to drawing the eye into the composition of diagonal lines, the seagull gave the painting a feeling of life and motion in progress.

The main wave in the original photograph had a certain raw power. Still, it was a rather odd shape, which would have drawn undue attention to that area of the painting. So I sketched a simpler shape for the wave and foam patterns that seemed to fit better with the overall look of the painting. In the background water I added a distinct secondary wave and suggested several smaller waves in the distance for interest.

CHAPTER 29
Dramatizing a Scene

Earlier in the book, I made a comparison between painting and the theater: I said that in art as in theater, scenes must often be overstated to get a point across. This is a somewhat roundabout way of saying that we need to make our scenes a little more vivid, a little more striking than they are in real life. In seascape, this means that a sunlit wave will be rendered with more light and purity of color than we saw in nature; that moss or seaweed will be greener, and so on.

Of course, in sharp focus painting, our task is more difficult, because we have to be careful to dramatize without stepping over the line of believability. To carry the theater analogy a little further, what we want is drama, not farce or melodrama. So in our enthusiasm to add drama to an image, we should try to avoid "neon" waves and "decorator" skies; colors should remain basically true to nature, with the least embellishment necessary to create a dramatic image. For me, that means beginning with the strongest composition possible, then creating an image built of the best moments of the element I want to feature in a particular painting.

In *Spring Flowers* (opposite), for example, I wanted to dramatize the lighting on the dune and in the wave. With that in mind, I kept the sky simple to avoid distracting from the foreground. I also made other adjustments: In the scene that inspired the painting (see photograph), the ocean was farther away from the dunes and the waves looked small in comparison. So, I simply focused on one wave and made it closer and larger.

The dunes in *Spring Flowers* are typical of southern California: they're partially overgrown with a ground cover called "ice plant." This interesting plant has juice-filled "leaves"—about the size of your finger—which vary in color from medium to deep green. In season, beds of ice plant are dotted with bright yellow or lavender blossoms. In the photograph, the ice plant was rather lacking in the flower department, so I dramatized the scene by adding more blossoms.

Of course, being a good artist/gardener, I made sure that the upper edge of the bed of ice plant (lower right corner of painting) formed a diagonal line to carry the eye up, across, and into the painting. That line, in turn, leads to a second diagonal line moving in the opposite direction and pointing toward the illuminated portion of the wave. These elements are minimally present in the original scene, although I've rearranged them a little and heightened the contrast between sun and shadow for dramatic purposes.

Two other areas where I've deviated from nature are in the colors of the wave and of the ice plant. In the actual scene, the colors are somewhat grayed and mostly middle values. In the painting, I've made the colors deeper and richer. The colors as they appeared in nature would probably have made a quite satisfactory painting; the colors and perspective you

choose are what will make your style different from that of any other artist who sets out to paint the same subject in a realistic manner.

Regardless of how you choose to modify a scene in color or perspective for dramatic effect, the key point is to avoid overstepping the limits of believability. And that, finally, is what sharp focus painting is all about: creating a realistic portrayal of a scene that is both exciting and dramatic without requiring the use of artificial colors or a contrived treatment of the subject.

In the original scene, the ocean was too distant and the waves were too small. Because one wave appears larger and closer, the painting gains a sense of drama and immediacy that was lacking in the original scene. The actual scene also had few flowers to break up the fairly uniform green blanket of ice plant. After a few strokes of the brush, a profusion of new and colorful blossoms added interest and vitality to an otherwise bland crop of ice plant. And once the diagonal movement along the edge of the bed

(vaguely present in the original reference) is reinforced, the viewer's eye moves smoothly across the painting en route to the center of interest. The edge of another bed of ice plant at the far right deftly turns the viewer's eye back into the painting and toward the center of interest; the illuminated portion of the main wave.

With the colors of the wave and ice plant somewhat purer and stronger in contrast than in the reference photograph, the painting gains a feeling of drama that is far superior to the original scene.

Spring Flowers
20″ × 28″

CHAPTER 30
Selecting a Point of View

Before you ever set brush to paint or pencil to sketch pad, you need to make a critical decision: what will be my point of view? When you begin painting a new subject, you'll probably try many different vantage points, but in time you'll settle on one or two favorites. Eventually, your favorite point of view, along with your favorite palette and way of handling paint and brushes, will become the hallmarks of your work—your style.

At the risk of oversimplification, point of view in seascape can be reduced to two major compositional choices: (1) symmetrical (looking straight ahead) versus asymmetrical (looking at a scene from an angle), and (2) beach-level versus a view from above the beach. These choices, in turn, yield the following possibilities: a view from above (on a bluff, for example) looking straight ahead; a view from above looking along the shore at an angle; a view from the beach looking straight out to sea; and finally, a view from the beach looking down the coast.

If you are a student of mechanical drawing, there are a number of fine books on perspective to assist you in rendering a scene from whatever point of view you select. Personally, I prefer a more intuitive approach: I like to sketch from several points of view until I get something that looks and feels right for the painting I have in mind. Learn to trust your eyes and you'll seldom be disappointed.

Now let's take a moment to look at the merits of each of the four points of view.

From above, asymmetrical. This view seems to be the favorite of most contemporary seascape artists. It is visually very strong, and it has few hazards. Nevertheless, I find that it somehow holds me and my viewer at a distance from the subject—and I simply prefer a closer, more intimate point of view.

From above, symmetrical. This point of view solves the problem of horizontal bands that can be a distraction in the beach-level, symmetrical approach—perhaps because this view forces you to paint more of a panorama and, thus, to include rocks, eddies, and other asymmetrical elements in what is otherwise a basically symmetrical composition.

From above, asymmetrical

From above, symmetrical

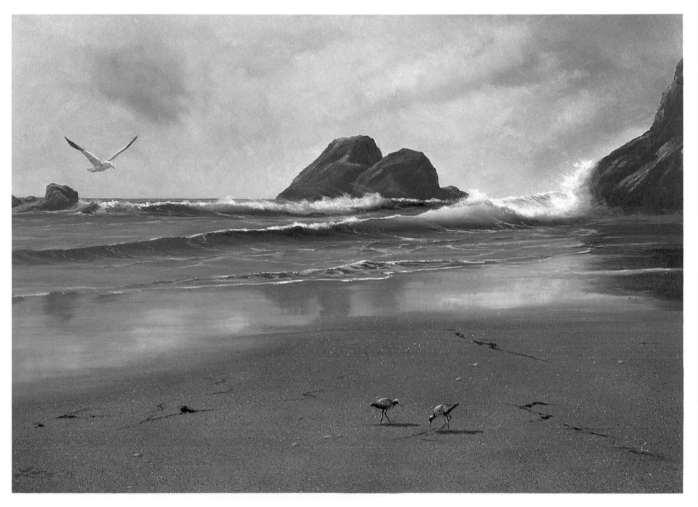

Secret Cove
14″×20″

Secret Cove *was based on the bottom photo on page 78, but modified to make it more dramatic. If you need a magnifying glass to see the waves in your photograph, make the waves larger and bring the ocean closer; you'll save your eyes and get a stronger painting in the process. No wave was present in the reference and the sea was calm, yet the rocks needed a wave to dramatize their strength and immovability, so I borrowed a wave from a sketch of a similar scene I'd kept for just such an occasion.*

Beach-level, symmetrical. In general, current trends in painting do not favor symmetrical compositions. Nevertheless, the symmetrical point of view has earned a rightful place in art—witness da Vinci's masterpiece, *The Last Supper,* for example. The symmetrical approach can be quite powerful, though not without hazard—especially when painting seascape at the beach level. As mentioned earlier, waves and background water can easily form distracting horizontal bands that lead viewers out of a painting. To a degree, this problem can be controlled by placing rocks to stop the eye from exiting at the side or by lowering value contrasts so the eye is not drawn to the edge in the first place.

Beach-level, asymmetrical. This point of view eliminates the difficulties inherent in the previous approach. For reasons that I'm at a loss to explain, however, this view isn't used much. Nonetheless, I like it because it is the best representation of how I see the ocean when I walk on the beach.

Secret Cove (page 77) is a good example of the beach-level, asymmetrical approach. My starting point was the view seen at bottom right, which is what I saw from the beach as I looked to the left of the large monolith. As you can see by comparing the painting with the reference photograph, I made a number of editing changes. For instance, by choosing a long panel for my painting, I reduced the amount of beach I had to deal with. I kept the sky simple to focus on the rocks and what remained of the beach in the foreground. I used only part of the large rock on the right, and eliminated several smaller rocks completely. The beach in the bottom photo seemed rather lackluster, so I got an

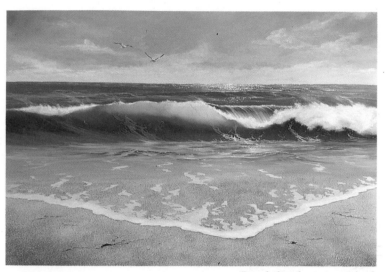

Beach level, symmetrical

Beach level, asymmetrical, looking right

Beach level, asymmetrical, looking left

inspiration from the photo above it, and added sky reflections in the wet sand. Finally, I sketched a wave breaking against the rock on the right and added birds for a little life.

Of course, *Secret Cove* is only one of the possible interpretations that could have been painted from this scene. What is more important is that regardless of the point of view you ultimately select, the fact that you can classify the possible points of view into four groups should in no way limit your options regarding subject, color, or composition. Instead, armed with a clearer understanding of your chosen point of view and of its strengths and weaknesses, you should be able to move ahead with confidence into other, more demanding aspects of creating a painting.

The fun part of painting realistically is that you don't have to paint exactly what you see. In this detail of Secret Cove *you can see that I included a reflection that was more interesting than what was visible in the original. So, with a flick of my brush, I appropriated the better beach you see here.*

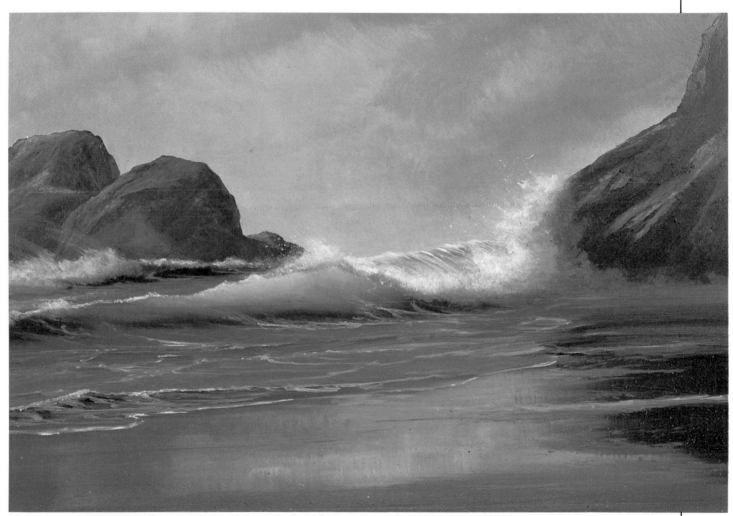

Detail of
Secret Cove

Dramatic Skies

Many seascape artists think of dramatic skies as brooding or stormy. Yet the term *dramatic skies* undoubtedly means something a little different to everyone. For me, the term implies strong contrasts between light and dark values and, generally, well-defined cloud forms. And since I rarely ever paint brooding or stormy seascapes, my dramatic skies take place on sunny days or at sunset.

So, how do you go about painting dramatic skies? I've already mentioned two of the attributes of dramatic skies: strong value contrasts and well-defined cloud forms. Following are a few other pointers:

Perspective/Brushwork. The clouds that are closest to us appear near the top of the panel, which represents the sky overhead. These should be rendered with bolder strokes and should appear larger than more distant clouds. In the middle distance, clouds will be smaller, with softer edges. By the time

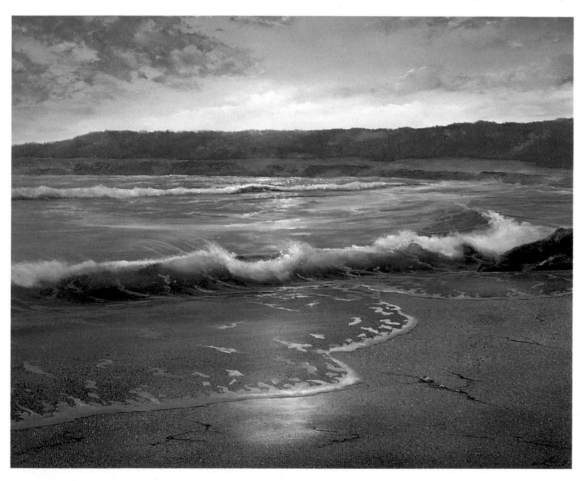

In Carmel Sunset, *strong value contrasts and well defined cloud forms create a dramatic sky. The sky overhead, at the top of the panel, is purer and darker; the sky near the horizon is lighter and less pure. The clouds form subtle diagonals that direct the eye toward the center of the painting.*

Carmel Sunset
16″ × 20″

you reach the horizon line, your strokes should be almost parallel with little definition.

Color. Remember, the sky does not exist in isolation; in nature, the colors of the sky are reflected and infused throughout a scene. Your paintings should follow nature's example to impart a sense of realism and to assure color harmony. Remind yourself, also, that as you move nearer the horizon line (paint more distant objects), your colors should become less pure and lighter in value to convey a feeling of depth. In other words, be sure to include atmospheric perspective in your paintings.

Cumulus or What? It's said that a picture is worth a thousand words. So, unless you're planning to give the weather segment on the local television news, I wouldn't worry too much about having an encyclopedic knowledge of the various cloud types and their subtle nuances. Instead, observe carefully, then bypass the abstract terminology and learn to "speak" directly with your brush.

Composition. Perhaps the least obvious attribute of dramatic skies is their composition. Yet it is precisely because skies (as well as the rest of a painting) are well-composed that they are dramatic. In symmetrical compositions, for example, I like to use the diagonal lines formed by clouds to point toward my center of interest. In asymmetrical compositions, I use clouds and cloud edges to help move the eye along a zig-zag or circular path.

Let's take a look at *Carmel Sunset* (left), to see how I put

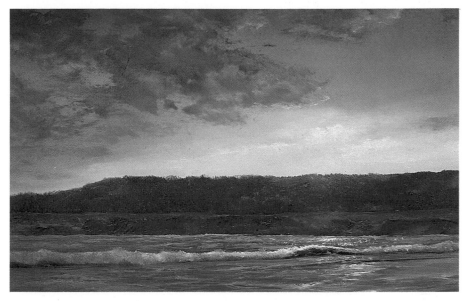

Dramatic skies still require the basics for perspective in clouds—shapes that grow smaller and softer as they near the horizon. The clouds nearest the horizon line should appear rather long and slender, with relatively soft edges. An apparent exception occurs at sunset, when strong back- *lighting can cause edges to appear more defined.*

Keep your colors working together in daylight or sunset scenes by bringing sky colors into the background water as reflected light and by glazing over the background water and headlands with a transparent mixture of the sky color.

some of these principles into practice:

Perspective/Brushwork. Notice that the cloud forms in the upper half of the sky are larger and have stronger contrasts than the more distant cloud forms in the lower half of the sky.

Color. Now, look closely at the waves in the background water. Interspersed throughout are accents of the sunset hues from the clouds. Also, though it's not apparent, I glazed over the headland and background water with a transparent tint of cadmium yellow deep (from the sky) to bring all the colors together.

Cloud Names. The clouds as I have rendered them are typical of many of our California sunsets, though I couldn't

name a one of them in technical terms.

Composition. Notice that the light cloud edges on the left form a loose diagonal line pointing toward the center of the painting. On the right, an even looser series of lights forms another diagonal. If these diagonals aren't immediately obvious, don't worry. They aren't supposed to look as though drawn with a ruler. The effect is rather like playing connect the dots. Notice too that the clouds become smaller and less distinct as they near the unseen horizon.

Now that you know what to look for, why not turn back to *Rolling In* (Chapter 13) and see how many of these characteristics you can find in a daylight scene. Happy hunting!

Creating Dynamic Textures

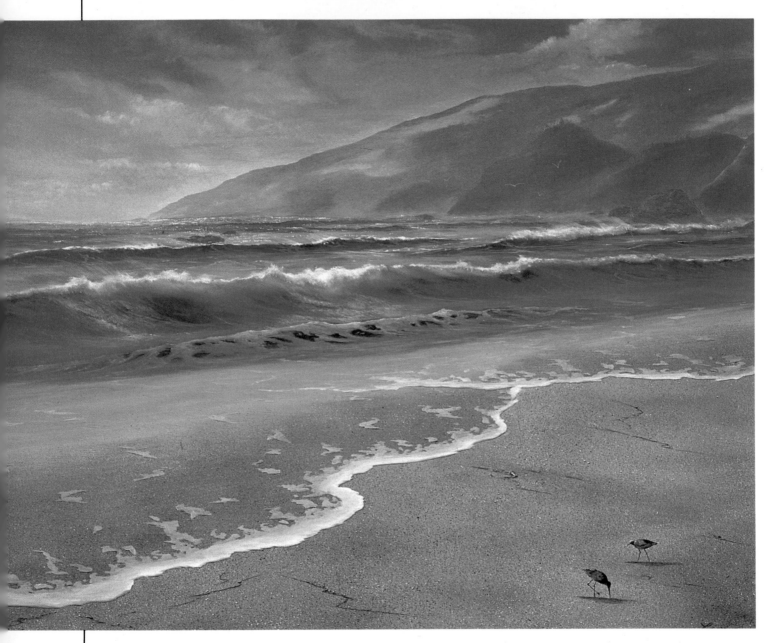

Along the Big Sur
Coast
24″ × 30″

Texture is any change in color, value, or edges which is used to keep a passage from becoming monotonously even. The overall feeling of dynamic texture in a painting is often the result of many less obvious textures. Here, the relatively even tone of the background sky is subtly textured with suggestions of wispy clouds during the block-in while the paint is still wet. The cloud edges to the left are more defined than in other parts of the sky to add interest and keep the sky from being easily comprehended in one sweeping glance. The basic shape of this cloud was established during block-in, but edges were reinforced with white and yellow ochre at a second sitting after the under-painting dried. The clouds to the right are more definite, but still have very soft edges. These clouds were also painted during block-in, but with a slightly heavier application of paint and less blending.

An accomplished and successful artist once advised me to look at my paintings one square inch at a time, as if that one square inch were a tiny canvas all to itself. If that "tiny canvas" won't stand on its own, he said, the painting needs more work. I listened patiently, but felt like the engineer who set out to turn the Everglades into dry farmland: After ten years of hard labor, he had only succeeded in creating a few acres of tillable soil. When asked by a reporter why it had taken so long to do so little, he replied, "Well, son, it's hard to remember that you came to drain the swamp when you're up to your fanny in alligators!"

And so it is with painting. In the eagerness of the early days of my career, I, too, set out to "drain the swamp" by trying to master the fine points of painting before I'd learned the basics. And, like the engineer, I quickly became mired, not in brackish water, but in the complexities of color and composition. In those days, I felt fortunate when I could say that a whole canvas (or a panel, in my case) would stand on its own, let alone worrying about every single square inch.

As I painted more, the basics of color and composition became almost second nature, and I was able to concentrate on the finer points of what makes a good painting good. What my friend had been trying to tell me was not that I had to paint a separate little painting in each square inch, but rather that I should be sure that each square inch was interesting on its own. The way to do that, I learned

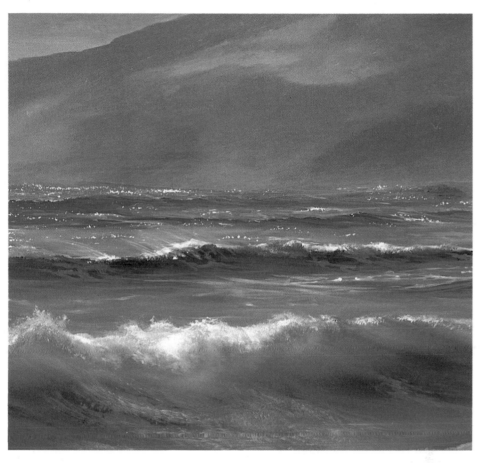

at last, was by making sure that each square inch had an interesting texture. Or, to put it another way, I learned to watch for areas of flat, boring tone, then to break them up with some sort of texture, however subtle.

In *Along the Big Sur Coast* (opposite), for example, I've used many different textures to create an image that is visually complex and interesting. The sky, for instance, contains numerous clouds in different sizes and shapes; some edges are hard, others are soft. And, though the distant headland has little distinct texture, I've made it more interesting by adding flying seagulls and lighter values to suggest dry,

A grayed value of the beach color was used to add light patches to the headland to suggest dry, grass-covered slopes. When the underpainting had dried, the entire headland was glazed with a transparent tint of the sky color.

The main wave is also a place for many textures. Reflections of sunlit foam are dabbed onto the face of the wave with the tip of a bristlette flat brush. Then, with the same brush and more sweeping strokes, reflections of the sky color are also added.

grassy slopes. The background water is subtly textured with reflections of the sky in the troughs and occasional white foam on wave tips. The smooth texture of sunlit water in the major wave contrasts against broken reflections of sky and foam. The beach area is divided by the veil of surf and floating wisps of foam. And the dry sand, a texture in itself, is further textured with strands of kelp and two beachcombing willets.

Elsewhere in the book, you'll find other textures: short and tall grasses, ice plant, shells and shell fragments—to name only a few of the possibilities. In fact, why not take a moment now to look back over the illustrations in the previous chapters and put them to the "square inch test." Then try the same thing with your own paintings, and see if you can think of additional textures to enrich your imagery.

As you begin to work consciously with textures, you'll undoubtedly worry about creating paintings that are too "busy." But as you gain experience, you'll realize that textures don't have to stand out like a plaid shirt at a formal wedding. In fact, a painting can and should contain all degrees of texture, from bold contrasts to barely noticeable changes of color or value. The key to creating dynamic textures lies in realizing that painting realistically means learning to observe and emulate nature—where even the simplest rock or leaf is composed of a variety of colors and textures, each skillfully interwoven and carefully balanced with the whole.

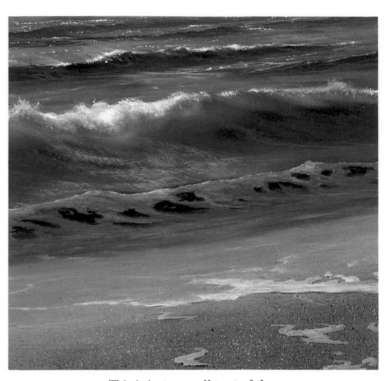

This is just a small part of the whole painting, but notice the variety of textures. Despite the variety, the passage is interwoven with the whole painting and contributes to its visual appeal.

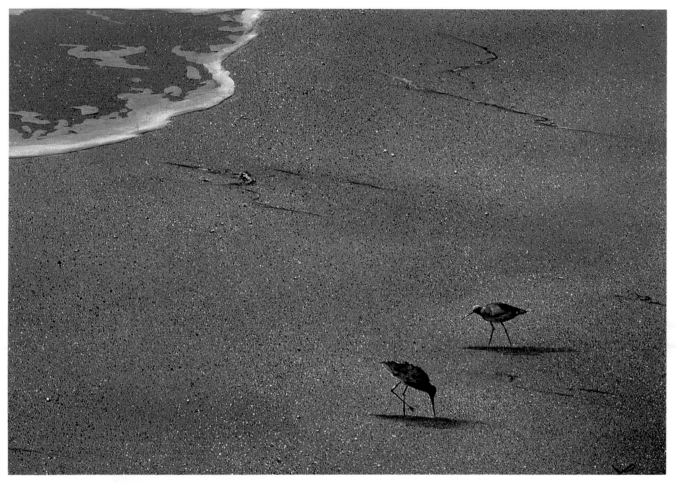

The basic sand texture in this painting was created with speckles, but sometimes one layer of texture or complexity isn't sufficient. Here, even the texture gets a texture: dark striations in the underpainting, along with willets and kelp, work to keep the sand texture from becoming too even and monotonous.

Building Detail and Strong Color

Ironically, the first lessons I had to learn when I began painting were to gray my colors and to avoid an excessive preoccupation with detail. And with good reason. My inexperienced eyes were not yet trained to know when and where to use strong color, nor did I know when, where, or how much detail to include.

Before I could use strong color effectively, I had to learn to look past the obvious color to see its underlying value. And later, in addition to seeing the basic value of a color, I had to learn to tell how pure or how grayed the color was. Only then could I begin to use strong color effectively.

From this sensitivity to values and purity of color, I also learned that detail isn't as much the result of precise draftsmanship as it is of proper relationships between colors and values. Or, to put it another way, I learned that by paying attention to values and color, the details almost take care of themselves.

In *Strollers at Sunrise* (opposite page), for example, I set out to capture a group of willets out for an early morning stroll. During the block-in, I ignored my star subjects entirely and concentrated on establishing strong lighting on the rolling foam by contrasting it against the dark water (Permanent Sap Green and *lots* of gray). The colors of the water in the background and just ahead of the wave are grayed mixtures of Permanent Light Violet and Permanent Light Blue, in keeping with the dim morning lighting. Since those colors are rather monochromatic, I added a reflection of the morning sky using Light Magenta and gray. Next, I blocked in the beach using mixtures of raw sienna and gray.

During the third sitting, I sketched the willets directly onto the panel over the underpainting, then blocked them in as silhouettes using an opaque mixture of burnt umber, ultramarine violet, and gray. Next I developed the basic areas of light and shadow on the birds, using Vivid Red Orange mixed with *lots* of light value gray for the highlights and cerulean blue for the reflected light in the shadows under the birds' necks and stomachs. With these two strong colors, which are near-complements on the color wheel, the willets have a much better feeling of dimension and vibrancy than I could have gotten with more closely related colors.

When I had taken the five willets as far as I could go at that sitting, I allowed the paint

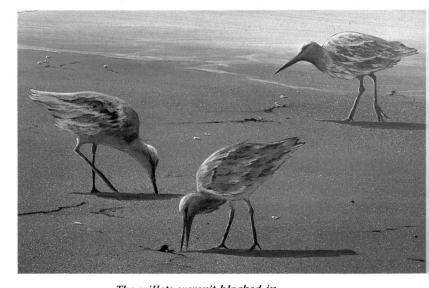

The willets weren't blocked in at the first sitting. Instead, the underpainting was allowed to dry first. Then the birds were blocked in as simple silhouettes with highlights and allowed to dry. Finally, I returned to sharpen the highlights and darken the dark values to give the willets strong color and sharp detail.

to dry, then returned to sharpen highlights and darks with a liner brush (using mixtures of Vivid Red Orange and gray for highlights, and burnt umber, ultramarine violet, and gray for the darks).

While it might seem redundant to return with the same colors used earlier, there is actually a sound reason for the procedure. During the first application, colors inevitably intermix and lose some of their intensity: darks get lighter, highlights get darker, and everything gets a tiny bit "muddy." On the second application, the basic values have already been established, and it is seldom necessary to bring lights and darks into contact again. Hence, colors remain strong and details are sharpened.

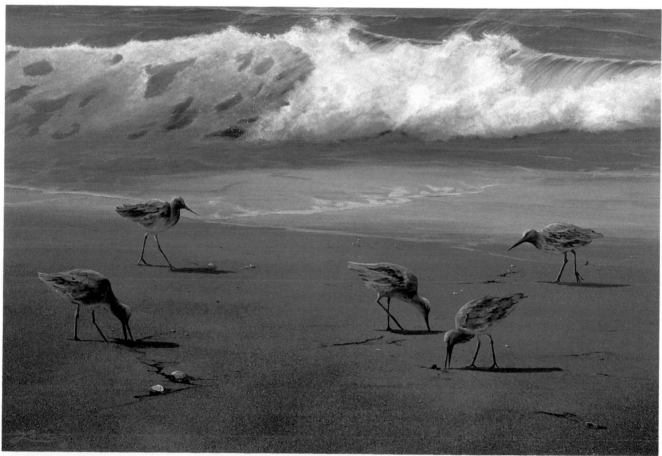

I used white slightly tinted with Permanent Light Violet and magenta for the foam, and grayed mixtures of Permanent Light Violet and Permanent Light Blue for the water. The wave is mostly gray with a dab of Permanent Sap Green.

The dim light of sunrise affords only a limited palette. However, I built strong contrasts between the rolling foam and darker background water, and added a patch of magenta to the water in front of the wave to perk up the colors and suggest reflections of pink from the morning sky.

Strollers at Sunrise
20″ × 30″

Reflected Light

One of the qualities of the sea that tantalizes me most is its ability to reflect light (as if the constant motion of water and swirling foam weren't challenge enough). Who could resist trying to paint the wavering reflection of a seagull on a wet beach? Or the glint of sunlight on a breaker moving powerfully toward shore? Reflections add the finishing touch to a painting, imparting a sense of realism almost more real than the actual scene.

So where are we to begin? Next to the water itself, the sky supplies the most pervasive color in any seascape. Its color is reflected primarily in the troughs between waves and swells, and to a lesser degree in the rocks, birds, and other objects over which it reigns. Once you have selected colors for the water and the sky, block each area in. Use the dark from your water palette to indicate the placement of major and minor waves and swells. Then introduce the middle value from the sky into the troughs. Be sparing if you decide to reflect the sky on the more vertical portions of major waves—instead, use foam patterns to suggest the curve of the moving water.

Though the vertical face of a wave produces few reflections, the gentle, sweeping contours at its base have more to offer. A breaker's magnificent foamy white burst, for example, commands our attention and makes it easy to

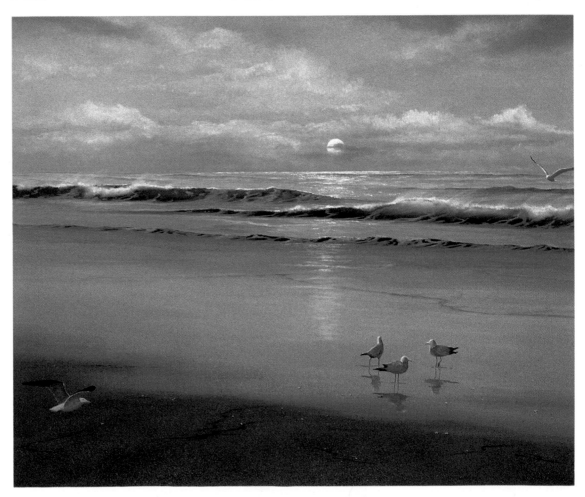

Enchanted Morning
24″ × 30″

In Enchanted Morning, *reflected light creates the color harmony which unifies the composition.*

Sky colors are reflected in the troughs between the waves and on the beach, as if the sky was simply hinged at the horizon line and folded down.

Break the edge of the reflections with soft transitions into dry sand, with shell fragments and kelp, or with darker lines to suggest ripples. Make the beach more interesting by reflecting not only the sky, but seagulls as well.

overlook the less dramatic but equally important reflection lying just below. If the water is relatively still and the day not too windy, the reflection will be well-defined with only small ripples disturbing its surface. If the day is windy and the water choppy, the reflection will be broken into small pieces like a shattered mirror—but it will still be there.

Rocks and headlands frequently reflect in the water also, particularly on beaches still wet from the last wave. The basic form of the reflection will be an upside-down mirror image. Of course, remember to soften the edges and break the reflection with ripples, exposed spits of sand,

pebbles, shells, kelp, and so on. Small touches such as these will add immensely to the sense of realism and sharp focus in your paintings.

Let's take a look at *Enchanted Morning* (opposite) to see how I've incorporated reflected light into a typical scene. First, notice that the sky has three major areas of color. The top portion is mixed from Light Blue Violet, Permanent Light Violet, and gray. The middle area is mixed from Light Magenta and gray, with a little white added in the lightest part. Finally, the fog bank is mixed from Permanent Light Violet and gray.

For the wave color, I used Permanent Sap Green and gray. The color from the mid-

dle of the sky is reflected in the troughs, along with subtle accents from the other two sky tones. Beyond the beach (which is painted using raw sienna and gray), each of the sky colors is reflected on the wet sand in reverse order from the way they appear in the sky. The birds also reflect the colors of the sky in the white of their feathers and in low values in their shadow tones.

Reflected light isn't the first thing you notice in a scene or in a painting, but it is the glue that holds your colors in harmony and adds a vitality that is often the "something" found lacking in otherwise good paintings.

Natural Movement—Creating a Visual Flow

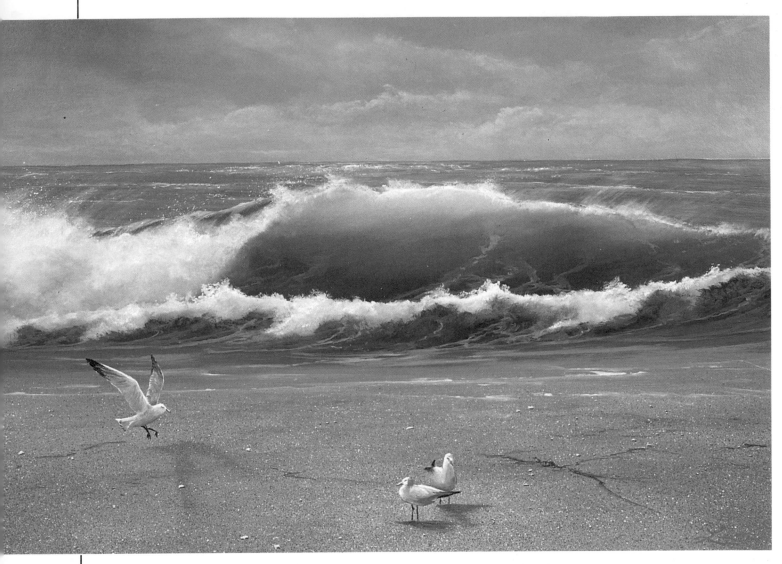

Breakers
12" × 18"

Creating a visual flow simply means helping your viewer's eye know where to go next. By dividing our image into unequal rectangles, we don't leave viewers "on the fence" visually. Right away, they know that the important action will take place in the larger of the two rectangles.

The eye is naturally attracted to a light value when it contrasts strongly with adjacent values. In this painting, seagulls provide dots of light value to guide the eye around the lower half of a circular visual flow. In addition, the upraised wing of the flying gull serves a subtle compositional function by forming a visual bridge between the sand and reflection while at the same time directing the eye upward toward the foam, which forms the upper arc of an almost irresistible visual path.

The subtle clouds (which repeat the form of the foam edge below) form a secondary arc to safely guide the viewer's eye along the visual path in the event the viewer inadvertently misses a compositional turn signal.

Despite what anyone says, composition is far from a science. There are, of course, certain basic principles which apply to most paintings, but ultimately composition has to reflect many choices that can only be attributed to one's own sense of style. The objectives of any compositional scheme, however, are to create a balance among the various elements in a painting and to create a smooth visual flow.

Composition in a painting is much like a musical composition (a song or a symphony, for example)—if one note is played too loudly or too long, it becomes the focus, and listeners are distracted from hearing the melody. So it is with a painting. If a value is too dark or too light, it draws attention; if an element is awkwardly placed, it also draws attention. Just as we develop an "ear" for music that is pleasing, so too we can develop an "eye" for compositions in painting that are pleasing.

Perhaps the most universal rule of composition is to always divide your panel into unequal proportions. A proportion of about one-third sky to two-thirds water and beach is normally quite pleasing (see *Breakers,* left). Using this basic framework, I build a smooth visual flow using values and "pointers." Here's what I mean:

Values. Your eye is naturally drawn to extremely light or dark values, or rather, to areas where contrasts between light and dark are strong. To apply this principle in practice, stand back from your painting and see where your eye is drawn. If your eye is "pulled" somewhere you don't want it to go, then diminish the value contrasts at that point until the visual tension feels the way you want it to.

Once you've eliminated unwanted contrasts, stand back again and see how your eye travels through the image. Normally, the most pleasing path is either an *s* with gentle turns, the more abrupt zigzag, or a circular path. As you look at your painting, one of these should suggest itself. At that point, carefully raise values along the path in a sort of connect-the-dots fashion until your eye moves smoothly through the composition.

In *Breakers,* for example, I've developed a basic circular flow where the eye travels along the light foam at the top of the wave, then around through the seagulls and sand for the return trip.

Pointers. This is my own term for any line that points the way along the compositional path. Pointers can be edges of rocks, the wing of a flying seagull (as in *Breakers*), the angle formed by a cloud bank, or—one of my favorites—kelp lying on the sand. Needless to say, watch for unintentional pointers that detract from your composition by leading your eye astray or out of the painting. By the same token, avoid overly obvious pointers, since these can be more disturbing than none at all.

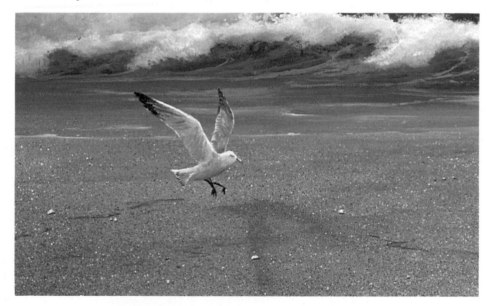

"Pointers" mark the way along the compositional path so the viewer's eye goes where you want it to. Here, the wing of the flying gull and the kelp act as pointers to the rolling foam to move the eye along the visual path.

CHAPTER 36
Incoming Surf

I find every aspect of the ocean fascinating. But if I had to choose a favorite, I'd probably pick the thin sheet of water and lacelike foam that often sweeps across a flat beach just ahead of an incoming wave. The blanket of foam is sometimes so thick it completely obscures the water and sand over which it rides. At other times, only a few widely separated tufts of foam ride on the water, like tiny islands adrift in a miniature ocean. Each new wave creates a new pattern in the swirling foam, and each pattern is as individual as a snowflake or your own fingerprint.

Except for the sand on which I walk, this thin veil of water and foam is the part of the ocean I can examine most closely without getting wet. A good place to begin your own study of the incoming surf, however, is from a high bluff, looking down the length of the coast. This view will give you a sense of the overall contours along the front edge of the surf line. From a high vantage point, you'll see that the front edge undulates down the length of the beach in graceful curves. You can approximate the shape of the front edge by drawing overlapping circles of various sizes in a row (see reference photo and sketch).

When you get down to the beach level, the front edge of the incoming surf will appear to be a nearly straight line most of the time. From an artist's standpoint, such straight lines are not only uninteresting, they're dangerous, because hard straight lines can carry viewers right out of a painting. Fortunately, due to

A quick way to get an approximation of the shape of the surf line is to sketch a series of overlapping ellipses, then draw a line along the resulting front edge.

Barefoot On the Beach
12″ × 16″

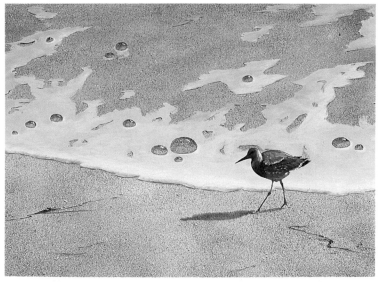

Floating foam can take almost any shape you can imagine, but I prefer to think of it as looking like the tattered edge of a blanket. Surprisingly, the flat surface of the floating foam isn't pure white; it's actually a slightly lower value which reflects the color of the sky *(even when the sky isn't visible as in this painting). Since the sun shines down at an angle, the brightest whites occur only on those surfaces which face directly toward the sun. As the surface of the foam turns away from the sun, it darkens slightly into shadow values.*

92

slight variations in the slope of the beach, the circular pattern seen from above will occasionally be visible. But if that's not reason enough for making the front line more interesting, then simply exaggerate the curvature for dramatic effect (as I did in *Surf Patterns* in Chapter 22).

As you've doubtless noticed in the course of the book thus far, there is no one "right" distance or point of view from which to paint the incoming surf. In *Barefoot On the Beach* (above), for instance, I've again decided to take a close-up look at my favorite subject. In this painting, the foam is somewhere in between the "heavy blanket" and "tiny island" variety. I've seen and heard many different ap-

proaches to painting this foam. Some seascapists recommend circles or ovals, others figure eights.

I like to think of foam as an elastic blanket stretched over the water. A hole forms, then another. As the foam continues to stretch, the "fabric" remaining between the holes stretches thinner and thinner, until it tears. If a piece of foam is torn free from the rest of the blanket, it becomes a small, floating island. Finally, what remains of the foam rides up on the beach, trailing the tatters of the blanket behind. Look at *Barefoot On the Beach* and see if you agree.

What else do you notice about the incoming surf? The sand under the water is a different color because it's wet.

The undulating surf line is clearly visible when viewed from above.

The wet sand is both warmer in color and slightly darker in value than the dry sand just ahead. What else? The foam at the very front edge is brilliant white, the foam just behind is lower in value and reflects the sky even though we don't see the sky in this painting. More? What about the shadow at the base of the front edge? What about the bubbles?

Learn to look at the ocean, to really *look* at it closely, and you'll be surprised at all the wonderful details you'll find. Of course, don't feel compelled to use every detail in every painting; save the best for close-ups such as this.

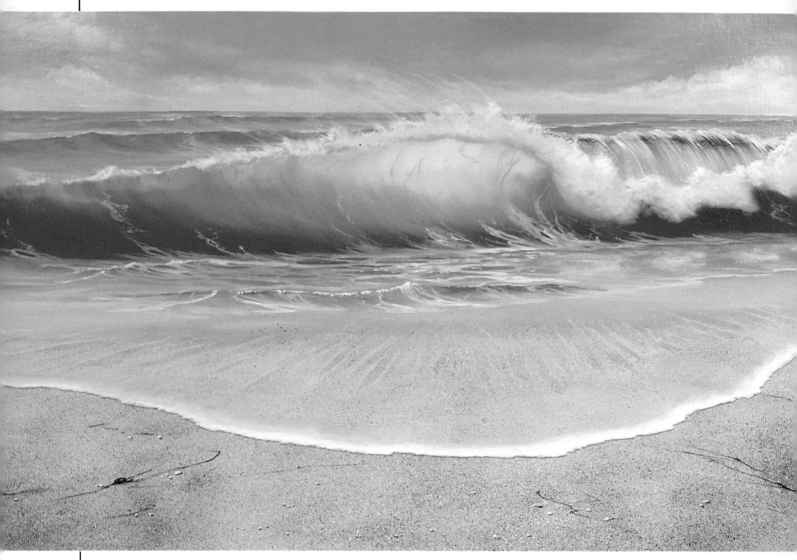

Receding Surf
20″ × 30″

When painting receding surf, I almost always use a symmetrical composition, perhaps because the tiny rivulets of water drain back to sea in a pattern that is reminiscent of the spokes of a wheel.

As the veil of surf drains back toward the wave, water and foam mix with sand, darkening the value of the water and foam slightly. The rivulets of water and foam can be painted directly into the wet underpainting with a liner brush using white tinted with colors from the sky. As the still-wet color of the sand mixes with the sky-tinted white, the effect will be very much like what actually happens in nature.

Like a miniature version of the tide itself, veil after veil of surf races forward onto the beach. And like the tide, each thin sheet of water and foam gradually slows, then pauses. For an instant, the cycle of energetic motion is broken by resolute calm. Then the advancing army of water turns in abrupt retreat. Hundreds of tiny rivulets form briefly, like columns of marching soldiers, before breaking into full disorder as they run pell-mell back to the sea.

During all this advancing and retreating, I am offered many opportunities to choose the moment that, to me, best typifies the surf as it recedes. My favorite is the fraction of a second just after the surf's forward motion has stopped, when the water begins to drain back toward the sea. A moment earlier and the foam still retains the look of incoming surf, a moment later and the foam becomes a jumble of indistinct forms.

Incidentally, I seldom paint wet sand in front of the receding surf, because the water hasn't yet rolled back far enough to reveal any. Also, I nearly always use symmetrical compositions for receding surf; somehow the surf looks more natural that way.

Now let's take a look at an aptly named painting, *Receding Surf* (left), to see what else we can discover. The basic block-in for receding surf is the same as for incoming surf: the wet sand should be deeper in value and warmer in color than the dry sand; the front edge of foam, again, brilliant white. Now for the differences: Since the front edge of water and

foam is moving back toward the sea, it collects all the tatters of foam left behind on the way in. The result is a fairly well-defined edge facing out to sea. This inner edge touches the small rivulets of foam all along its length. The rivulets, in turn, are lower in value than the front edge and reflect the sky colors.

The difference in appearance between incoming and receding surf is one of the many small things most people don't consciously notice at the beach. In fact, many people, on first seeing a painting of mine that includes receding surf, have said, "It doesn't do that"—only to return later and admit that they have since seen that moment in nature.

But if receding surf has a problem as a subject, it is simply that the similarities overwhelm the differences. In other words, though the variations in sky, waves, foam, and sand are practically endless,

the human mind is geared toward locating common elements and so tends to focus on a generalized image of the receding surf, ignoring many smaller but equally important dissimilarities.

Apparently, close inspection of differences is reserved only for those things with which we are most familiar—the human face, for example. If we looked at faces the way we often look at the ocean, we'd likely say that all faces are the same because each has two eyes, two ears, a nose, and a mouth.

Yet it is only by looking past the obvious similarities that we learn the true nature (identity) of a face. The color of the eyes, the hair, the arch of the eyebrows, the tilt of the chin, a mole on the cheek— these small differences make each face in the world unique. And so, too, each wave and sweep of receding surf has its own identity.

I seldom paint wet sand in front of the receding surf because the water hasn't yet rolled back far enough to reveal any.

95

Experimenting with Subtle Color in Skies

As an artist dedicated to painting realistically, I used to think daylight skies could only be blue with white clouds. That, of course, was a comfortable assumption which, in the beginning, seemed to make painting much simpler. In retrospect, I realize that my basic blue/white palette was extremely limiting. Nevertheless, it provided solid training in using values to establish good lighting and build definition in clouds, so the experience was hardly wasted.

As I painted more, I noticed that other artists appeared to use almost any color they found on their palette to paint skies. Many of the resulting effects were quite pleasing, but the images they produced weren't realistic, by my standards. Still, I found those other colors increasingly tempting—in fact, almost irresistible.

Yet, before I could allow myself to succumb to the obvious charms of those other colors, I had to learn how to include them in skies without losing the sense of realism I'd worked so hard for in all other aspects of my paintings. The key here, as I mentioned in an earlier chapter, is knowing how far you can "push" your colors without overstepping the limits of believability. And those "limits" are learned only with time and experimentation.

Sunsets, of course, allow much wider latitude in choosing colors. Even so, it's easy to push beyond the limits of realism. At the risk of unnecessarily restricting your color options, I recommend that you rely solely on your own direct observations of color in the sky or rely on your own photographs. If you use another artist's painting as a guide, you surrender your own color sense to someone else's—and who knows whether they share your conception of realism? Be especially careful of photographs from postcards and magazines: processing tricks and colored filters often produce calendarish colors that seem even more artificial when used in a painting.

Now that I've warned you of the dangers of using someone else's photographs, let me share one of mine with you. This shot was taken just about at sunrise in Key West, Florida—and you have my assurance that no trick filters were used. To render this sky, I'd paint the background using a little Vivid Red Orange and lots of white near the top of the panel (you may need to gray it slightly). In the middle, above the clouds, the color appears to be cadmium yellow deep with white and possibly some gray. Toward the horizon, the color goes to Light Magenta plus gray.

For the clouds, I'd use Light Magenta on the warm side and Permanent Light Violet or Brilliant Purple for the shadow sides. The deepest shadows might also include Light Blue Violet. In any event, I'd add lots of gray to keep the colors subtle and white, if necessary, to raise the basic value. The sunlit accents on the cloud tops in the upper right would probably be cadmium yellow deep plus white. For other accents, I'd use Light Magenta plus white.

Without actually painting this sky, of course, I can't guarantee that my color suggestions are absolutely correct—but if I could, I'd be depriving you of the chance to learn through experimentation, wouldn't I? One final tip: if your colors seem too bold, you're probably not graying them enough.

Key West, Florida

Begin by blocking in a simple, graded background sky. The color at the top appears to be white tinted with Vivid Red Orange and gray (to calm the orange down!). Near the horizon, the color warms slightly, so try a mixture of white tinted with cadmium yellow deep and gray. Use your Skyscraper brush to grade this color into the one above with x or figure eight strokes.

Experiment a little when painting the horizon. I'd start with Light Magenta, white, and gray. If that seemed too cool, I'd add a little Vivid Red Orange and possibly a dab of cadmium yellow deep, but the predominant color should still be light magenta. When you're satisfied with the color, use the Skyscraper as before to grade this color into the one above, then blend lightly with a synthetic sable fan brush.

Establish the lighted side of the clouds with light magenta and gray, again using the Skyscraper brush. Accent the glowing edges with mixtures of cadmium yellow deep and white. Grayed mixtures of Light Blue Violet and Brilliant Purple should work well for the deep, luminous, cloud shadow areas. Blend the entire sky area lightly with a synthetic sable fan brush if desired, but be careful not to sacrifice the definition of cloud edges.

You'll want to make up your own foreground waves or borrow a wave from another sketch or reference photograph. When you do, be sure to reflect all the colors from the sky in the troughs between waves and in any wet, reflecting sand on the beach.

97

SHARP FOCUS PAINTING
PROJECTS

IV

This section contains sixteen chapters, each of which includes one or more reference photographs of actual scenes. You'll find that these photographs are much like the scenes I used as the basis for the paintings pictured in the book thus far. To gain the most from this section, I suggest that you treat each chapter as a painting project. Then, from the reference photographs I've provided, create your own paintings incorporating the material we've covered in the previous sections.

In each chapter, I've suggested what I think are appropriate techniques or palettes, or both, for dealing with the painting problems posed by each scene. In a number of chapters, I've also included an actual painting—my own version of that type of scene to give you an idea of at least one way the scene could be interpreted.

Don't feel that you have to do it my way, however. The purpose of this book is to arm you with the techniques necessary for painting the sea in sharp focus, as well as with an understanding of the "why" and "when" for each. With that knowledge combined with your own creativity, your only limits are your own desire and imagination.

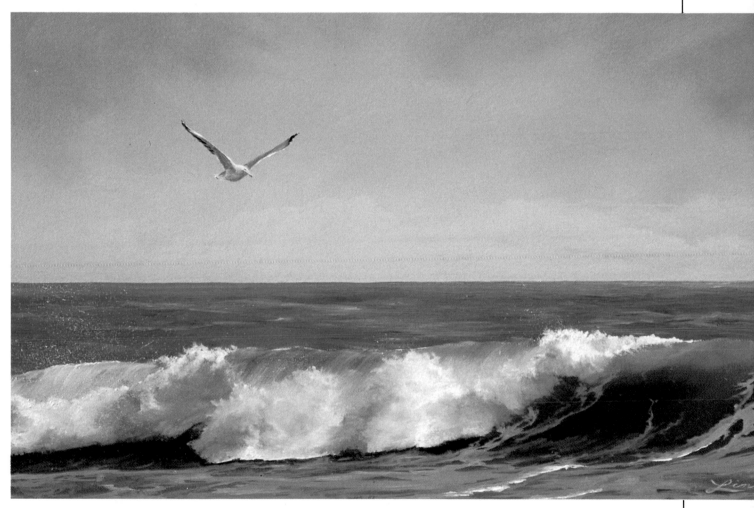

Moment of
Reflection
9" × 14"

Editing a Scene for Added Impact

Nature rarely presents us with a scene perfect for painting "as is." And it's probably just as well, for without the element of artistic judgment required to edit and compose a painting, little would remain to distinguish realist painters from photographers.

Photographers must largely accept what is—subject only to their own cleverness in choosing the best angles and to their own physical strength in being able to move what displeases them (beer cans, tree limbs, small rocks, and the like). As artists, however, we need only possess the strength to lift a two-ounce brush to move entire mountains. Of course, we also need to know where to move them or, in fact, whether to keep them at all.

In my experience, large mountains are less often the problem than boring skies or smaller boulders that block my visual path. Since the sky is the first area I paint, it is also the first to be "edited." Usually, this simply means that I import clouds to add interest, because the sky I painted from was a barren expanse of dull blue. And, while I'm at it, I normally dispense with dull blues and replace them with stronger colors to increase contrasts and add vitality to the sky.

When it comes time to deal with small boulders, I plot my visual path and dispose of any rocks that block the route. Next, I check to see if any of the remaining rock groupings can be combined into larger, more easily comprehended rock masses. Finally, I nearly always strengthen the effects of atmospheric perspective. In other words, I make certain that more distant objects (headlands and background water, for example) contain blue from the sky.

Let's take a look at a photograph from Montana De Oro State Park near Morro Bay, California, to see how I'd put my principles into practice. First, the sky. The colors are rather lackluster, so I'd go stronger, using cobalt blue as my basic color. I'd darken the value at both upper corners and grade my color to a lighter value above the horizon line. Then, I'd introduce wispy clouds sloping diagonally from the upper left down toward the right.

Next, I'd eliminate the low rocks in the middle and replace them with a nice, interesting wave. The basic colors of the headland are fine, but I'd mix just a little of the sky tint into them, or glaze over them afterward to build a stronger sense of depth. The beach has many interesting textures and patterns as is, so I'd use it fairly literally, though I'd probably add some kelp strands to direct the eye toward the center of the painting. Finally, I think I'd add a few seagulls just to give the image a bit of life.

My editing principle is this: the key to a successful seascape lies in simplifying an image so that it is easily comprehended and building enough complexity into what remains so that the result has the look of reality.

A: *This even-toned sky is boring! Substitute more lively mixtures of cobalt blue (slightly grayed). Use darker mixtures in the upper right and left corners, then grade to a lighter value just above the horizon line to establish a greater sense of depth. Add soft clouds angling down from left to right to add interest and to balance the opposing slope of the headland.*

B: *These rocks obstruct the visual path. Get rid of them and import an interesting wave from another scene.*

D: *In the headlands, the colors and forms are quite interesting, but would be more effective in conveying depth if glazed with a transparent mixture of the sky color from just above the horizon.*

Montana de Oro,
Morro Bay

C: *The beach looks good as is, but could be improved by adding kelp trails that point toward the center of the painting. In addition, seagulls would add a nice spot of color and could be placed compositionally to guide the eye across the beach in a connect-the-dots fashion.*

Creating Depth with Sea Oats and Grasses

Whenever I recall a visit to a new beach, my fondest memories are of the moment when I caught my first glimpse of rolling waves framed by tall grasses or leaning stalks of sea oats. And even though I'm no longer at the beach, the sight of sea oats and grasses in a painting brings back other memories: the sound of wind brushing through grasses, the crunch of sand and dried stems beneath my feet, the smell of salt air. After visiting many beaches over the years, I've come to associate sea oats and grasses not only with what I've seen, but also with the excitement of discovery and with a host of related sensory impressions—impressions of things I've heard and smelled and felt with my hands.

I suspect other beach lovers have a similar reaction. Knowing this, I try to paint not only with my brushes, but also with an understanding of what sensory or emotional responses my imagery is likely to evoke in viewers. Too often, we think of depth in a painting as extending from somewhere out in front of us to the most distant point on the horizon. In doing so, we leave our viewers on the outside of our paintings looking in. How much better to literally catch our viewers up in the middle of the scene, to put them among the grasses and sea oats as if all they needed to do was reach out, and they would surely feel the blades of grass.

By capturing this sense of immediacy, a painting becomes a vital, living thing. But how can we create that sense of depth and immediacy? Let's take a look at a couple of photographs for some clues. The first photograph is from the dunes around Gulf Shores, Alabama. The second

Gulf Shores, Alabama

This photograph would make an attractive painting with little modification. The large stalks of sea oats bring the viewer right into the painting, creating that all-important sense of immediacy. Use yellow ochre and white for sunlit areas of the dune. Try grayed mixtures of Permanent Sap Green and raw sienna for grasses.

The shadows lead the viewer "into" the painting from the lower left, adding a three-dimensional effect when rendered with sharp focus techniques. Try ultramarine violet for shadows. And don't forget textures: sand, of course, but also pebbles (with shadows), and possibly even wind-softened footprints.

is from South Padre Island, Texas. You could find similar scenes in many places along the Gulf Coast, the East Coast, and parts of the California and

Oregon coasts. The point, however, is not where you find them, but how you look at them.

Which photograph makes you feel more a part of the scene? Obviously, the grasses and sea oats are closer to us in the view from Gulf Shores. We see the shadows of the grasses and stalks; we're very aware of the textures of the sand and dried stems. In the view from South Padre Island, we're kept at a distance. We know that we're seeing grasses and sea oats, but we're left to fill in too many details. It lacks immediacy.

Imagine for a moment now what would happen if we combined the two images, placing the view fom Gulf Shores on the right side of the South Padre Island view. Now we'd have a strong sense of depth and texture in the foreground as well as cues to depth in the middle and far distance. Finally, for a finishing touch, we might also want to define a small wave to build additional detail and interest in the middle distance.

When you walk the beaches or bluffs overlooking the ocean, try not to be so overwhelmed by the panorama that you forget to see what is at your feet; humble grasses, even weeds have a surprising capacity for bringing the immensity and power of the ocean back to human scale. Remember, the key to creating a strong sense of depth lies in making your viewers feel *a part of* rather than *apart from* your paintings.

South Padre Island, Texas

The distant water and dunes angling in from the left and right create a good feeling of depth, but this photograph lacks the immediacy of the scene from Gulf Shores, Alabama.

The grasses and sea oats are an excellent depth cue, but there's nothing between the viewer and the grasses to make the viewer feel a part of the image. *Make the colors of these grasses "atmospheric" by adding sky colors to your grass mixtures, and import the closer grasses and shadows from Gulf Shores (from previous illustration) to the lower right-hand corner of this scene. The resulting image would be stronger than either one separately.*

Mastering the Challenge of Open Ocean

The open ocean is surely one of the most challenging subjects for an artist painting the sea in sharp focus. The raw power of storm-fed waves breaking over craggy rocks seems to cry out for a painting knife and bold, emotion-filled strokes. Yet, although such an energetic approach will probably capture a sense of the ocean's potentially destructive fury, it will almost certainly do so at the expense of a realistic image.

For the sharp focus painter, the challenge of open ocean lies in finding a balance between dispassionate attention to detail and the urgent, emotional appeal of the subject. Here, in deep water, is the place to ply all the techniques learned in earlier chapters, especially those concerned with developing the illusion of motion. Here, too, is the place to carefully control values, the place to use strong contrasts to convey the power and dra-

ma of this subject.

Let's take a look at *Big Sur Action* and at a photograph of the area I painted from, to see how I dealt with the challenge it presented. No doubt, though you can see a "family" resemblance between the photograph and the painting you can also see many differences. The photograph is certainly a fair representation of reality, yet it lacks the feeling of power that I've captured in the painting.

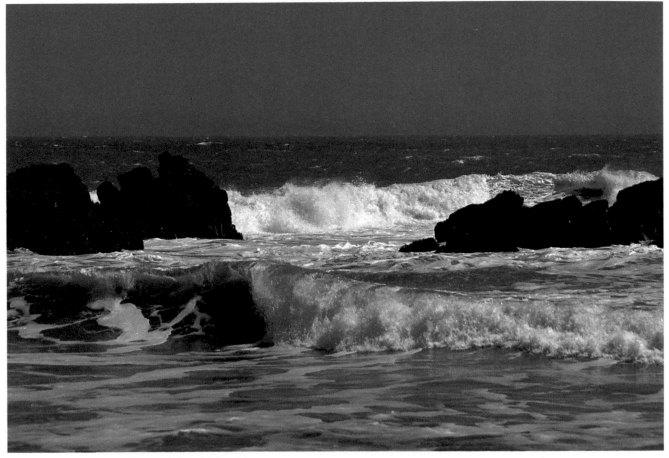

Moonstone Beach, Cambria, California

By comparing the reference photograph with the completed painting, Big Sur Action, *you can see the changes made to capture the power of natural forces. The overall color has become bluer and colder, the amount of background water was reduced, the main wave enlarged, and the size of the rocks adjusted.*

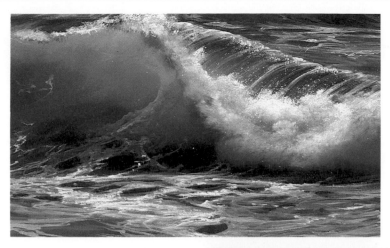

In this detail of the main wave, you can see how the pattern of foam establishes an inviting visual path into the painting. I used the lightest values where I wanted the viewer's eye to go, while I kept other foam values subordinate.

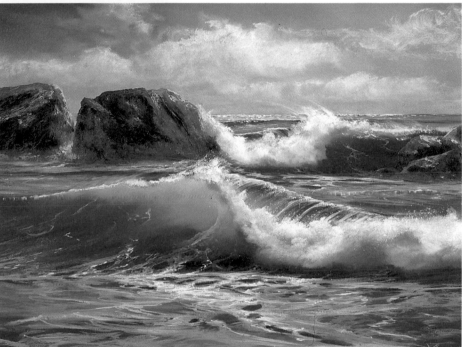

Big Sur Action
12″ × 16″

What did I change and why? First, I went to a completely different palette, one based on cerulean blues, because I think of deep water as cold, and blue expresses that quality better than the warmer green of the photograph. Second, I've lowered my point of view nearer to water level, thus reducing the amount of uninteresting background water. At the same time, I have also made the foreground wave larger, made the background wave smaller, and refined the shapes of both waves to better express the power of the ocean.

In keeping with the feeling of action in this painting, I've added clouds whose shapes continue the rhythm of the ocean below and suggest cool ocean breezes. I've made the rocks on the right larger, to better contrast their strength and solidity against the relentless action of the waves. In addition, the larger rock mass serves a subtle, compositional duty, as well, by breaking the horizon line.

Notice also that the horizon line is broken by the crest of the rear wave—together, the rocks and wave crest minimize the separation of sky and sea. As a result, the eye moves easily through the painting. At a deeper level, the unity of sky and sea aptly expresses the action of natural forces working in concert.

A few more changes between the photograph and the painting are worth noting. To create a better sense of depth, the rocks and background water were glazed, using a tint of the sky color from just above the horizon. Also, in the shadow areas of the rocks, I've included strokes of the sky color to ensure color harmony and liven up otherwise dull colors. Last but not least, I've spent quite a bit of time on the foreground foam, first making sure the movement led the eye in a gently zigzagging movement toward the major wave, and second, by reinforcing that path with some of the lightest values in the painting.

Every deep water scene presents its own set of compositional and artistic problems, but this example should give you an idea of where and how to begin mastering the challenge of open ocean.

Combining Images

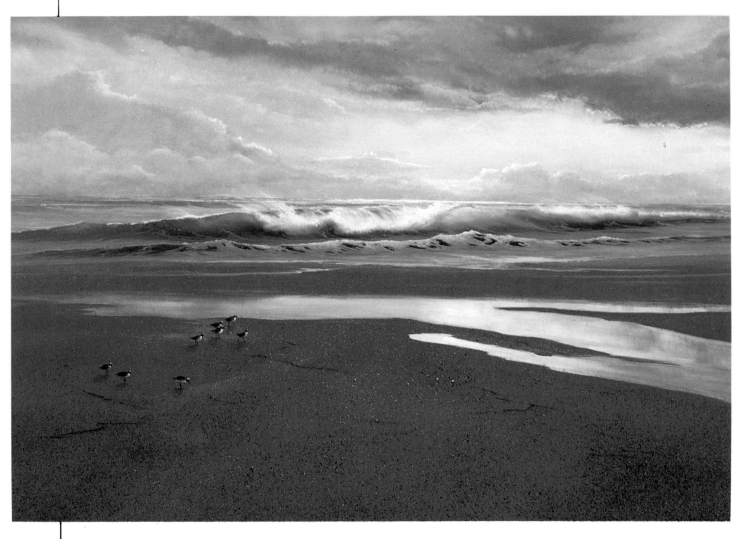

North Coast Sunset
16″ × 24″

The ocean is immensely beautiful, but I've seldom seen a time when everything was "arranged" to my satisfaction for a painting. If the waves are perfectly formed, for instance, then the sky is inevitably overcast. If the sky is blue and filled with exquisite clouds, then the sea is calm. If a rock face or headland is dramatically lit, then the sea is too turbulent for the mood I want to create. The solution, of course, is to collect the "best" bits and pieces in a sketchbook or with your camera un-

til you can combine several to create the painting you see in your mind.

This solution, however, brings a few problems of its own, chiefly those concerned with color and lighting. Typically, when you work with references collected over several days, each day's sketches or photographs will offer a different palette. If you try to use them all in one painting, you'll have "mud" or clashing colors. So choose one palette before you start, then stick with it.

The final picture is a combination of elements taken from many different sources. Consistent lighting and harmonious colors unify the image.

The other problem is lighting from different angles or at different times of the day. Once again, the solution is to pick one type of lighting and then adjust the rest of your reference as you paint.

North Coast Sunset (above) is a good example of combining different ele-

ments into a unified image. Here, lighting is less of a problem than in a daylight scene, because what few shadows are visible are cast forward, toward the viewer. The basic framework for this painting was suggested by a scene of puddles reflecting on a beach (Illustration 1). I planned to modify that scene with the colors from another sunset sky (Illustration 2).

I still felt the image needed more action, so I selected an interesting wave (Illustration 3) to use as a basic guide for that part of the painting. Once again, however, the image seemed to need more, so I selected another piece of reference (Illustration 4) to use as a guide for a foam covered wavelet ahead of the main wave. Finally, to add life to the image, I found a photograph of a flock of sandpipers (Illustration 5), which I could use as a guide to proper color, form, and postures for these tiny beachcombers.

As you can see, the color and form of my sky are only loosely based on the reference photographs. I decided to work with Light Blue Violet and gray for the most distant sky (seen through the clouds), and various mixtures of Light and Medium Magenta, cadmium orange, and gray for the cloud forms. Highlights along cloud edges were mixed from light magenta, cadmium orange, cadmium yellow deep, and a light value gray.

Since no wave was present in the basic scene, I had to invent sunset colors for my wave. In this case, I chose Permanent Sap Green plus gray for the darker portion of the

Illustration 1:

This photograph was the inspiration for the painting, but the image was a little too tranquil and lacking in specific detail to make a good painting.

Nevertheless, I liked the general movement of the clouds in the sky and of the reflective puddles on the beach.

Illustration 2:

I used this photograph of an actual sunset as a general guide for the colors in North Coast Sunset, *although I wasn't particularly concerned that I replicate the colors exactly. The background sky looked like a pale mixture of Light Blue Violet and gray. The darks of the clouds seemed to be mixtures of*

Medium Magenta and gray, while the lighter portions appeared to contain cadmium yellow deep. In the painting, I added brilliant light values just above the horizon line mixed from Light Magenta, cadmium orange, cadmium yellow deep, and a light-value gray.

wave, and Bright Aqua Green and white for the illuminated portion. For the foam, I chose white tinted with the deeper colors from the clouds. Next, I painted the reflective puddles on the beach using colors from the sky, altering the shapes of the puddles in the process for more interest. Finally, I created a mixture for the sand from three colors: raw sienna, the darker color from the clouds, and gray.

The sand in the reference photograph (Illustration 1), by the way, appears darker than it really was because photographic film doesn't have the same sensitivity to light as the human eye. Consequently, you must compensate for the film's deficiency by making your own sand lighter, as I have done in my painting.

When I'd taken this underpainting as far as I could, I allowed it to dry, then returned to texture the sand and wipe stray spatters out of the reflecting puddles. Then, after that texture dried, I returned to indicate the shapes of the sandpipers using only a dark value and a highlight from the sky colors.

You may be tempted to think of this as a recipe for a painting. Actually, it is more like a jigsaw puzzle, where each component must have the proper color and shape to create a recognizable and balanced image. Furthermore, it's important to realize that while each piece of reference provides a valuable guideline for some element of the painting, no amount of reference can substitute for artistic judgment and experimentation.

Illustration 3:

What the first photograph obviously lacked was a major wave as a focal point, so I used this daylight wave as a general guide for the shape of the wave in my sunset painting. I had no color reference for a wave at sunset but, from experience, I chose a grayed mixture of Permanent Sap Green for the base of the wave and a second mixture of Bright Aqua Green for the upper portion.

Illustration 4:

Somehow, the wave I had just chosen looked isolated, so I decided to add a smaller wavelet in the foreground ahead of it. For that purpose, I picked this photograph so I could refer to the foam-covered wavelet in the foreground.

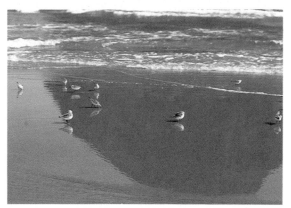

Illustration 5:

By now, the image was nearly complete. But I always like a bit of life in my paintings, so I pulled out this photograph of sandpipers as a guide to their coloration and poses. Of course, I had to decide how they would look at sunset. In the end, I used a dark mixture of burnt umber and gray to block them in, and the light color from the sky to highlight them.

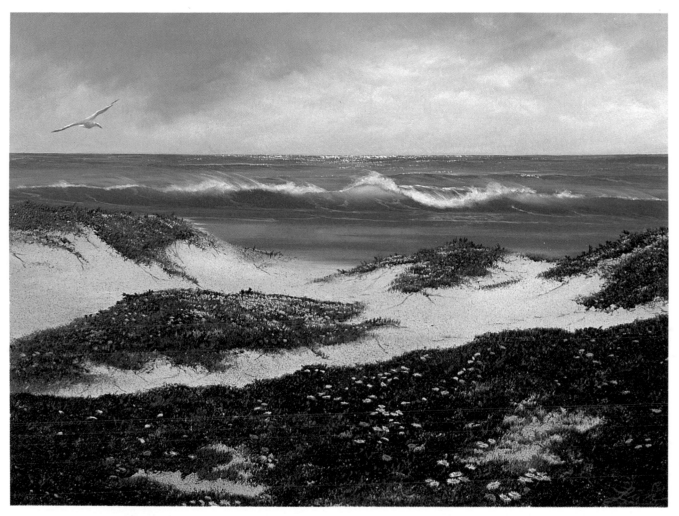

Springtime at
Big Sur
12″ × 16″

CHAPTER 43
Limiting and Simplifying a Subject

In Chapter 28 we looked at one example of how to limit and simplify a complex subject. In that chapter, I showed you the completed painting *Rocky Shore* and a reference photograph of the area from which I painted it. In this chapter, I'll show you two more reference photographs and give you several suggestions about how you could use them as the basis for paintings of your own.

Both photographs are from Moonstone Beach near Cambria, California (in case you're ever in the vicinity and would like to paint on location!), and both photographs were taken from essentially the same vantage point: standing on the beach. In the first, I looked fairly directly out to sea; in the second, I looked down the beach at an angle. Neither photograph would make a good painting as is, but both

have the potential to become very strong subjects.

Since the first photograph has no visible beach, that's one of the first changes I'd make—I like to show sand as a reference point for my viewer—but you could as easily leave the water in the foreground more or less the way it appears, if you prefer. The basic proportion of sky area to water is fine; the resulting rectangles (sky area versus

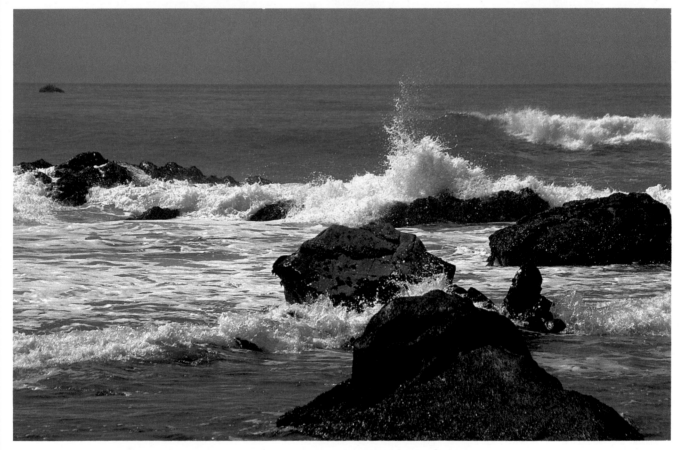

Moonstone Beach, Cambria, California

This photograph could serve as the basis for a successful painting with a few modifications. The sky is too bland. I'd deepen the value overall, and darken the sky color in the upper corners. The rock in the center would be *eliminated and the rock in the foreground would be moved to the left to act as a stop rock. I like beaches, so I'd replace the uninteresting stretch of foreground water with a nice sandy beach.*

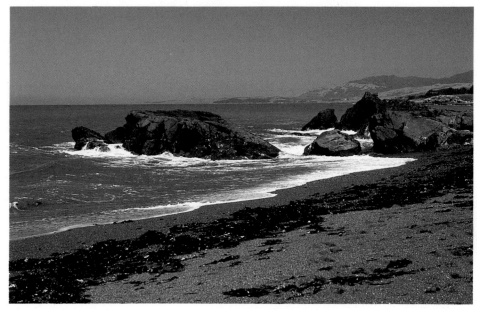

Moonstone Beach,
Cambria, California

This photograph also illustrates the process of "editing" reality to produce an effective painting. The diagonal of the beach pulls the eye into the composition, but I would reduce or eliminate the rock in the center and add a wave as a more dynamic focal point.

water area) are unequal and therefore interesting. I would certainly make the sky deeper in value along the top and at the corners, then grade it to a lighter value at the horizon line. A few feathery clouds would be a nice touch.

The rocks are a jumble, so I'd get rid of the rock that now dominates the center of the photograph, and I'd move the large foreground rock to the left side to use as a "stop rock." The background wave is very attractive as is, but I'd make it smaller. At the same time, I'd define the shape of the foreground wave and give it less foam. Overall, I'd simplify the foam patterns and let more of the water show through. You could also add birds for interest, as they are frequent visitors to the area.

Now for the second photograph. In this example, we have a nice, diagonal composition shaping up, with fog-shrouded headlands in the distance. We even have a beach! Alas, the beach is clut-

tered with kelp and other debris. So I'd forget the kelp in the photograph, and instead, use a few kelp strands of my own design to point toward the center of the painting. As in the first photograph, I'd make the sky deeper in value and graded, and add subtle clouds angling slightly down from left to right.

I'd eliminate the large rock in the middle altogether, or at least make it smaller, possibly with some water or foam run-off. The scene is a little too tranquil, so I'd define one wave as the focal point, taking care to make it smaller on the right than on the left to show the effects of perspective. The water's edge is interesting as is, though I might use somewhat less surface foam. Finally, I'd pay close attention to the atmospheric colors of the distant headland, and also put an atmospheric glaze over the rocks in the middle distance (at the right side of the photograph) to heighten the sense of depth.

Capturing Reflections on Wet Sand

The ocean always reflects light and color to some degree, but when a thin layer of water rests briefly on a sandy beach, the surface becomes an almost perfect mirror. If a sunset is beautiful, then seeing it softly reflected on wet sand makes it doubly beautiful. Yet capturing reflections realistically can present problems, because many factors such as the angle of the sun, the depth of the layer of water, and even the slope of the beach can affect the appearance of the reflections.

Let's take a look at two photographs that demonstrate many of these variables. The first is from Myrtle Beach, South Carolina, the second is from Gulf Shores, Alabama. The shot from Myrtle Beach was taken with the sun at my back. As a result, the colors are softer. The shot from Gulf Shores was taken looking directly toward the sun. The colors are purer, with a rosier tint, and of course, the sun ball and its reflection are visible on the wet sand.

Though it may not be apparent from the two photographs, the sand at Myrtle Beach is nearly flat, while the sand at Gulf Shores rises nearly a foot only a short distance from the water's edge before leveling out. On the steeper beach, the edge is quite defined; on the flat beach, the transition between wet reflections and dry sand is gradual. The transition area on the flat beach also illustrates the effect of slight variations in the depth of the reflecting layer of water. In the immediate foreground, only larger pebbles

Myrtle Beach,
South Carolina

In this scene from the East Coast, the sun was setting at my back. Notice that both the colors and their reflections are quite soft. Because this beach is nearly flat, water doesn't remain behind as puddles, yet the beach remains moist and reflective for some time after a wave has receded. Notice also that the colors of the sky are repeated, albeit upside-down, on the beach. When you paint a beach such as this, make soft, gradual transitions between the colors of sand and sky reflections, then carry your sand speckling slightly into the latter to capture the appearance of moist reflecting sand.

Gulf Shores,
Alabama

This scene is from the Gulf Coast, which faces generally west. As a result, the sun sets over the water, and both the sun ball and its reflections on the water and wet sand are visible. When you paint a scene such as this, make your colors somewhat purer than you would in this illustration. Although this beach appears flat, in reality it rises near the water's edge, then levels out again. As a result, the water lingers momentarily on the relatively flat beach, mirroring brilliant reflections of the sun.

show through. Near the dry beach, granules of sand begin to give the reflection a speckled appearance.

Notice also the relationship between the colors of the sky and their reflections. Basically, except where disturbed by waves or an agitated surface, the wet sand reflects a mirror (upside-down) image of the sky colors. You can feel fairly safe blocking in reflections using the same colors you used for the sky. In fact, if you find it easier, you can even turn the panel itself upside-down if necessary to create a proper mirror-image reflection.

When you've blocked in the reflected colors, block in the sand. If you want to suggest a steeper beach, let the reflected edge remain definite, but do blend it softly so it doesn't look "stuck on." If you want to suggest a flatter beach, *or a thinner layer of water,* blend the sand colors gradually into the reflection colors over an inch or two, depending on the size of your panel. Then, when you speckle the sand texture, carry it lightly into the transition area as well.

The final photograph, from La Jolla, California, shows wet sand reflections in a daylight scene. In this example, the reflection isn't quite as strong because the water layer is thin. The sky color is reflected, but its color is diluted by the color of wet sand caught up in the water gliding back to sea. This, of course, is not always the case. On another beach, less steep, perhaps with a slightly deeper layer of water, the reflections would be as crisp and perfect as nature allows.

La Jolla Cove, La Jolla, California

Many factors affect the nature of the wet sand reflections: the slope of the beach, position of the sun, time of day, and turbulence of the water, for example. In this daylight scene from the Pacific coast, the beach is steep and the water soaks in more quickly. The resultant reflections are somewhat duller— a mixture of sand color and sky reflections all at once. To get this effect, simply add paint from your sky mixtures directly into the wet sand underpainting until you hit the proper balance of color.

CHAPTER 45
Making Rocks the Star

In previous chapters we've talked about rocks chiefly in terms of moving the ornery things out of our way, since they seem to be inevitably in the wrong place. In Chapter 43 for instance, both photographs had large rocks squatting almost squarely in the center. In this chapter, however, we'll take the opposite tack and see how we can capitalize on the unique attributes of rocks. We might liken them to human traits: rocks are steadfast and patient. The ocean, in contrast, is fluid and ever in motion. These traits of rocks and water, though opposite, reinforce each other and make each other more credible. These, then, are the qualities we'd like to capture when we paint our "portrait" of rocks and water.

Needless to say, if you are going to paint someone's portrait, it's helpful to see them firsthand—even if your subject is a rock. Some of the best places to look for dramatic rocks are in northern California, Oregon, Washington state, and Maine. The two photographs pictured here, for example, are from Point Lobos State Reserve near Carmel, California. Let's look at each photograph in turn and see how we might give these rocks starring roles.

In the first photograph, the proportion of sky to water is pleasing, so I think I'd use it as is. Also, the distant headland offers possibilities for the use of atmospheric perspective: I'd add more sky color to play down the headland so that it didn't vie for attention with the foreground. I'd also glaze over the two smaller rocks just below

the headland for the same reason.

The foam is a bit overwhelming for my taste, so I'd let more of the water show through and work to establish some interesting foam patterns. I'd keep the stop rock in the lower left, but keep value contrasts low so that attention would be directed toward the center of the painting, toward the major rocks and foam.

Overall, I'd keep to darker values along the top, bottom, and sides and reserve my lightest values for the foam and sunlit faces of the rocks. In practice, this would mean that I'd make the values around the perimeter darker than they actually are, while making the highlights on the rocks lighter than they really are. The foam, of course, is already light enough. This exaggeration of light and dark, incidentally, is the portrait principle of chiaroscuro applied to seascape.

Since no wave is clearly defined in the photograph, I'd have to invent one. If I were on location, I'd simply wait for a likely looking breaker, then sketch it in. In the photograph, however, you can get a clue to the angle and movement of the waves by observing the front edge of the foam moving across the lower right corner of the photograph. As a last touch, I'd add clouds to the sky to continue the feeling of motion in the water. (Take a look at the sky in *Big Sur Action*, Chapter 41, to see what I mean.)

The second photograph offers yet another point of view from which to treat this subject. To me, this photograph

seems more dramatic than the first. In any event, by choosing a perspective that eliminates the sky altogether, we can concentrate on the two main contenders: rocks and water. In my underpainting, I'd pay especially close attention to color changes in the water moving over and among the rocks, because that's where much of the story of this painting will be told.

Foam patterns should also be carefully laid down—not randomly, nor so they obscure the rich colors of the water itself, but rather so they show the flow of the water and serve as a compositional device to guide the eye smoothly through the painting. The large rock is almost in the center of this photograph, but that doesn't bother me—after all, it is supposed to be the "star." In fact, the stop rock in the lower right helps guide the eye along a circular path around the central rock. Finally, although I wouldn't know for sure until I'd nearly finished the painting, I suspect I'd use seagulls for accents and as compositional devices to reinforce the circular flow.

All other elements in this picture should be subordinate to the rocks and water starring in the center. A wave is needed here, since a seascape without a wave somehow just doesn't quite work. Develop a wave using the surf line in the lower right corner as a guide to the proper angle.

Point Lobos,
Carmel, California

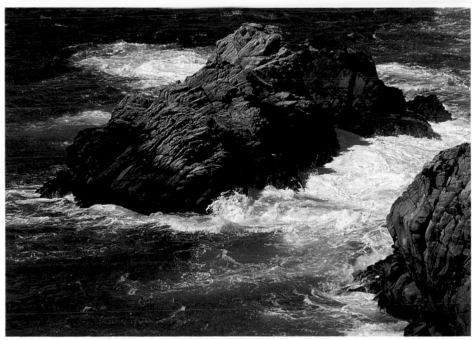

This perspective concentrates on the main subject—rocks and water—and the deep water colors are wonderful! Pay close attention to subtle shifts in color and value to make the most of this image. Keep transitions between adjacent colors soft-edged wherever possible. Let your colors tell the viewer how the water moves in graceful curves and eddies around the massive rock in the center.

Point Lobos,
Carmel, California

Expressing the Many Forms of Foam

I remember many a sunny day when, as a child, I'd go outside and lie on a bed of cool, sweet-smelling grass. I'd close my eyes, just enjoying the warmth of the sun on my face, then look up, searching the clouds for animals or an Indian chief. In those days, the nearest ocean was hundreds of miles away. Today, I'm fortunate to live much closer, and I still enjoy watching clouds, but I've discovered I get much the same feeling from watching foam floating on a "sky" of green and blue water. I'm amazed at the varied forms it takes: one moment a solid blanket; the next, wave-stretched into long streamers, finally breaking into little "islands" that endlessly change shape, merge, then stretch again in a tireless kaleidoscope of foamy patterns.

The very changeability of foam makes it both difficult and undesirable to offer any set "formula" for painting it. In fact, every seascape artist I know paints foam a little differently, yet the foam always seems to look right. In an earlier chapter, I compared foam to handwriting, and I think the analogy is a good one. We all begin with the same alphabet and, though each of us forms the letters with a different sweep, a different curve, for the most part everyone easily recognizes the letters and words the handwriting forms.

When it comes to foam, there's no substitute for first-hand observation to subconsciously impress a sense of its form and rhythms. Nevertheless, the reference photos illustrate a brief sea "alphabet" that should help you learn to express the many forms of foam.

This brief "alphabet" is hardly all-inclusive, but should give you a good idea of what goes where. Learn to think of foam in terms of where each distinct form occurs, then when you sit down to paint foam, concentrate on the forms of only one area at a time. Before long, foam will be as easy as A, B, C.

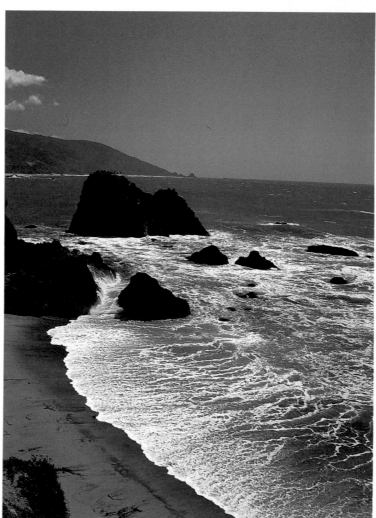

Big Sur, California

This is the "big picture," so to speak. If you keep this image in mind while you paint, foam won't seem quite as random. Notice the soft, undulating curves along the surf line, and notice that the foam trails generally point toward the upper right (in this case) along the perspective lines. Try turning the book around until the edge of the surf line is on top. Notice that the foam trails look a little like the branches of a tree, getting more numerous and delicate as they near the surf line.

Here again is a similar surf line, this time as seen from beach level. Now that you're sensitized to seeing the pattern of the foam trails (which here form loose lines pointing toward the center of the horizon line) and the curvature of the front edge of the surf line, you can see that those same features are still here, though less obvious from this angle. Nevertheless, this should assure you that there is a logic to surf patterns and should give you an idea of what forms are necessary to paint foam trails in a believable manner.

The patterns in the bottom third of this photograph are typical of foam over slightly deeper water than in the previous illustrations. Once again, there is a definite logic to these patterns; perhaps you see circles, or figure eights, maybe even a honeycomb. If that doesn't work, try looking at the shape of the "negative spaces"—the dark water showing through the foam—for another clue to the patterns.

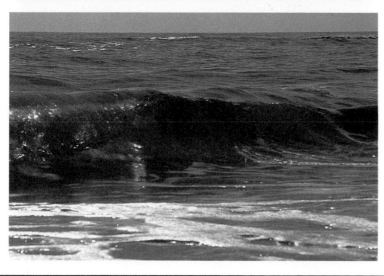

As a wave overtakes foam patterns lying on flat water, they are swept up the face of the wave in slender lines to form graceful arcs. Near the base of the wave, however, the foam begins to assume the curvature of the water, but briefly retains its globular form.

Here, in deeper water, in a lull between waves, the foam patterns are stretched out in thin lines forming loose, octagonal shapes. Near the bottom of the photograph, notice that the foam patterns are similar to those in the third photograph.

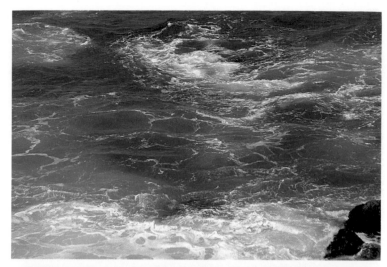

As a wave forms, it picks up the threadlike foam from the lull (see previous photograph), and carries it up the face of the wave. Also notice that several other foam patterns already mentioned are obvious as well. Can you find them?

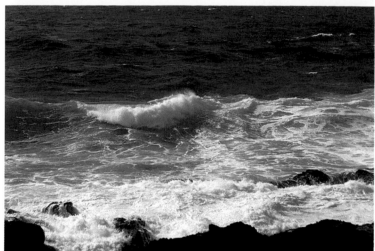

This is it, the climax! The big wave rolls over, trailing gossamer wisps of spray. This is good work for your bristle fan brush, using graceful, sweeping drybrush arcs. These windblown spray trails, by the way, are also an excellent device for suggesting the motion of the wave.

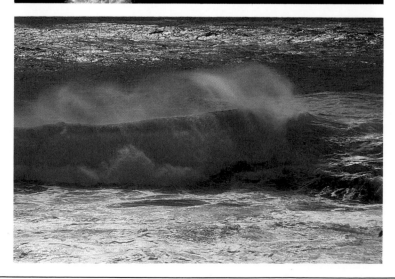

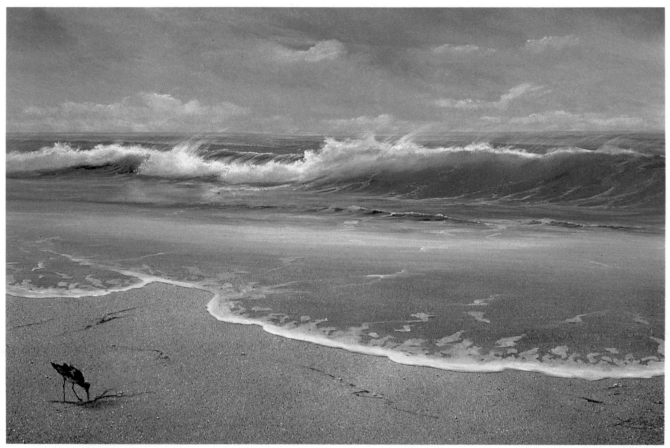

Returning Tide
12" × 18"

CHAPTER 47
Adding Life with Sea Birds

This photograph provides a wealth of information about seagulls' poses. Make sketches of those you like and alter the slightly awkward poses into more graceful ones.

To paint a close-up from a photo, block in the shape in a value that contrasts slightly with the background. Then, into the still wet shape, work with a liner brush to add highlights and shadows. I usually work on these details over several sittings.

When I first began painting the sea, "birds" were droopy **v** shapes tucked into out-of-the-way places in my paintings. As I got better acquainted with the beach, I came to love all its winged visitors and gradually moved them from the shadows to center stage. I don't know them all by name, but I still smile whenever I see them. Of all my beaked acquaintances, the three whose faces I know best are seagulls, willets, and sandpipers.

Seagulls are incredibly gregarious, and garrulous to a fault. They are the clowns of the ocean skies; while all the other birds seem much more intent on going about their business with the least help from or involvement with man, seagulls do everything but stand on their heads for a bite of bread. They gladly pose, and if you get too close, they simply walk away, peering nervously over their shoulders to see if you're still there. As a last resort, they fly a way down the beach.

When the air is cool or the wind too strong for easy flying, they stand on the wet sand with their heads pulled low onto their chests, facing the wind to avoid ruffling their feathers. To me, they look like a crowd of little, overcoated men waiting for a parade.

Willets are more wary of man and not at all interested in any enticements. So, with my binoculars or telephoto lens, I watch these long-billed beachcombers stride the sand on stiltlike legs, probing for a morsel here, another there. As I watch them, they watch me—lest I get too close. And

if I do, they fly far down the beach, chirping sharply as if to rebuke me for having disturbed their meal.

Sandpipers are perhaps the most elusive birds of all. They typically travel in groups of three or four, and even when I'm lucky, all I usually see is a blur of tiny feet going in the opposite direction. With a 300mm telephoto, I can occasionally get pictures of them as small specks on the beach. Still, despite their timidity, I love them, and the ocean wouldn't be the same without them.

I've yet to make the acquaintance of a long-necked black cormorant or a low-flying brown pelican, but I see them nearly every time I go to the beach. They, together with seagulls, willets, sandpipers, and all the other species whose names I don't know, give the sea a sense of vital life that goes far beyond crashing waves and lacy foam.

For me, painting small portraits is an excellent way to get to know these winged fellows better. *Beachcombers* (on the copyright page) is one example of such a "portrait." *Heading Home* and *The Meeting* are additional examples. I find that painting these small portraits of sea birds helps me understand the subtleties of their coloration and movements, and often provides material for larger paintings.

When you go to the beach, take time to study these birds. Learn their colors, habits, and mannerisms, and your seascapes will be better for it. In the meantime, why not use these reference photographs as the basis for some sea bird portraits of your own?

Notice all the interesting shadow shapes. Shadows are one of the easily overlooked small touches that really put the sharp *in sharp focus.*

Heading Home
6″ × 8″

These small studies of birds helped me understand their coloration and gestures better and they became references for larger paintings.

The Meeting
6″ × 8″

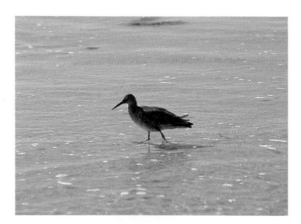

This lone willet is a common beach sight. Many people mistakenly call these fellows sandpipers. He's not as colorful as the seagulls, but has a lot of personality with his long beak and long legs. I usually block willets in with a grayed brown in a value that is slightly darker than the background color, then add middle and lighter values with a liner brush.

Recreating the Look of Bright Sunlight

There's something wonderful about bright sunlight reflecting on the ocean's surface, like thousands of diamonds scattered on rippled blue velvet. Alas, the light is usually too brilliant to look at directly even with dark sunglasses. In fact, the contrast between light and dark values is so intense that my camera's light meter hits the top of the scale so hard I expect to see the needle come around the other side! For our purposes, the range of values we see (or try to see) in bright sunlight is well beyond what we can paint with a value scale that extends only from black to white. Fortunately, we don't need to reproduce the painful extremes of light from the scene to create the look of bright sunlight in a painting.

Under "normal" lighting conditions, the lightest value is usually reserved for the foam. With bright sunlight reflections, however, the foam must take a step down in value so that the proper relationship among values is maintained. In other words, the sunlight reflections now become the lightest value, with the foam just slightly deeper in value. To keep the proper balance among values, you should mix the color for the bright sunlight (white tinted with yellow ochre) in advance, then test all other values in the painting against that standard. The bright sunlight color should, of course, be saved for last and then used sparingly.

Let's look at a few photographs to see where and how to place our bright sunlight color for best effect. (All three of these photographs, inciden-

tally, are from the vicinity of Carmel, California.) As you can see, the reflections are off to the side in each example. This is because the light was too extreme for the film I was using and, consequently, I was unable to shoot directly into the sun. In a painting though, I'd center up the reflections for better composition.

Notice that the sun ball is not visible in any of the photographs. Even if I'd shot straight into the reflections, the sun itself would not have shown in the photograph because it was above the top of

the area framed by the viewfinder. Usually, when the sun gets low enough to show in this portion of the sky, you've moved from daylight colors to a sunset palette. Even so, the value relationships hold; only the colors change. (That is, the sunlight reflections will still be the lightest value).

In the first photograph, notice how light the background water is at the horizon line. This area should be painted *almost* solid white/yellow ochre, using a drybrush stroke. As you extend the reflection left and right (assuming you've

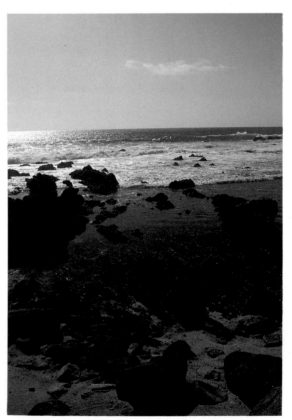

Carmel, California

At this time of day, natural sunlight is too brilliant for either the camera or your eye to look at squarely. So when using reference photographs such as this, you'll probably want to *center the bright sunlight reflections at the horizon line unless you have a particular reason for wanting them to one side, as they appear here.*

centered it as I suggested), two things should happen: the value should gradually darken (by addition of sky or distant water color), finally reaching the same value as the background water; and the dry-brush texture should thin out to a few isolated, low-value sparkles near the edge of the panel.

In the second photograph, again notice the sparkles at the horizon line. Now, move downward and notice that the wave is basically a dark silhouette. In a painting, you'll probably want to moderate that color with some low-value foam patterns or a slight glaze of atmospheric haze. The bright reflections at the base of the wave are tempting, but tricky—try them if you like. If you do, remember to stand back frequently as you paint to see if you're getting the desired effect. Finally, notice the sparkles on the crest of the wavelet in the foreground and on the tips of many smaller ripples. These should be applied with a fine brush and opaque color alternating short and elongated strokes, rather like dots and dashes.

In the third photograph, the dot-and-dash sparkles in the foreground are more easily seen, as is the fact that the foam is slightly lower in value than the sparkles. A final tip: Aside from value, one way to help differentiate between the sparkles and light-value foam is by color. The sparkles, as I mentioned earlier, are mixed from yellow ochre and white. The foam, in contrast, is mixed from white tinted with colors from your sky plus a little gray.

The point of interest in this photograph is the wave, which appears as a dark silhouette just below the horizon line. That's pretty much how it really looks, but when painting it, you'll want to include low-value foam trails curving up the face of the wave to add interest to an otherwise boringly even tone. Also notice the sparkles on the smaller wavelets and elsewhere in the foreground. These require advance planning to keep the basic foam values low enough so that your final highlight values can still contrast sharply. When you apply these "sparkles," avoid outlining a wave or wavelet—instead, use a liner brush to lay down short, irregular strokes, allowing the lesser value of the foam underpainting to show through.

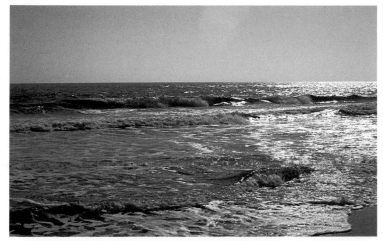

Carmel, California

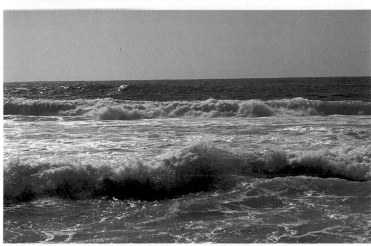

Carmel, California

In this photograph, the broken pattern of sparkles is more easily seen. Take a look at the wave in the upper left, just below the horizon line, for example. Also notice the bright sparkles in the water below the dark foam near the center of the image. Sparkles only "sparkle" if there is a noticeable change in value from dark to light, so always remember to paint your foam slightly lower in value than you might be inclined—it's like remembering to save room for dessert!

123

Putting People in Paintings

I enjoy a good game of Frisbee at the beach, and I really don't mind lying "bumper to bumper" with other oiled sun lovers, but the fact that real-life beaches are crowded with people doesn't mean that my paintings have to be, too. Instead, I prefer to paint a more pristine environment—the kind of beach we'd all like to discover and have just to ourselves. If someone must be in a scene, I'd rather let viewers imagine themselves being there. And so, thus far at least, I've scrupulously refrained from putting people in my paintings, with one exception: I do occasionally include a child in a painting, but only under certain special conditions. Let me explain:

If you pause to watch children at play on the beach when they're unaware that anyone is watching, you'll see that they're as natural in their movements and curiosity as the seagulls and sandpipers. Totally absorbed in the wonder of their surroundings, it doesn't occur to them to assume any of the artificial poses and expressions that adults so often fawn over—and it's that natural absence of artifice that attracts me.

Thus, in choosing a child to paint, I try to avoid "cute" poses and I seldom paint full-face views, because I'm looking for a more universal quality. Typically, I'll choose a view with the side of the face partially visible, or only the back of the head visible. As the child looks intently into the painting, likewise, I hope my viewer will also be drawn into the image. Now, let's look at several examples that will illustrate what I mean.

Unless you are specifically out to paint someone's portrait, don't. By avoiding stereotypical poses and full-face angles, you can impart a more universal quality to paintings that contain people. This photograph happens to be of my niece Erin Lin, but only I would know that. What is more important than who she is, however, is what associations she evokes in those who see her: perhaps they see themselves as children; perhaps they see their own children or granchildren. In any event, by avoiding specifics, you allow your viewer to become a part of your image and move beyond merely "cute" to something more lasting.

Here is another delightful, self-absorbed pose. I did pretty much the same thing when I was her age, and my parents probably still have bushel baskets of shells to prove it. The wet sand reflections of the little girl are especially interesting, though for a painting, I'd want to add more interest to the beach—perhaps some stringy kelp and more noticeable shells and shell fragments.

This young lady seems a little surprised to find the water so close, but appears to be having a good time nonetheless. Her reflections are somewhat sharper than those in the previous photograph and would provide good practice in the subtle variations possible with wet sand reflections. If you plan carefully and sketch well, you can probably come pretty close to those reflections during your block-in. Otherwise, you'll have to wait for the sand and texture to dry before returning to paint the reflections.

The first photograph is of my niece, Erin Lin, at a beach near Bar Harbor, Maine. The pose is completely natural, one of expectation, wonder, and a little trepidation all mixed together. We don't need to see her face to understand the story. I think I'd paint this one fairly literally, perhaps simplifying the rocks and water in the upper middle portion, and adding a seagull to contrast with the dark rocks on the right.

The second and third photographs are of two little girls I saw at a southern California beach. The first young lady is completely caught up in building her shell collection; the second looks a little surprised to see the water so close. In each case, the story is self evident. The wet sand and reflections of each girl offer many exciting painting possibilities, as does the water's edge. In this case, I think I'd combine the pose from the first photograph with the water details from the second to create the strongest image.

And finally, to give you an idea of how I put the preceding rules and suggestions into practice, take a look at *Free Spirit* (right). The visual angle is higher—I was standing on top of a high dune looking down. The boy dragging the kelp seemed to race against the wave that's directly above him in the painting. The scene had such a simple, natural feeling of peace and harmony that I couldn't resist trying to capture it.

Free Spirit
10" × 16"

Here is an example of a painting which shows how I put these ideas into practice when I choose to include a child in the painting.

Lighthouses Add Interest

Bodie Head
Lighthouse, Cape
Hatteras, North
Carolina

I like to think of the world in my seascapes as unspoiled, so I stubbornly resist painting anything that admits to the incursion of mankind. Yet certain buildings seem so much a part of the nautical environment that even I succumb to their charm. I love lighthouses—perhaps because I imagine myself as the lone lightkeeper contentedly surveying my watery domain. In my mind, at least, the storms are few, far outnumbered by bright, sunny days with endless parades of billowy clouds and fiery sunsets.

I have yet to paint a lighthouse in a storm or at night, but I may one day. For now, I prefer blue sky, a cool breeze, and a warm sun. These conditions are well-suited to sharp focus painting as well: the white of a lighthouse provides crisp contrasts against the sky, as does the top part of the tower, which is often a rusty red or soft black. With a few notable exceptions, however, lighthouses do pose a problem for all who would paint them: the very storms that make them necessary also threaten their existence. As a result, lighthouses are often placed far from the water—which can make it difficult to paint a proper seascape.

Bodie Lighthouse on Cape Hatteras, for example, is a beautiful, tall structure with distinctive alternating bands of black and white. Alas, it is firmly landlocked in a grassy field. In a similar manner, Eastern Point Lighthouse near Gloucester, Massachusetts, is perched on a rocky knoll that defies sea views. You could, of course, simply paint a portrait of either of these lovely buildings, but that wouldn't be a seascape. Or you could let your imagination run free and "relocate" the buildings closer to the water.

With a little persistence, however, you can find one of the many lighthouses that offer sea views as well. Perhaps the most famous of these is Cape Hatteras Light, with its barber pole stripes in black and white. And, as another example, Portland Head Light near Portland, Maine, is also a promising subject.

Regardless of what lighthouse you choose, make a careful drawing of all significant details, then transfer the drawing onto your panel. A quick coat of fixative will keep the drawing from smudging. Next, carefully apply two-inch masking tape over the entire drawing, then cut through the tape, which should be translucent enough that you can see the drawing beneath. (Do *not* cut into the panel, and use a razor blade or X-Acto knife and straight edge.) Finally, remove the excess tape, leaving the shape of the lighthouse masked.

Now, block in your sky, water, and the ground the lighthouse sits on. When that's complete, use an X-Acto knife to lift an edge of the masking tape. Peel away the tape, and paint in the lighthouse. Your edges will be crisp and straight and the image strikingly realistic. When your underpainting has dried, you'll probably want to glaze over the lighthouse with the sky tint to push it back into the image and add a little at-

Most lighthouses are placed high atop rocky headlands, but in this case, there are none— only low, rolling dunes. So this lighthouse was built well inland on what is now a flat, grassy field. To paint this one, you might want to imagine water in somewhat closer proximity. But more likely, you should substitute sand for the grass—which is probably the way the lighthouse originally appeared.

This is perhaps one of the most famous lighthouses in the country, and the tallest, too, as I recall. What is intriguing about this image is the reflection of the lighthouse on the water in the foreground. I'd paint the water and let it dry before returning to paint the tower reflection in semiopaque glazes of the colors used earlier for the lighthouse.

mospheric perspective.

Take a look at *Bass Harbor Light* (page 128) to see how the techniques just described work in a completed painting. This lighthouse is perched on the rocks near Acadia National Park in Maine, and is actually somewhat more obscured by trees that I have painted it.

Once the basic sky, headland, and water were blocked in, I removed the tape and painted in the lighthouse with all its final details. Next, I turned my attention to the rocks. I wanted to capture the ruggedness of this coastline, so I spent quite a bit of time developing cracks, crevices, and various textures, using a liner brush. Then I returned to indicate the trees and low growth around the top of the headland, using a fan brush.

To complete the painting, I mixed a glaze slightly tinted with the sky color and used it to go over the lighthouse, trees, headland, and distant water to push them back into the image with atmospheric perspective. Finally, I returned with the liner brush and reinforced some of the highlights on the rock faces to bring them forward in the image.

Now it's your turn. Why not try creating your own version of one of the four lighthouses pictured on these three pages?

Cape Hatteras Light, North Carolina

Eastern Point Lighthouse, Gloucester, Massachusetts

This has the rudiments of a good painting—an interesting visual angle and strong lighting. I'd dispense with the red-and-white checked outbuilding and the radio tower. In general, I prefer to paint these structures the way I think they would have looked when first built.

This is a classic setting much like the one I used for Bass Harbor Light. *The primary changes I'd make here would be to develop more clouds and some interesting wave action. Watch the placement of the horizon line—it's almost in the center of the image. You needn't raise or lower it much, however, because the lighthouse and rocks form an effective "bridge" between sky and water.*

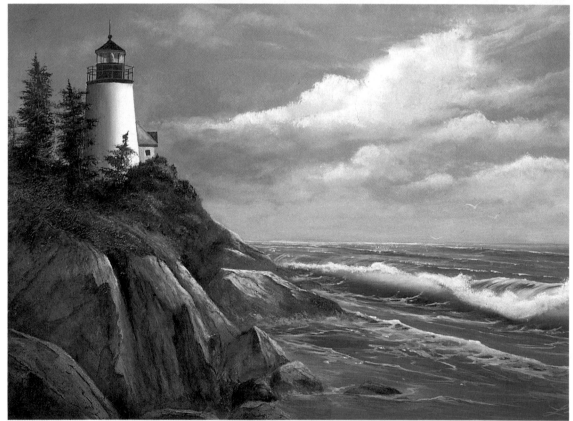

This painting of Bass Harbor Light *near Bar Harbor, Maine, has many elements in common with the photograph above. Notice how the angle of the main wave and the clouds direct your eye to the lighthouse, the focal point of the composition.*

Bass Harbor Light
12″ × 16″

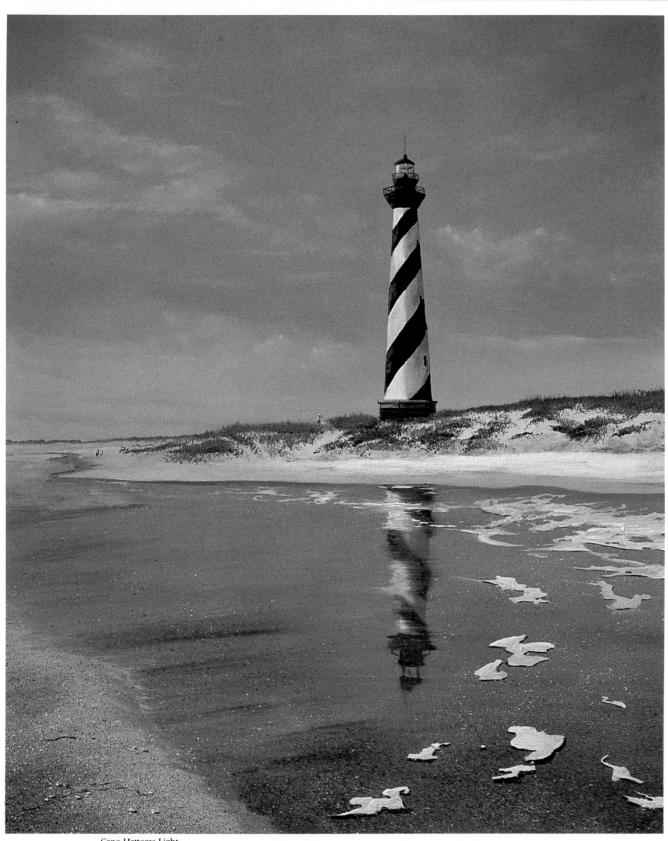

Cape Hatteras Light
16″ × 20″

Looking at Shells and Kelp Close Up

I find that the best way to get to know what something really looks like is to paint a picture of it—preferably a close-up view. Then, when I need to paint the same thing again, perhaps in a larger painting, I know which details are essential and which can be left out.

Shells and shell fragments, for instance, when viewed from a distance are recognizable only as a noticeably lighter stretch of beach (sometimes nearly white), usually along the high tide line. As we move closer, a few of the larger shell fragments become discernible, though not yet well-defined. Finally, kneeling down to look closely, we see all the bits and pieces and possibly even an intact shell. Typically, the shells are some form of clam with ridges radiating from the hinge toward a broad lip. From this last vantage point, the subtlest details of coloration and shadow can be studied.

Having spent this time examining both individual shell fragments and larger patches of broken shells at close range, I find that when painting a similar area, I'm inclined to work with the textures a bit longer. By doing so, I get a feeling of realism not formerly possible.

As just one example of how this works in practice, I have learned that at a certain distance, a shell fragment can be distinguished from sand or pebbles only because it reflects light quite strongly—so I paint it as a dab of white with a thin shadow line beneath. As I move closer, the radiating ridges as well as some of the shell colors become visible on a few of the larger fragments. So the white dab now becomes somewhat larger, with the first suggestions of ridges and shell color.

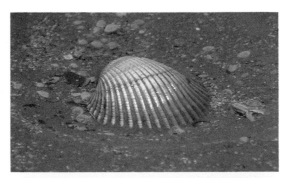

Top left: I lay kelp down with a liner brush held at the very end so that the resulting lines are loose and flowing. For the darks, I use burnt umber and gray, and for the lighter areas, burnt sienna and gray. Bottom left: Again, the exact form of kelp floats is up to you.

Top right: Use this photograph to try your hand at sketching and painting an intact clam shell. Bottom right: For shell fragments I usually use white tinted with yellow ochre for the brightest portions, with a little ultramarine violet for the rest.

Finally, if I want my viewer to be really drawn into a painting, I may include a shell in the foreground in sharp detail, then progress into the less defined forms to build a sense of depth.

The same principles apply when painting kelp. Up close, individual leaves or perhaps a kelp float may be clearly defined. Colors are richer and more varied. Further away, kelp assumes the typical clump formation with trailing leaves, and finally, when very distant, kelp may require no more than a quick scribble with a brush.

Nothing makes me look more closely at a shell or a piece of kelp than trying to paint it. And when I work with paint, I understand the difference between casually looking at something and really seeing it. My little close-up "portraits" of shells and kelp have been valuable training— not to mention being an enjoyable challenge.

Beach Buffet (below) is a good example of one such portrait which includes not only kelp and shells, but also seagulls and the water's edge. This painting required four sittings to establish and refine the various layers of detail. During the first sitting, I established the wet and dry sand textures. Then, at the second sitting, I blocked in the shapes of the floating foam, seagulls, kelp, and shells. At the third sitting, I refined the lights and darks in these same elements. And finally, at the fourth sitting, I brightened the highlights further and laid in the last few delicate strands of kelp lying on the beach.

In Beach Buffet, *we see how the little details such as kelp and shells, as well as seagulls and the water's edge can be combined into a simple, but effective and realistic image of the seashore. By making detailed studies of these elements, I learn what they really look like and what details are essential when including them in my paintings.*

Beach Buffet
10" × 16"

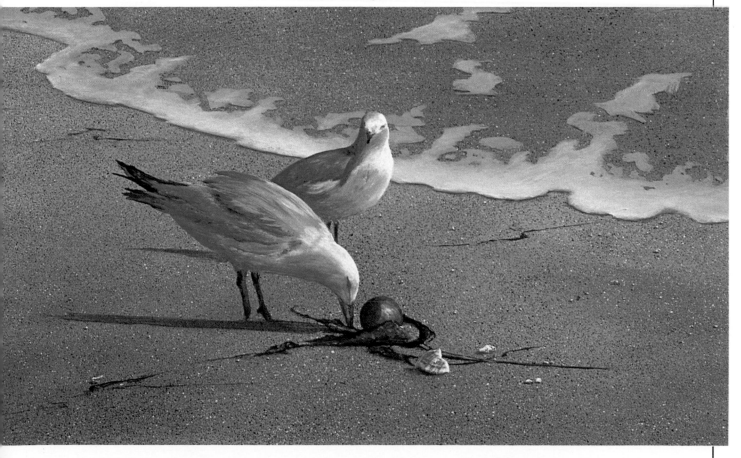

Contrasting Distant Forms and Foreground Detail

For me, painting the sea in sharp focus has two objectives. The first is to create the most realistic image possible. The second is to create a sense of immediacy—a feeling on the part of my viewers that the place they see is not only real, but almost tangible. In other words, I want my viewers to forget for a moment that they are outside the painting and feel that they are literally at the scene—that they could almost touch the sand, grasses, or rocks they see.

As I've pointed out in earlier chapters, painting the sea in sharp focus doesn't mean painting every drop of foam and every grain of sand in excruciating detail. Our eyes are simply not capable of seeing every detail of our world in sharp focus simultaneously. Consequently, if a painting provides more detail than we are accustomed to in reality, we become uneasy—the painting looks surrealistic.

The action of atmospheric perspective determines that most of the detail will be concentrated in the foreground, and if we comply with nature in this regard, we'll be well on our way to satisfying that first objective, to create the most realistic image possible. The second objective, creating a sense of immediacy, requires a little more consideration. Here's why:

When we observe a scene in nature, we may look at the broad panorama and exclaim how breathtaking it is—and in fact, that might be all we'd remember if asked to describe what we'd seen. Yet, in reality, we'd have also been keenly aware, through our peripheral vision, of what we were standing on (the beach, a rock, whatever), and what was nearby (a dune, a hillside, branches, and so on).

In real life, these peripheral images would be blurred. In a painting, however, we deviate from reality by making them precise—as if our viewer had momentarily glanced from side to side to gain his or her bearings.

No one seems to mind this little subterfuge, perhaps because it is so reassuring. Branches or rocks, for example, when depicted as if within reach, are reassuring because they impart a sense of security, a sense of having something to grab onto should you lose your balance, a sense of being firmly anchored to earth that is subconsciously comforting to viewers. Let's look at a few examples:

Illustration 1 is a view from the Kalalau Trail on the Napali coast of Kauai. Notice how the broad-leaved plant on the left and the branch on the right tell us that we are standing on solid ground looking out as if we'd just parted the foliage for a peek. In Illustration 2, we're looking down the Big Sur coast, near Carmel, California. This time the ground on which we're standing is plainly visible. Try to imagine the scene without the foreground to anchor you. Feels like the view from an airplane, right?

Illustration 3 is more nearly at ground level. Still, the waves and rocks are distant, and it would be easy to feel remote from the scene were it not for the hillside and grasses that give us a comforting sense of where we are.

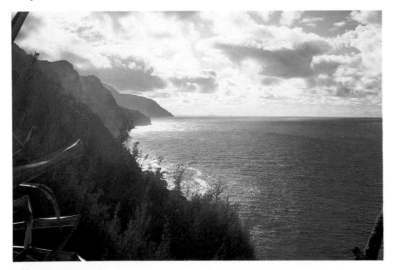

Illustration 1:

This scene from the Kalalau Trail on the island of Kauai, Hawaii, is a good example of the effectiveness of contrasting distant forms against foreground detail: the sense of depth and scale is very strong.

The succession of headlands, each more "atmospheric" than the last, are excellent depth cues. The clouds are especially dramatic, yet soft at the same time.

Napali Coast, Kauai

Any of these photographs could, of course, be made into an attractive painting. In the first photograph, I'd define waves and arrange foam patterns to help create a circular composition. I might also work with bright sunlight sparkles along the horizon line. I'd handle the second and third photographs in a similar fashion and also add clouds to make the skies more interesting. In all three photographs, I'd spend considerable time developing crisp detail and strong contrasts between light and dark in the foreground foliage while keeping the background very atmospheric.

Take a moment to look over the paintings in previous chapters to look for similar anchoring devices in the foreground. *Near Morro Rock,* in Chapter 24, is one good example. For another, look at *Rocky Shore,* in Chapter 28. Even seagulls, as in *The Beach Crowd,* Chapter 12, impart a sense of immediacy. In many of my paintings, the sand itself serves as solid footing for the viewer.

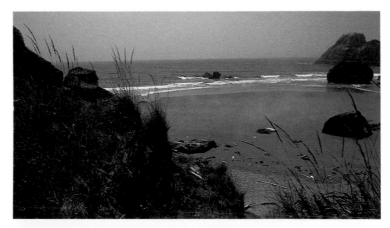

Illustration 2:

The plants and yellow flowers in the foreground are the purest in color and are untouched by atmospheric perspective. As we proceed into the distance, the first headland is visibly tinted with color from the sky, the second headland more so, and the large rock even more so. By using transparent glazes of the sky color, you needn't worry about getting the atmospheric perspective exactly correct during block-in. Fortunately, it's a simple matter to apply as many successive glazes as are required to achieve just the right sense of distance for each object in an image.

Big Sur, California

Illustration 3:

This scene has considerable potential and could be interpreted in many interesting ways. Foggy with sunlight breaking through onto the foreground hillside and grasses would be one possibility. Another would be to keep the foreground in shadow and have the light breaking onto the beach area. Still another possibility would be to set the whole scene in brilliant sunshine. In fact, I liked this scene so much that I painted Secret Cove (Chapter 30) from a vantage point on the beach just below this hillside.

Patrick's Point, California

Capturing the Ocean's Many Colors

Over the years, I've been fortunate to travel fairly widely in pursuit of my love of the ocean. I've been up and down the Atlantic and Pacific coasts; to Oahu, Maui, and Kauai, in Hawaii; and to the island of Mooréa, Tahiti. In all of these places, I've been amazed at the many variations of color I've observed in the ocean. True, the colors are mostly blues and greens—but what a marvelous and surprising range of possibilities these two colors offer!

Many factors affect the color of the ocean. The sky is the major influence. Under the bright blue skies of Hawaii and Tahiti, for instance, every color seems incredibly crisp and pure. By contrast, the overcast skies so typical of summer on the Pacific coast mute the ocean's blues and greens with somber tones of gray. Still, regardless of whether the sky is sunny or overcast, the colors of sky and water are inextricably bound, because the troughs always reflect the colors overhead.

Depth is also an important factor in determining the color of the ocean. The deepest waters are a dark blue that approaches black. In shallower waters, however, the color depends on whether what is below reflects light back upward or not. A rocky bottom doesn't reflect much light; consequently, the water remains dark blue. A shallow, sandy bottom, on the other hand, reflects enough light to cause the water to appear green. Near a sandy shore, the water is almost clear and barely conceals the color of the sand.

The color of the ocean is

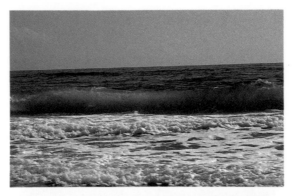

Illustration 1:

This is a good example of how a wave looks when it picks up sand from a shallow bottom. Of particular interest here is the translucent portion of the wave at the top. By now, you should already have an idea of the proper palette for this wave from earlier chapters, so try painting this one for experience in getting the form and color of the wave.

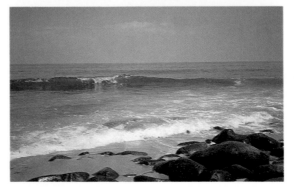

Illustration 2:

This wave provides another sample of colors from slightly deeper water. The form of this wave is much more interesting than the wave in the previous illustration. Look closely at the sky reflections in front of and on the face of the wave. Try painting this one fairly literally, with one exception: simplify the foam patterns in the foreground, and use them to establish a visual path into the image.

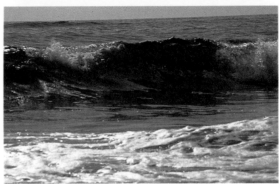

Illustration 3:

Here we have another example of how much the sky is reflected on the surface of the water. In fact, if you look closely, you'll see that very little of the dark water actually shows through the sky reflections! Aside from remaining true to reality, using sky reflections on the surface of the water offers the additional benefit of unifying the colors of sky and water.

Illustration 4:

This photograph illustrates how, in slightly deeper water, the wave color moves more toward blue and blue-green. Why not use this excellent scene to try your hand at all you've learned in the previous chapters?

also affected by turbidity, the amount of air or sand caught up in the water. In the aftermath of a large, foamy breaker, the water becomes milky green or blue because of air bubbles still trapped beneath the surface. Likewise, when a breaker crashes in shallow water near shore, it often picks up sand, kelp, and shell fragments, all of which impart a little of their color to the wave. In sheltered waters, however, like those found in lagoons and behind protective reefs, breakers are few and the water is stirred up less. Under those conditions, when a wave crests with the sun behind, the upper portion glows with the clarity of a rare jewel.

Let's take a look at a few specific examples of ocean colors. (Suggested palettes for green and blue water are given in Chapter 13 and elsewhere throughout the book.)

Green Water. Illustration 1, from Gulf Shores, Alabama, shows a wave murky with sand from the shallow bottom. Illustration 2 shows the colors of another green wave, but over somewhat deeper water.

Sky Reflections. Illustration 3 is a good example of how the sky color is reflected from the water's surface in the troughs between waves and swells. Notice how little of the dark water actually shows through the reflections.

Blue-Green and Deep Blue Water. Illustrations 4 and 5, from La Jolla, California, are examples of water and waves in the blue-green and dark blue palettes. Here, because the bottom drops off quickly, little light is able to penetrate and the water remains a cool, dark blue.

Clear Water. Finally, Illustration 6, from the island of Kauai, shows the dramatic range of colors possible with clear water, clear skies, and a sandy bottom. The darker areas in the light green water are coral beds. A little farther out, beyond the coral beds, the sandy bottom drops off rather steeply, and as a result, the water fairly abruptly turns to a greenish-blue. The characteristic dark blue of deep water will be still farther out,

because the clear tropical water allows light to reflect and illuminate to much greater depths than would be possible in more turbulent waters.

For practice, why not paint the composition and colors from Illustration 4 as is? Then use the same composition and try your hand at painting the other colors of the ocean from each of the five remaining photographs. (Refer to earlier chapters for palette suggestions.)

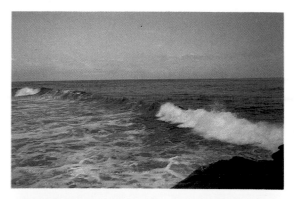

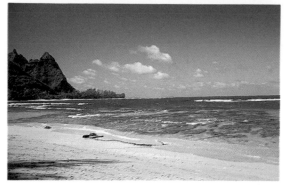

Illustration 5:

In this photograph, the water is well into the blue palette. The basic arrangement of forms is quite interesting and with only a little imagination could make a fine painting. The stop rock in the lower right corner provides an excellent bit of foreground detail—notice the subtle blue reflections on its surface. The lacy foam could, of course, be simplified. See what you can do with this one!

Illustration 6:

If you're ready for a real workout, this scene from Kauai has it all—sand, jewellike tropical water, dark coral beds, and deep blue ocean.

Appendix: Making Your Own Color Map

There are many possible ways to approach color mixing when painting. One is "spontaneity"—simply letting whatever happens happen. Another is written notes—a certain blue plus a certain yellow yields a cool green, for instance. I've tried both of these and several others in the course of my career, but the technique that works best is making a "map" of each key color at different values.

To do this, we need a standard frame of reference for the values (degrees of lightness or darkness, ranging from black through middle grays to white), so the first task is to create a gray scale. Here's how:

(1) Start with a white such as titanium white and a black such as ivory black. Mix a little of each to get a gray that looks to be halfway between black and white. You now have three globs of paint: black, middle gray, and white.

(2) Mix a little of the black and the middle gray to get a value that appears to be midway between the two parent values.

(3) Mix a little of the white and the middle gray to get a value that is visually midway between those two values.

At this point you have five values: white, light gray, middle gray, dark gray, and black. You could proceed to mix an intermediate value between each of these values to arrive at a scale containing nine gradations, but for purposes of illustration, we'll work with these five.

Now that you have these mixtures, tape off a panel or canvas into rows, according to the number of gray values you have mixed, and into columns, according to the number of key colors you want to "map." Allow three columns for each key color: one for the pure value (basic color lightened with white), a second column for the pure color with a little gray, and a third column for the pure color plus lots of gray. When you make your map, I suggest you make columns for all the colors you intend to use, but for now, we'll just use phthalo blue to demonstrate the procedure. Here's how to "map" your colors:

Arrange your gray values in a column on the left of a disposable, paper palette. Next, place a pile of phthalo blue next to the black value and a pile of white next to the white value. Now carefully repeat the process of mixing a middle value, then the two intermediate values corresponding to the grays directly to the left. The only new twist is that you should add a faint hint of the phthalo blue to the white value of that column to create a bluish-white. These are your "pure" blue values.

After you've completed that column, begin a third column of slightly grayed blue values by mixing some of the gray from column 1 with some of the "pure" blue value from column 2 (directly to the left). Place the resulting mixture in column 3. Do this for each of the five values.

Finally, begin column 4 (pure color plus lots of gray). Repeat the steps just described, but mix the grays from column 1 with the slightly grayed blue values from column 3. Now your palette should contain five rows representing five values from black to white, and four columns with neutral gray, "pure" blue values, slightly grayed blue values, and heavily grayed blue values.

Transfer some of each mixture to the corresponding square on your taped-off panel, and begin again with the next color until you've mapped all your key colors. This may seem like a lot of work, but the resulting map will make it simpler for you to quickly identify the color, value, and approximate amount of gray you need for a particular passage in a painting.

A less obvious but equally important benefit of mapping your colors is that you'll gain experience recognizing the values underlying the colors you use and in graying colors to the levels present in the real world you're trying to recreate in oils.

The preceding is, of course, only a basic guide to making your own color map. Incidentally, the process of mixing gray values can be greatly simplified by purchasing a selection of the neutral grays, which are available in tubes.

Finally, if you're sufficiently intrigued by the concept of color mapping and would like to explore this procedure in greater detail, I suggest you look for the Liquitex Oil Color Map & Mixing Guide at your local art supply store.

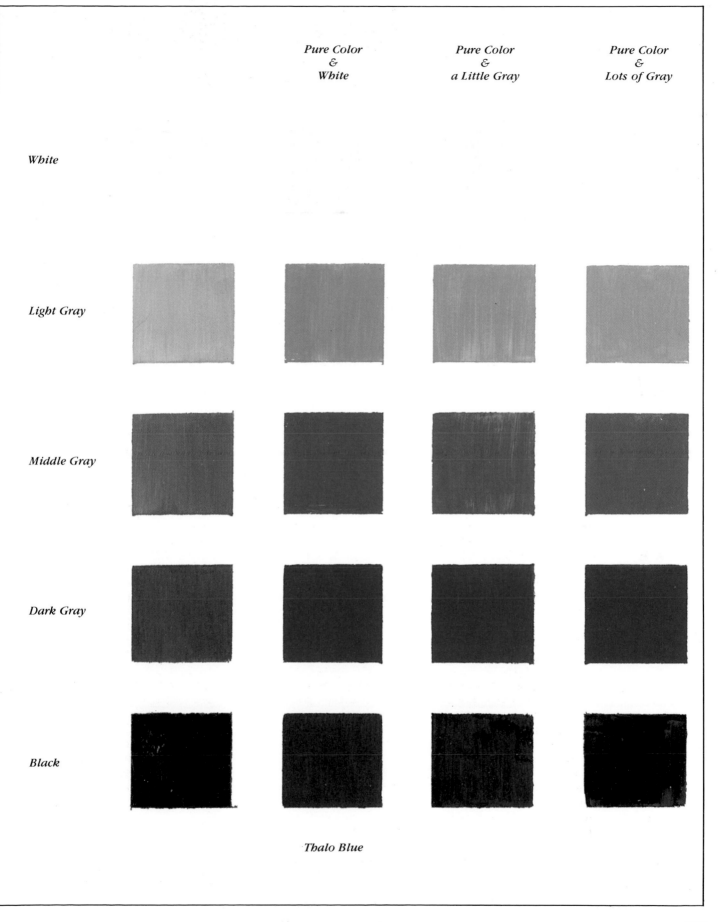

	Pure Color *&* *White*	*Pure Color* *&* *a Little Gray*	*Pure Color* *&* *Lots of Gray*
White			
Light Gray			
Middle Gray			
Dark Gray			
Black			

Thalo Blue

137

Index